Women in the Victorian art world

WOMEN
IN THE
VICTORIAN
ART WORLD

edited by

Clarissa Campbell Orr

Manchester University Press

Manchester and New York

distributed exclusively in the USA and Canada by St Martin's Press

Published by Manchester University Press
Oxford Road, Manchester M13 9NR, UK
and Room 400, 175 Fifth Avenue, New York, NY 10010, USA

Distributed exclusively in the USA and Canada
by St. Martin's Press, Inc., 175 Fifth Avenue, New York, NY 10010, USA

British Library Cataloguing-in-Publication Data
A catalogue record is available from the British Library

Library of Congress Cataloging-in-Publication Data
Applied for

ISBN 0 7190 4122 8 *hardback*
ISBN 0 7190 4123 6 *paperback*

Reprinted in paperback in 1996

Designed by Max Nettleton FCSD
Typeset in Monotype Columbus
by Servis Filmsetting Ltd
Printed in Great Britain
by Redwood Books, Trowbridge

CONTENTS

FIGURES

CONTRIBUTORS

Clarissa Campbell Orr is a Senior Lecturer in History at Anglia Polytechnic University, Cambridge. Her essay on 'Romanticism in Switzerland' appeared in *The Romantic Movement in National Context*, edited by Roy Porter and Mikulas Teich (1988). She has also contributed to the *Blackwell Companion to the Enlightenment* edited by John Yolton (1991) and to *A Dictionary of British Women Writers*, edited by Janet Todd (1989). Manchester University Press will be publishing a collection of essays she is editing, *Wollstonecraft's Daughters?: The Woman Question in Nineteenth Century France and England*, in 1995.

Deborah Cherry teaches the history of art at Manchester University. Her publications include *Painting Women: Victorian Women Artists* (1993); and *The Edwardian Era* (1987) and *Treatise on the Sublime: Works by Maud Sulter and Lubaina Himid* (1990), both co-edited with Jane Beckett. She is currently writing a study of the relationships between feminism and visual culture in Britain before 1900.

Sara M. Dodd, a lecturer in art history at the University of Hull, specialises in the nineteenth and twentieth centuries and has previously published on the Victorian Olympians and on Atkinson Grimshaw. She is currently engaged on a book on music and art education for women in the Victorian period.

Ann Eatwell worked in the Ceramics Department of the Victoria and Albert Museum for over ten years and has published widely in the fields of ceramic history and collecting history. She is currently working on the evolution of specialist societies and their effect on collecting behaviour and taste in the nineteenth century, and on the context for silver, its manufacturer, marketing and use. Her essay on Pugin's contribution to the design of silver accompanied the retrospective on Pugin at the Victoria and Albert Museum in 1994, where she now works in the Metalwork Collection.

Pamela Gerrish Nunn has taught the History of Art since 1978. She has published articles and books on women artists, especially of the nineteenth century, including *Victorian Women Artists* (1987) and, with Jan Marsh, *Women Artists and the Pre-Raphaelite Movement* (1989). Since 1989 she has lived and worked in New Zealand, and is presently writing a book on the sexual politics of Victorian painting.

Pam Hirsch formerly taught English and History in secondary schools in Cumbria. A deepening interest in the history of the woman's movement led to an MA (1989) and Ph.D. (1992). She has written on Mary Wollstonecraft, George Sand and George Eliot and is currently writing a biography of Barbara Leigh Smith

Bodichon. She runs 'Cambridge Women's Studies Forum' and supervises University of Cambridge students working on nineteenth-century writers.

Francina Irwin was until October 1993 Keeper of Fine Art at Aberdeen Art Gallery. She was co-author with her husband, David Irwin, of *Scottish Painters at Home and Abroad 1700–1900* (1975). She is currently working on a fuller study of women amateur painters *c.* 1760–1860.

Jan Marsh is author of *Pre-Raphaelite Sisterhood* and a number of other studies of women in the Pre-Raphaelite circle, most recently *Christina Rossetti: A Literary Biography* (1994). In 1988 she organised an exhibition on Jane Morris, and in 1991 the first exhibition of Elizabeth Siddal's work, in Sheffield. Her current projects include a study of the representation of ethnicity in nineteenth-century painting.

Lynne Walker formerly taught the History of Architecture and Design at the University of Northumbria. She currently chairs the Women's Design Service and is writing a history of British Women and Architecture.

PREFACE

This volume of essays grew out of twin events held in Cambridge in June 1991 to commemorate the centenary of Barbara Leigh Smith Bodichon 1827–91: a retrospective exhibition of her work, the first since her death, held at Girton College and a symposium on women in the Victorian art world at Anglia Polytechnic University.

Both exhibition and symposium addressed the issues of what it meant to be a woman and an artist in the latter half of the last century. To what degree did gender determine the parameters within the artist might operate? How far did the very specific conditions governing a woman's life in the mid-nineteenth century construct the questions of what she might paint; how she should paint; when, where and what tools she might use for the purpose.

At Girton, the exhibition was structured in such a way as to set Barbara Bodichon's art in context with her life. Her paintings and sketches were displayed alongside examples of her activities as a pioneer in the campaigns for women's work, suffrage, legal rights and education. What was portrayed was a life of intense involvement in diverse issues concerning women, in which art played an integral part. The exhibition left no doubt that she was an atypical Victorian woman both in her circumstances and in her temperament, but one who derived great satisfaction from living outside the strict conventions of her age. This uncoventional approach enabled her to assume attitudes which were critical to her position as a woman artist. For example, she adopted professional status, and for her art, although not for other aspects of her life, she was ambitious, unafraid to seek both recognition and praise.

The symposium, which drew speakers from as far apart as Cambridge and Algiers, aimed originally to contextualise the paintings hung at Girton. However, the day went far beyond this by presenting the broadest possible view of women's place in the Victorian art world while at the same time keeping a close focus on the decades encompassing the life of one particular artist. The net result of this strategy was an exciting cross-referencing from paper to paper. Contributors examined the social and economic backgrounds of women artists, their opportunities for professional training, their representations both as women and artists in art and fiction and the constraints imposed on them by the

social mores of the period. However, although there was evidence to suggest a strong networking amongst at least the middle-class women of this period, what emerged most strongly was not the conformity but the great heterogeneity amongst nineteenth-century women artists and it became apparent that the questions of *how a woman might paint* was a very small part of what was at issue.

Both events engendered a sense of uncovering the work of women who had been hidden from history, those who had been forgotten, lost or possibly never perceived. However, it was also abundantly clear that an inventory of women artists was not enough and that what was necessary was to unpick the constructed stereotypes, to re-examine the available sources and reconstruct the information in new and different ways.

Kate Perry

ACKNOWLEDGEMENTS

There are many people I should like to thank for their help at various stages of this project. Some essays in this book were originally given at a symposium on Barbara Leigh Smith Bodichon at Anglia Polytechnic University (then Anglia Polytechnic) in June 1991. My colleagues Felicia Gordon, Penelope Kenrick and Susan O'Brien gave invaluable help in organising this. Kate Perry provided the occasion for the symposium by her commemorative exhibition at Girton College, and the Mistress of Girton, Dame Mary Warnock, generously allowed a private view of it. A special thank-you must also go to John Crabbe, for his dedication as a collector of Barbara Leigh Smith Bodichon's work, and his generosity as a lender.

In the transition to book form, I must again thank Kate Perry; Marcia Pointon; and for Manchester University Press, my editor Katharine Reeve and my copy-editor, Christine O'Brien. Sally Bienias provided supremely efficient secretarial help and the Computer staff at Anglia Polytechnic University their cheerful and unstinting assistance.

It is said that collaborative books are difficult to do, but I can honestly say that it has been a great pleasure to work with all my contributors, and that one of the most agreeable aspects of the book has been the opportunity of drawing on the expertise of established as well as less well-known authors, and of people working both in academia and the museum world. Nor is it an idle convention to thank my students, past and present, for the stimulus of their enthusiasm and interest, which has particularly helped me think about the themes discussed in the Introduction.

Finally, on a more personal note I should like to pay tribute to my Victorian grandmother, Nelly Louisa Campbell, whose eye for colour, interest in design and passion for collecting china was faithfully passed to me by her daughter, Sylvia Stephens Orr. Their enthusiasms, coupled with my mother's keen sense of historical change and sympathetic encouragement as the book neared completion, have been important influences in shaping my outlook as a historian, and I warmly thank them both for their legacy. Other friends whose interest has been welcome throughout the making of this book should also feel much appreciated.

Women in the Victorian art world

Clarissa Campbell Orr

WHAT does this collection mean by the term 'Victorian art world', and how does it approach the study of women's participation in it? The term 'Victorian' is freighted with all kinds of ideological baggage. When joined with 'woman', it has conjured up a picture of crino-lined, repressed femininity, ever since Bloomsbury's rebellion against their parents and grandparents. In the 1980s, calls to rediscover Victorian values prompted several reassessments of what those values actually might have been, and show that it is possible to define quite contrasting kinds of values and behaviour as 'essentially' Victorian. But it is incontestable that the proper role of women was a much debated issue during Victoria's reign. Consensus was never reached, but nevertheless between 1837 and 1901 a revolution in British property rights occurred when the law relating to married women was changed; new laws on divorce and child custody were enacted; and the educational prospects and work experience of all kinds of women were transformed.[1]

Persons of the female sex did not share a uniform social economic of cultural experience, so to speak of women as though they constitute an undifferentiated historical category is in itself misleading. There were many different kinds of women from a variety of social backgrounds who were associated in some way with art in the Victorian age, some of whom were self-conscious about their role as women and aligned themselves with feminist strategies, and some of whom either ignored or deplored – as did the Queen herself – talk of women's rights. Furthermore, the study of Victorian women by twentieth-century historians has been approached in a number of ways and from different historical specialisms, some more overtly feminist than others, and the nine

contributors here exemplify some of this variety. What this introductory essay can best hope to achieve, then, is first some clarification of the nature of the art world in the nineteenth century; secondly, to review the present discussions among historians about studying Victorian women, and to relate these to ways in which women were or were not a part of the art world; and third, to suggest both how the different essays contribute to our understanding of these issues, and also to touch on areas which need further attention.

What is comprehended by the term 'Victorian art world' can be discussed quite briefly. It includes not only various kinds of artist – painters in oil and water-colour, magazine and book-illustrators, graphic designers – but also the institutions which trained, regulated and professionalised them, such as the Royal Academy and the schools of art and design. It must also include the art market through which paintings and sculpture were sold. The nineteenth century saw a decisive shift toward the commercialisation of art, whereby the dealer acted as middle-man between the artist and the customer, whose taste was formed by critics, connoisseurs, historians and biographers of art. The art world must not leave out these interpreters, as well as the patrons and collectors of art. The nineteenth-century European state witnessed a growth of responsibility for national cultural provision, and the British government financed some on the national scale, with the expansion of the National Gallery and the British Museum, and the founding of the National Portrait Gallery and the Victorian and Albert Museum, while the thriving industrial and commercial centres of Victorian Britain echoed these developments at municipal level, building and decorating town halls, museums, galleries and libraries. Scholars and administrators had to be found to manage this enlarged cultural infrastructure. The art world can also include the applied arts and their place in industrial Britain, a topic which provoked so much searching debate among idealists and social reformers. What today would be called the design industries expanded to soak up the increased spending power of later Victorians, which was lavished on the new directions in domestic architecture, decorations, furnishing, gardening and fashion; here too the customer needed guidance from taste-makers and pundits. A full look at the Victorian art world would also comprehend the comparisons and contrasts not only between London and the regions, but also between England, Scotland and Ireland.[2]

Obviously in a book of modest scope only some of these topics can be examined. The applied arts have been omitted, though there is much of interest still to be explored about women's participation in these.[3] In the fine arts, only painters in oil and watercolour are discussed, one of whom, Barbara Leigh Smith Bodichon, known more for her feminist activism today than for her art, receives particular attention in an attempt to do fuller justice to her many-

faceted life. But women are present within these pages as critics, connoisseurs and collectors, as well as in their capacity as artists. Their social context is explored, but an attempt is made also to examine their subjective state, and to analyse the motivation and inspiration which gave them courage and persistence. It is an English and even rather a London-centred book, and also chiefly focused on the first half of Victoria's reign, but some essays glance back to the start of the century, and others look forward to its end.[4] If it stimulates comparison and discussion with what other books have already told us about women in the Victorian art world, as well as pointing toward new problems and perspectives to be explored, it will have achieved its purpose.

Women, the arts and the 'public sphere'

Much historical writing on Victorian women in the past twenty-five years has revolved around the concept of 'separate spheres'. This refers to the prescriptive ideals of important sections of Victorian society, whereby men were supposed to act in the 'public sphere' of paid employment and political life, and women to keep within the 'private' or domestic sphere of home and family. Victorian moralists were the heirs of the Evangelical Revival of the late eighteenth century, and like their forebears continued to urge on women a role as guardian of family morality, with a particular responsibility for nurturing the moral foundations of their children's behaviour. Their special feminine virtues of sympathy and moral insight would enable them to make the home into a sanctuary from the countervailing influences in the world of work, which would otherwise dehumanise the male head of the household. The social and economic background behind this prescriptive advice was the separation of home and workplace and the increasing affluence of the entrepreneurial and commercial middle classes, which enabled them to emulate the professional and upper middle classes' custom of maintaining their wives and unmarried daughters in leisure. However, such leisure was not to be wasted in self-indulgent frivolity, but used to assist more actively in the early, home-based stages of their children's education, and in exercising a charitable, uplifting influence in the neighbourhood.[5]

Even though this was essentially an ideal of the middle classes, it was one which exercised a pull on the aristocracy, some of whom rejected the dissolute manners condoned in their rank during the Regency period, to respond to the Evangelical 'call to seriousness'. They might not need to work, but aristocratic women could still make more of their role as mothers, and devote themselves to good causes. The royal couple, with their obvious devotion to one another and unaffected pleasure in their children, and their sense of public duty, embodied

this culture of respectability, much as Victoria's grandparents, George III and Queen Charlotte, had done.[6]

The ideal of separate spheres likewise influenced the aspirations of the working classes, who recognised a distinction between those who were 'respectable', as the middle classes would have defined it, and those who were not.[7] Some of the most successful mid-Victorian literature played on the idea of separate spheres, from Tennyson's *The Princess* (1847) to Coventry Patmore's poem sequence, *The Angel in the House* (1854–63), while art historians such as Lynda Nead have shown how the visual representations of respectable versus 'fallen' women helped to reinforce these constructions of Victorian femininity and contribute to their ideological power.[8]

It would seem, then, that the Victorian ideal of separate spheres with its associated notions of what constituted respectable womanhood was also endorsed in reality, that it was instrumental in governing codes of behaviour, and that it is therefore a valuable conceptual tool for the historian in guiding research and understanding the mental outlook of the Victorians, and their organisation of work and civil institutions.

Nevertheless, historians have found that these codes were honoured as much in the breach as in the observance, and among recent revaluations two have crystallised the growing doubts as to how accurate and useful the concepts of public versus private, male versus female, really are. Amanda Vickery's wide-ranging historiographical essay has contested the chronology of when the doctrine of 'separate spheres' first gained influence and whether it was particularly characteristic of the urban provincial middle classes, rather than having wider currency in English county society as well. She has also suggested that even when it has some interpretative value it was a far less restrictive doctrine than historians have assumed. While paying tribute to the achievement of art historians like Nead, Vickery also reminds us of the diversity of lives led by women, citing the 'intrepid emigrants, formidable travellers, and driven philanthropists' of the age, and urges historians both to look at the ways in which women 'accepted, negotiated, contested, or simply ignored' advice on their proper behaviour, and to understand more precisely what men and women in the past might have meant when they used the categories of public and private or talked of separate spheres.[9]

Anne Digby's essay in a collection scrutinising Victorian Values has also questioned how clearcut the demarcation between public and private spheres actually was.[10] She suggests using the concept of a social 'borderland', where women acted outside the immediately private sphere without drawing adverse attention to themselves, provided their demeanour was tactful and avoided direct confrontation. For those who openly flouted convention and made them-

selves uncomfortably visible, she notes that Victorian psychiatry itself talked of a borderland, one of moral insanity, a concept invoked to police unusual female behaviour. Philanthropy and social activism were, she observes, areas where women like Barbara Leigh Smith Bodichon and her friends in the 'Langham Place' group successfully inhabited a wide borderland, and exploited the ambiguities and inconsistencies inherent in Victorian attitudes and practice to their advantage. But even this useful modification of the concept of public sphere may overlook the fact that, as Susan O'Brien has pointed out, historians have not really decided where churches, sponsors of most philanthropy, fit into the public/private dichotomy. They are, after all, by definition places of public worship, not private devotion, and until it became more acceptable for the government to accept responsibility for more areas of the national life, churches were major social and educational providers.[11]

Nonetheless, Digby's suggestion of a borderland whose boundaries can be, in Vickery's phrase, contested, ignored, or negotiated, is undoubtedly a fruitful one. Certainly, the more that historians have looked at the range of activities that can be grouped under the heading of philanthropy, the more they have found women doing a number of things, such as speaking in public and fund-raising, which a slavish adherence to the precepts of 'separate spheres' might have precluded. Women were able to do this partly by redefining 'public' issues such as the abolition of the slave-trade and of slavery, or public health matters, as essentially women's issues, and by arguing that the 'public sphere' was in need of the values ascribed as feminine.[12] Furthermore, there was often a link between art and philanthropy. Influential Victorian critics such as Ruskin and Morris believed that the practices as well as the products of the artist/craftsman were part of the cure for the ugliness and dehumanisation wrought by industrialisation. Such links are exemplified in the life of Octavia Hill, best known for her work in the reform of housing management and as a founder of the National Trust.

As a young woman she had thought of devoting herself to art, and later she earned some income copying paintings for Ruskin, who financed her first housing project. She taught a drawing class at the school run by Barbara Leigh Smith Bodichon, and signed her petition to reform the laws on married women's property. Octavia's sister Miranda founded the Kyrle Society in 1876 as a means of 'introducing colour and beauty in all respects to grim lives,' which among other things arranged for the dwellings the Hills managed to be better designed and decorated. Close family friends included the writer Mary Gillies and her artist sister Margaret, who provided the illustrations for Shaftesbury's campaigns against child factory labour; and William and Mary Howitt, whose portrait by Gillies is discussed by Cherry, and whose daughter Anna Mary

Howitt's career as an artist and writer is discussed in several essays. A younger generation of Hill's assistants included Dame Henrietta Barnett, the founder of Hampstead Garden Suburb, who with her clergyman husband Samuel was at the centre of the East End Settlement movement. Central to their work for the East Enders was the desire to bring beauty into their lives, and the couple founded the Whitechapel Art Gallery.[13]

Where, then, do women involved in the Victorian art world most clearly belong – to the public or the private spheres, or to some elastic borderland in between? To answer this we must first clarify the usage of the terms private and public spheres. There are at least three usages of these terms which are, I suggest, relevant to this collection of essays, and to the wider debate among historians trying to understand the position and attitudes of Victorian women.

One usage reflects the kind of distinctions that are helpful in looking at women's work, following the example of Catherine Hall and Leonore Davidoff, who integrated the category of gender into the study of class formation, taking as case studies the provincial middle classes of Essex, Suffolk and Birmingham. Typical of these developments is the Taylor family of writers and engravers, whose women contributed to the family business, and wrote and illustrated precisely the kind of poems and stories which eulogised the middle-class home and clearly differentiated spheres for men and women.[14]

Even though there are numerous women from the middle classes who entered the public sphere by painting for money, they were not given the accolade of full professional recognition because they were excluded from membership in professional associations such as the Royal Academy, or the Society of Painters in Watercolour. Their work was therefore not fully 'public', but could be classified either as 'woman's work', or as a 'trade' rather than a profession. This latter distinction beset male artists as well, who struggled to establish their work as truly professional and to dissociate it from lingering associations with artisanal production. Victorian Britain gave unprecedented opportunity, material reward and even titles to its most successful artists but remained ambivalent about the place of the arts in national culture, subsidising them less than did other European states, and male artists were anxious to be accounted gentlemen.[15]

The fact that the work of painting could take place in the home helped to obscure its visibility as paid work, and make it more appropriate for women of the middle classes who worked from financial necessity. Further up the social scale from Hall and Davidoff's aspiring middle classes were women in the more affluent and socially established strata, whose wealth had roots in the financial and mercantile late Georgian elite. Women in these middle classes were afflicted with the curse of amateurism: they were often cultured and well-read, and like Barbara Leigh Smith Bodichon might have grown up in a family already

engaged in collecting Old Masters and modern art. They were expected to have artistic accomplishments, but not to advance them beyond amateur dabbling without losing their status as 'ladies'. These women might lack the financial incentive to work, but some of them too wanted the right to work properly as artists and receive the highest possible professional recognition, alongside men. Similarly, women writing on the arts wanted equal acceptance that they had the intellectual and cultural authority to do so. The terms private and public spheres are therefore useful in describing this process of recognition as paid professionals: this ambition to move right over the border area into the public sphere of art, on truly equal terms with men. But this was not just a question of being admitted to art schools or the Royal Academy, but of challenging the whole notion of what an artist was. The changes brought by Romanticism to what art and the artist was supposed to be created new problems for women making this move into the public sphere of paid work, because Romanticism tended toward a remasculinisation of culture.

Secondly the term 'public sphere' is used by historians of eighteenth-century Court culture and the Enlightenment, to suggest the development of a freer press and a more informed, wider reading public, which in turn led to public evaluation and criticism of rulers and their immediate circle of courtiers and officials. In this context, the public sphere means the intellectual scrutiny of government, and demands for its public accountability, and is linked to the development of constitutional monarchy and parliamentary systems.[16]

Art history has contributed significantly to a study of these changes within the public sphere, because rulers creating or modifying absolutist systems of government made investment in the 'cultural infrastructure' and the pursuit of an arts policy a deliberate part of their state-building. Enlightened rulers showed their willingness to enlarge the public sphere by, for instance, tolerating greater freedom of the press, or opening access to court-based theatre or opera, or allowing the development of a commercial entertainment sector alongside the royal court, or encouraging secular and meritocratic education. This process was accelerated by the French Revolution and many rulers followed France's example of opening art collections to the public as part of the state's widening and enlarging of cultural access and provision. Conversely, dissent from the ruler could take the form of criticism of his or her cultural politics, or of the kinds of art favoured under his or her regime: George III's founding of the Royal Academy in 1768 became embroiled in debates about his alleged attempt to create a tyrannical personal monarchy.[17]

Issues of gender are integral to these developments: the leading theoretician of early eighteenth-century culture, the Earl of Shaftesbury, was deeply concerned with the proper formation of artistic taste and the models of

masculinity and femininity appropriate to polite culture. It is interesting in this context to note that Barbara Leigh Smith's private notebooks show her working out her response to Shaftesbury's aesthetics.[18] Moreover, the art institutions of the *ancien régime* were not completely inimical to the woman artist, and it is notorious that when it was founded the English Royal Academy included two Continental women artists, Angelica Kauffman and Mary Moser, but after that, no other women until Laura Knight after the First World War.[19]

By the end of the eighteenth century, England had its critics of its public sphere, both within the established political system parliamentary monarchy, and outside it, while by contrast Linda Colley has shown that women were an active and visible part of nineteenth century patriotic support for crown, church and nation.[20] The most radical critique came from religious Dissenters and Philosophical Anarchists such as Richard Price and William Godwin; their critique of aristocratic culture was also one of the exploitation of women within a libertine political ethos, and the insidious role played by women who used their sexual charms in retaliation to wield political influence. Thus the egalitarian feminism of Mary Wollstonecraft and her call for a reformation of female behaviour was integral to efforts to remodel the English public sphere and reform its *ancien régime* character. These Radicals were a part of what Gary Kelly has described as a middle-class cultural revolution aimed at creating a democratic, morally serious, meritocratic society, to replace the aristocratic management of the state. They idealised a model of work as autonomous professional achievement, instead of subservience to aristocratic patronage. As Cherry notes, Margaret Gillies aligned herself with men and women from this new aristocracy of talent by choosing them as her preferred subjects for portraiture.[21] England's *ancien régime* began to wane first with the Emancipation of Catholics and the removal of some of the restrictions on Religious Dissenters (1828–29), followed by the political enfranchisement of the Victorian middle classes in the 1832 Parliamentary Reform Act, but these reforms only heralded new developments to enlarge and remodel the public sphere. Before the crystallisation of a new party-political system, the middle classes made use of the techniques of pressure-group politics in which they were crucially dependent on enlisting the support of women; and they continued the cultural revolution with reforms such as the professionalisation of the Civil Service and Army, the complete removal of civil disabilities for non-Anglicans, and legal and educational efforts to advance the status of women.[22]

My point then is this: if we use the term 'enlarged public sphere' to refer to this long process of remodelling the political and cultural institutions inherited and continued by Victorian Britain, and opening up participation within them to various excluded groups, then we can observe that women were always a part

of this enlarging process, and also that at least for certain groupings within the middle classes, a certain 'feminist' sympathy was a part of it. These groupings were differentiated mostly by regional or religious association – categories which often overlap, as with Unitarians in Manchester or Norwich, and which cut vertically through various layers of the Victorian middle classes, to include various income levels.[23] One such subculture was famously anatomised by Noel Annan in his classic depiction of the formation of an 'Intellectual Aristocracy' that had come to dominate the universities and professions by the early 1950s.[24]

Annan gave more attention to men than to women, though not overlooking those women who had attained a specific professional role, but he was more interested in the later generations than in the earlier ones in his survey, when it was more obvious that women were indeed part of the professional landscape, and many women are mentioned only as relational links in the chain. He observes of the women that typically, they were 'trained in self-sacrifice'. But very possibly they also found ways of making space for their claims as women, either in their negotiation of a companionate style of marriage, as Jeanne Peterson's study of the Paget women argues, or by moving within Anne Digby's borderland, being active in less formalised ways before the professions were opened to them to enlarge and remodel the public sphere. Annan does not ignore such women completely, noting the contribution of several branches of the Leigh Smith women, for instance, but a fuller story could be told, building on his edifice.[25]

Therefore, if we take fully into account the diverse cultural groupings within the middle classes, and establish the networks between them, we should be less surprised to see women in the public sphere in the first place, instead of trying to account for how such women had somehow escaped from the private sphere into a more public world. This might help tamper the uncritical use of the public/private dichotomy which is invoked only to be explained away, and encourage a more accurate focus instead on the different *terms* on which women acted in the public sphere, differences which of course were still, as this book argues, significant, and could certainly restrict women, but which did not entirely and uniformly prevent women from being a part of the new, enlarged public sphere. Instead we could direct our attention to what it was about their background or personal disposition that made negotiation possible.[26]

What I have called the 'enlarged public sphere' – enlarged, that is, compared with its eighteenth-century manifestation – is thus a more historicised interpretation of Anne Digby's metaphoric 'borderland'. I should like it to alert us to the point that the public 'sphere' was not a fixed field of operation for men, either, but that it was being invented and developed as part of the greater democratisation of government, and its formalisation and bureaucratisation. The

very fact that men were in the forefront of inventing this new modern public sphere, no doubt made them the more alert to women's parallel attempts to remodel or to gain the kind of informal authority they had often exercised in the *ancien régime*; hence the terms on which women entered this enlarged public sphere could often become a point of issue and contestation.[27] By the end of the reign this process had produced nationally and locally the great political and legal institutions of the public sphere in Victorian Britain, together with learned societies and regulatory bodies for new and old professions, and women were increasingly visible within some of these institutions.

A third usage of the public sphere which is relevant to this book is the way in which for Victorians it was closely related to the concept of 'high society'. Those families who had the right of introduction to the monarch, the apex of the social pyramid, which is basically what is meant by being 'in society', became 'publicly' known by this appearance at Court, both to other such families and to the public newspapers and magazines who avidly reported their social amusements, fashions – and misdemeanours. Men in these circles led 'public lives' in several ways: by holding a position in the Royal Household, though here there were paid positions open to women as well, the post of Lady-in-Waiting being especially significant when the sovereign was female; by holding office in her government, which was exclusively for men; by taking seats in the House of Lords (where Peeresses only had the right to sit in the Visitor's Gallery, while their husbands discussed affairs of state); or by holding public positions in the Army, Navy, Church or Judiciary. On occasions of public ceremonial, however, such men would often be accompanied by their wives. The births and deaths of such men and women were also public events, symbolised, for example, by the funeral hatchments displayed at their London residences when a family member died. They signified to other families that their daughters were now marriageable by arranging their 'coming out' from their privacy within the family and taking part in the London 'season', one of whose main functions was to act as a marriage market. Among the key events on the social calendar of the 'season' was the Private View of the Royal Academy Summer Show, which marked its opening. Entrance was by invitation only; after that, admittance was to anyone who could pay the entrance fee. As Francina Irwin shows, women from these circles were expected to be accomplished in water-colour. Louisa, Marchioness of Waterford and her sister Lady Charlotte Canning were considered extremely able, but their social position absolutely precluded their working professionally. There are, then, connections to be observed between art, women and 'high society', but the role of women in the nineteenth-century female elite has been little studied until recently.[28]

With these three usages in mind, let me now discuss further how they relate

to the general theme of women in the Victorian art world, and to the essays in this book, bearing in mind that these three usages are not mutually exclusive. Lady Charlotte Schreiber, for example, belonged in London 'society' as well as entering the 'public' world of industry as her first husband's assistant in the Dowlais iron-works during his life-time, and as Director of them for a time after his death. At the same time, her provision of schools and other associated philanthropic projects makes her an actor in the enlarged public sphere along with other improvement-minded Victorians. Activists enlarging and remodelling the public sphere moved into 'high society' circles if they held government office or were the female relatives of such men, while public spirited members of 'high society' joined hands with philanthropists and reformers from other backgrounds to work for the general good.

Art and women's work in public and private

Painting was not subjected to industrialisation in the Victorian period, though, to the dismay of pundits like Ruskin and Henry Cole, the design trades were. This meant that home and workplace were not separated and some Victorian woman painters worked at home, in their father's or husband's house. The Stannard family, discussed by Cherry, or the Nasmyths, discussed by Irwin, provide examples at the start of the century, and it was still holding true for four of the Hayllar sisters in the 1880s.[29]

While art as family business has received some attention, other businesses connected with the art world have not. What for example could be discovered about the businesses which supplied artists' materials or framed the finished product? Following Hall and Davidoff's exploration of the role of women in middle-class businesses, it would be worth knowing if women contributed to such businesses by their capital or their labour.[30]

Francina Irwin's essay shows how the vast expansion of amateur painting was facilitated by developments in paint technology and the supply of equipment, which in turn enlarged the market for instruction manuals, especially for the water-colour medium, and she illuminates the part played by women in writing them.

Just as we know little about whether women helped to supply artists' materials, so we know little about women on the dealer's side of the art market. Some glimpses can be gleaned. The Victorian art market was at one time dominated by the competition between the suave Belgian, Ernest Gambart, and the flamboyant Prussian Jewish immigrant, Louis Victor Flatow. The latter was apparently illiterate, and was usually accompanied by his wife, Elizabeth Anne Simonds, who handled all the administrative side of the business and addressed

her husband, even in front of their clients, as 'chum', – which speaks volumes about the egalitarian dynamics of their relationship. Gambart, by contrast, seems to have married the Victorian equivalent of the trophy wife.[31] If our knowledge about women as fine art dealers is patchy, Ann Eatwell's article shows that there were women who dealt with collectable objects such as porcelain, and that other women liked being their customers.

The mark of the serious professional artist was that work was exhibited and sold: women had to commercialise their painting as well as professionalise their standards. Both Cherry and Marsh discuss ways in which women artists rethought and reorganised their access to training and exhibition-space, but there is room for more research into how women took the next step and marketed their art. Dealers like Gambart made art into big business and secured unprecedented sums for the successful painter, such as the 5,500 guineas stipulated by Henry Holman Hunt, aided and abetted by Charles Dickens, for his *The Finding of Christ in the Temple*. Yet one of the artists 'marketed' most successfully by Gambart was a woman, the French animal-painter Rosa Bonheur. Gambart traded on the unusualness of a woman painting large-scale works in a genre considered 'masculine', and was also aware of the frisson generated by her adoption of male dress. (As Walker shows, cross-dressing was not unknown in London, where it helped women be less conspicuous in certain situations). Gambart specialised in French and Belgian art, and gave 'Mme Bodichon', i.e. Barbara Leigh Smith Bodichon, several of her own shows.

Those who could not afford original paintings bought reproductions: the large sums paid by dealers like Gambart were recouped through engravings of the original. We know that in the late eighteenth century women were active in the print market. The widows of two of the leading dealers, Ann Bryer and Mary Ryland, took over their husband's businesses themselves. The female academician Angelica Kauffman was strongly represented in the print market, and women were often the dedicatees of prints. One of Kauffman's prints depicted *Queen Charlotte Raising the Genius of the Fine Arts* and Caroline Watson, who learnt the mezzotint engraving business from her father, became the Queen's engraver.[32] The Victorian age witnessed vast improvements in the technology and marketing of reproductions: in what ways did women play a part in this? Presumably they continued to run print shops and were involved in the manufacture of reproductions, but print technology was transformed into mass-production. This would have transformed women's work in the reproduction trade, as factory production did for so many other kinds of work. If paintings were not engraved for reproduction, they had to be copied by hand, one at a time. This was thought suitable for women to do, because they were supposedly deficient in the masculine attribute of inventiveness.

The ever-expanding Victorian book and magazine market also created a demand for illustration, and by mid-century it had become prestigious for academic artists to illustrate books. As Jan Marsh shows, Elizabeth Siddal's illustrations to Tennyson and Browning should be understood as her attempt to emulate the writer-artist collaborations common to male Pre-Raphaelites. A sign of professional success for the Victorian artist was the ability to commission an architect such as Richard Norman Shaw to build a studio-house as work-place and status symbol: one such professional was Kate Greenaway.[33] The Victorian cult of mothers and children may have reinforced gender biases and differences, but it also gave a platform for women illustrators to be extremely successful.[34]

As Irwin comments, there is much to be discovered about women as botanical illustrators. Flower subjects were thought 'naturally' suitable for women, and the amateur instruction manuals had helped to develop the botanical approach. Yet the career of Marianne North which took her to the Far East is a reminder that this supposedly genteel, ladylike activity could include women who were among the 'formidable travellers' cited by Vickery as contributing to the diversity of Victorian women's experience.[35]

However able they were in illustration, portraiture or other kinds of painting, women could still be classified as doing less prestigious forms of art suited to their sex. It was a realisation of this differential treatment, together with the net lack of opportunity, which propelled some women into the 'enlarged public sphere', and caused them to challenge institutions and practices in the art world which were inimical to women.

Women, art, and the 'enlarged public sphere'

It is no coincidence that the Quaker, Anna Mary Howitt, and the Unitarian, Barbara Leigh Smith Bodichon, were among the women artists who were also feminists; their careers are explored from different angles by Marsh, Cherry and Hirsch, and my essay also considers Howitt's role as a travel-writer. They came from religious minorities which were by definition excluded from being a full part of the public sphere because only Anglicans could hold public office before 1829; yet Quakers had been particularly prominent in the anti-slavery movement, and the Leigh Smiths had an outstanding family tradition of reforming activism in the public sphere. This did not mean that girls from these kinds of family were altogether free of the conditioning process which made them into leisured ladies if their parents were wealthy enough to attempt it; the familiar process whereby commercial wealth could translate into the life of the leisured rentier within three generations could make parents keen for their daughters to share the culture and deportment of the Anglican squirearchy, and, as Cherry

shows, Eliza Fox's father discouraged her from practising her art professionally, though he supported her amateur training.[36]

This is the kind of stifling conventionality that so frustrated Leigh Smith's cousin, Florence Nightingale, whose mother had married into the Hampshire gentry. As Jan Marsh shows, a talented middle-class girl who wanted to be a professional artist and not a lady amateur had to overcome all kinds of influences designed to inhibit her and discourage her from 'making an exhibition of herself' – inhibitions which an ambitious girl like Elizabeth Siddal, who was brought up to anticipate working for her living, did not necessarily have to overcome. Instead she had to be careful that, having modelled for the Pre-Raphaelites, she had not lost her respectability.

The Victorians were heirs of the Romantic Movement, and central to the diverse manifestations of Romanticism, was its redefinition of art as expressive rather than imitative.[37] The artist makes up the world painted, sculpted, composed, or written, rather than offering a selective and idealised transcription of the 'real' objective world, as prescribed by classical aesthetics. To fulfil the demands of this new vision the artist may have to transform artistic forms of conventions, discover new subject-matter, and rewrite the rules of art. Indeed, artistic ability is not so much taught as discovered; the Romantic genius is born, not made or educated, and must perforce struggle against adversity and misunderstanding until his – for it is usually his – unique vision is recognised. Above all the artist must not compromise his vision, whether by pleasing a patron, conforming slavishly to the standards of official art upheld by academies or other cultural authority figures, or by pandering to popular taste and the dictates of the market-place.

How can the Victorian woman figure in this scenario? Romanticism was both inhibiting and inspiring to her. At first glance, there was much in the Romantic ethos that militated against her unfavourably in comparison with academic classicism. Angelica Kauffman, a founder member of the Royal Academy, had been able to depict herself choosing between music and art in her *Self-Portrait: Hesitating Between the Arts of Music and Painting* (1791), placing herself in the middle of a story of heroic choice often previously pictured as an Herculean, masculine struggle between virtue and pleasure. The implication was that women too could improve on their native gifts by subjecting themselves to the rules of art, as men did, and through this dedication scale the heights of Parnassus. Kauffmann, her most recent biographer has argued, was at ease with her ambitions and successfully used her outsider status as both a Continental and a female artist in an England painfully aware that it needed foreign expertise if it was to establish the reputation of its Academy.[38]

Notwithstanding Kauffman's success and that of her co-founder of the RA,

Mary Moser, women were disadvantaged within the canons of academic art by widespread adherence to the hierarchy of genres. The highest form of art was considered to be the history painting, whether of a religious, classical, literary subject or even of a contemporary event of national significance: the history painting was not a documentary record but conveyed lasting moral truths, drawing out the universally significant characteristics of noble human endeavour from the circumstantial event. Women were considered incapable or less capable of depicting these universal significances, either through lesser intellectual capacity or, more kindly, defective training. Ruskin reinforced this assumption a century later when he pronounced that women could imitate rather than originate. On the whole, if women could argue that what they lacked was not inherent intellectual and moral capacity, but only the right schooling, then the way for them to take their place alongside men in the Victorian art world was to push for entry to the Royal Academy and its training schools, and for the same professional accreditation as men.[39] There was a strong economic dimension to the campaigns of mid-century egalitarian feminists, discussed by Cherry and Hirsch, to broaden the occupational opportunities for women and gain them access to the RA training school. They were aware of the difficulties faced by women who did not marry or whose families suffered sudden financial reverses, and who were ill equipped to face earning a living; as both show, they redefined the concept of 'women's mission' to help the poor and unfortunate to mean women's mission to help each other. The debates on art training for women analysed by Dodd were also conducted with a view to the needs of the anomalous 'intermediate classes' of respectable women fallen on hard times, who might use their training to work in the design industries, to become better governesses, or to be professional artists; which of these goals was most appropriate being far from clear. The precedent of Angelica Kauffman was cited in these discussions, and Elizabeth Ellet, an American journalist who wrote *Women Artists of All Ages and Countries* (1859) to encourage women by recalling their foremothers' achievements, also believed that the heroic age of Old Masters as well as Old Mistresses was now over for both sexes, and that talent and application was all that was required in modern times. This should have tempered high-flown Romantic ideas about the artist as wild genius.

However, the Romantic ideal of the artist could complicate the whole nature of female ambition. The male artist had the luxury of either pursuing his aims through conventional channels, or of scorning the staleness of his academic training, rewriting the rules of his art, and of exploring new modes of living as well. His quest might lead him to illicit love, or to exploring the limitations of consciousness through drugs of alcohol. The roles offered to women in this scenario were all too often that of model or mistress, not sister-artist; although, for

example, Rossetti encouraged Siddal's artist ambition, her career was crucially dependent on her association with him and his social world. A woman seeking fame and fortune in the Victorian art world was in some senses asking permission not only to be properly taught, allowed exhibition space and given critical attention that did not patronise; she was also asking to be a new kind of woman, who held the claims of personal self-expression higher than any other tie or obligation. While Barbara Bodichon succeeded in combining art, social activism, and her unusual marriage, her cousin Hilary Bonham-Carter, who had aspirations to be a sculptress, was never sufficiently single-minded in resisting the web of minor family obligation to which, as an unmarried and therefore supposedly unoccupied lady, she was subjected. Ladies were supposed to be modest, self-denying and above all relational creatures, who were to put being a mother, wife, sister or daughter first.[40]

It must be conceded that it was by no means easy for Victorian male artists to kick over the traces for a life in Bohemia either, and many did not want to. They were either too busy enjoying their accession to professional status, like William Frith, son of a Yorkshire auctioneer, or worrying about whether a devotion to art was consistent with being a gentleman, like Sir Coutts Lindsay. The successful artist Luke Fildes, with all the trappings of achievement such as a studio-house in Kensington, fretted that he might have sold out too readily to the lucrative genre of society portraiture after the searching social realism of his early work.[41]

Victorian men could tell their own tales of psychic stress, but from the point of view of aspirant women, it looked, as it did to Anna Mary Howitt, as though they had a clear run to fame and achievement. The cultural icons of European Romanticism were, all too often, masculine: to encourage Barbara Leigh Smith Bodichon, Bessie Rayner Parkes held out the examples of Goethe, Scott and Byron. But not all constructions of Romantic and post-Romantic artistic identity were fatally against women writers and artists. Anna Jameson made her first attempt at the cultural travelogue by inventing her own female version of the world-weary Byronic outsider for her *Diary of an Ennuyée* (1826). Hirsch shows how Bodichon also admired Charlotte Brontë and George Sand, and articulated her own, female Romantic aesthetic, which embraced both art and activism in disinterested love for nature and humanity. Both Jan Marsh and I discuss how painters and writers were able to draw on Mme de Staël's fictional heroine Corinne, the supreme example of female artistic self-expression; or else they emulated the confident, liberally minded and culturally authoritative tone of de Staël's essays on culture, such as *On Germany*, and wrote about art in the context of cultural travel. Such women would undoubtedly correspond to Vickery's formidable travellers: one of my subjects, Maria Graham, later Lady Callcott,

visited India, South Africa and Latin America. Women made their own contribution to the Romantic nationalism of the nineteenth century, often as mediators and translators. Mrs Merrifield's translations of early Renaissance Italian art treatises were even sponsored by the government. Lady Charlotte Schreiber, who did not conceal from her private diary that she had an ambition to excel in all that she did, had made a name for herself in Victorian literary circles when she learnt Welsh and translated *The Mabinogion*, an important ingredient in the Victorian construction of Welsh identity, as well as an inspiration for some of Tennyson's Arthurian poems, before she embarked on her collecting – which also included some extremely energetic Continental travel.[42]

Some Victorian 'young ladies' successfully resisted their schooling in self-restraint, then, because of a social background accustomed to criticising the Establishment, or because they drew on historical or imaginary role-models and admitted their own ambitions to themselves. They also gained strength from sharing their ideals with other women. These female friendships, often expressed in a romantic language that reads oddly to the modern ear, are explored by Cherry, Marsh and Hirsch. Howitt's visionary story, *Sisters in Art*, echoing her friendship with Elizabeth Siddal, imagined uniting women from the fine and the applied arts, thus using gender to overcome those deep-seated class divisions in training provision which dogged attempts at reforming art education for women. Catholic sisterhoods could also provide a model for mutual female support and a shared 'mission'. Anna Jameson, who was a mentor to the Langham Place activists, wrote about their work, and in her interpretation of Catholic art responded to its sympathy for women.[43]

Women could do together what it was hard or impossible to do singly: in particularly they could travel abroad or live away from the parental home. The growing contradiction as the century developed between the rhetoric of respectable young ladyhood and the reality of enlarged freedom to work, shop, dine and travel in the West End, is underlined by Walker's essay, with its accompanying social map. In theory women were supposed to flit unobtrusively through the London streets like 'grey moths' and by their dress and body language, as well as their careful avoidance of certain areas, to escape all risk of being taken for 'public women': that is, prostitutes. In fact women activists in the enlarged public sphere created their own spaces alongside those of male authority and pleasure, some of which positively excluded even their male sympathisers.

For women coming to maturity in the 1870s and afterwards, restrictions were lessening and opportunities widening. One of the trends which benefited women was the commercialised version of Aestheticism. Women were encouraged to be the representatives of the new tastefulness, wearing Aesthetic dress,

or frequenting shops like Liberty's for the latest furnishings and objects for the home. Those unsure of their own taste could read books of advice, such as the Macmillan series *Art at Home*; Lucy Faulkner, sister of Morris' partner, wrote on the drawing room, and Agnes and Rhoda Garrett, who ran their own decorating business, on decorative painting and woodwork. The ideal of personal self-expression had been diluted and diffused to circles beyond Bohemia.[44]

Just as ladies were supposed to have amateur artistic accomplishments, which had acted as a springboard for mid-century efforts to enter and feminise the profession of art, so now well-to-do middle-class girls were meant to be 'arty'. But if they were also aspiring professionals, they still encountered a very masculine world. Anthea Callen has shown that for all the association of women with the craft revival, the guilds and brotherhoods often had an all-male, pipe-smoking style of camaraderie which made life awkward; or else the homoerotic subtext of organisations like C. R. Ashbee's Guild of Handicrafts created a different kind of exclusion for women. In response, women continued to create their own all-female networks and set store by their supportive friendship for one another.[45]

The pattern observable in painting, whereby women have participated in some intellectual or artistic movement when it has been embryonic and/or informal, but have been excluded, or restricted to amateur status, once such activities institutionalise themselves into learned societies or professional bodies, can be found in other areas, together with similar strategies of response, such as forming all-women organisations, like the Society of Female Artists, or creating informal sisterly networks. Ann Eatwell's article on Lady Charlotte Schreiber shows how this pattern holds true for the world of collecting and connoisseurship. Women were excluded from the Society of Antiquaries until 1920; when the Collector's Club was founded in 1857, women attended meetings frequently, but were only admitted into a category of honorary membership, and only for a year at a time. But contacts made by women at meetings, helped to create their own informal networks amongst themselves. Lady Schreiber also produced her own catalogue for her collections, an implicit rebuke to the lingering assumption, even after they were beginning to attend university, that women were less suited than men to the kind of sustained scholarship required by connoisseurship. Moreover, she worked on the catalogues when she was in her seventies.

Pamela Gerrish Nunn explores in depth the difficulties encountered by women who wanted to be taken seriously as art critics and scholars. As she shows, the professional emergence of women as critics was preceded by a pervasive amateur practice, just as it was in watercolour painting. Following the development of 'polite society' and the art market in the eighteenth century,

women like the Hill sisters whom she discusses were expected to have a view on the exhibitions they saw – but to confide their opinions to correspondence or their diaries, not to earn their livelihood from it. Women had to learn to write for the public press in a way endorsed by the masculine gatekeepers of standards of taste, before they could be accounted serious art critics. She also shows how painters who happened to be women strove to get away from the patronising verdicts of male critics who declared their work to be good – for a woman, particularly when they attempted the 'masculine' genre of history painting.

Unfortunately for women artists seeking critical recognition, one of Victorian England's most influential and idiosyncratic art critics was John Ruskin. His unique approach to instructing amateur watercolourists is assessed by Irwin. But his aesthetic dogmatism, coupled with his extraordinary combination of status and gender insecurities, could have a devastating effect on female self-confidence, as his crushing verdict on Anna Mary Howitt's aspirations as a history painter, discussed by Jan Marsh, illustrates. If Barbara Leigh Smith Bodichon is something of the triumphant heroine of this volume, Anna Mary Howitt is its tragic victim. In this context it is heartening to see how the conventions of book-reviewing anonymity enabled Lady Eastlake to be so thoroughly dismissive of Ruskin's aspirations to be the definitive moralist of modern British painting: her remarks are quoted in my essay.[46]

Although many of the women in this book idealised and valued their friendships with women, their marriages also provide good examples of the Victorian companionate ideal in practice, a theme I touch on in my essay. Maria Graham (Lady Callcott after her second marriage) was a navy wife who accompanied her husband and as 'the Captain's lady' represented her husband onshore when he was ill. Eastlake married in her thirties after she was already an established author and had travelled extensively in Europe, and her published journals show the extent to which the annual trips abroad she made with Charles Eastlake, when as Director of the National Gallery he was making extensive purchases for the national collection, were regarded by them both as a joint enterprise. She was to be a benefactress in her own right to the Gallery when she left her personal collection to it on her death, including Bellini's *St Peter Martyr*. Similarly, for Lady Charlotte Schreiber, collecting porcelain with her husband was a joint profession to occupy the time left on his hands when he gave up his parliamentary seat, (to lead, as contemporaries would have described it, a private life); while, as Vickery has observed, her diary shows that during her first marriage she did weigh up the balance between her family, literary work and philanthropic commitments in the light of Victorian prescriptive literature recommending 'separate spheres' – but invariably kept on juggling all three.

Women, the arts, and Victorian high society

With the Ladies Eastlake and Schreiber we also come to the public sphere in my third sense, that of Victorian high society. Lady Charlotte came from an old Northumbrian family, the Berties, in some danger of becoming downwardly mobile as their fortunes dwindled, and she was conscious that some people regarded her first marriage to the iron magnate John Guest as a little déclassé. Eastlake was a physician's daughter from Norwich and her artist husband was knighted in recognition of his public service as Director of the National Gallery as well as President of the Royal Academy: a good example of the upward mobility possible to Victorian professionals. He also acted as Prince Albert's secretary on the Royal Commission devised both to give the Prince Consort a suitable role and to supervise the decoration of the rebuilt Houses of Parliament.

The monarch was not simply at the top of the social pyramid and able to confer the honours it was now increasingly possible for the artistic professions to attain: there were also continuing expectations that the crown would play its historic role as a focus of artistic patronage in the country. Victoria and Albert both fulfilled these expectations. The Queen's purchase of Frith's *Ramsgate Sands* helped to confer acceptance on subjects taken from modern life and broaden the parameters of contemporary taste; she was a consistent visitor and buyer at the RA Summer Exhibitions, and Cherry sees her as part of the phenomenon of 'matronage' – women's deliberate collecting and commissioning of art by women.[47] Irwin also shows how Victoria's interest and skill in watercolour painting was typical of royal women down several generations.

It had also become acceptable for Parliament to vote funds toward the nation's cultural provision, decades before it was acceptable for it to intervene in regulating public health, education or working conditions. When Victoria came to the throne in 1837, the National Gallery, inaugurated in 1824, was still very modest in scope. The decoration of the Houses of Parliament was one of the most extensive episodes of government patronage of the arts. Anna Mary Howitt's admiration for the Bavarian royal family's lead in encouraging national artistic expression is discussed in my essay, and she must have equally approved of the role played by Prince Albert in connection with the Great Exhibition. Parliament also financed the expansion of the British Museum. The works contained in its Sculpture Gallery were considered an important artistic resource for the training or art students, who were allowed regularly into the museum to copy the statues, without any discrimination as to sex.[48]

For decades after the purchase of the Elgin Marbles, Greek sculpture was seen as the apogee of the art; the work of earlier or different civilisations was ranked behind it in a supposed hierarchy of artistic achievement. But there were

important trends moving towards cultural relativism, which would facilitate an appreciation of other culture's artistic merits on their own terms. Women like Maria Graham, discussed in my essay, helped to widen taste through their travel writing; in Graham's case, through an account of Indian antiquities illustrated by herself. Charlotte Schreiber's cousin Henry Layard became famous for his excavations of the ancient Assyrian capital, Nineveh, and his outstanding finds were obtained for the British Museum. But this was not achieved without concerted lobbying of a parsimonious ministry from his supporters, including his aunt, Sara Austen. In so doing, she was indirectly contributing to the reorientation of taste away from the dominance of classical standards and toward the modern movement's discovery of America, Africa and Oceania.[49]

Sara Austen is better known for the role she and her lawyer husband played in advancing Benjamin Disraeli's early career as novelist and politician, and she is described by the latter's biographer as 'an ambitious, clever, attractive . . . blue stocking'.[50] We need to look more seriously at such women and their informal activities connected with the arts and public life; because so much was still accomplished through networks of influence and connection which leave traces largely in private correspondence or social anecdote, their contribution has been obscured.[51]

Today the balance in arts patronage and administration may have tilted more in favour of the paid than the leisured, but the mix persists. The connection between the private entertainments of high society and various kinds of cultural event is, I suggest, a context in which to view the role of Lady Blanche Lindsay in the exhibition and sale of 'advanced' art at the Grosvenor Gallery, jointly financed by herself and her husband, Sir Coutts Lindsay, rather than classifying them as art dealers. The gallery was designed to look like an Italian town palazzo, the pictures were hung as though in a private home, and Blanche presided over the evening openings as she would have done had she entertained guests at a private drawing-room reception. When it became more obviously a commercialised space, its popularity declined.[52]

There were also women more obviously involved in the connection between high society and the expansion of museum and gallery provision in their capacity of benefactress. This has eighteenth-century precedents, although museums then were mostly private, the preserve of a small circle of scholars and dilettantes. However the British Museum began with the national purchase of Sir Hans Sloane's collection, and was augmented when the Duchess of Portland sold some of her collection to it, at considerably below its market value. This collection was begun by her father, but she continued it in her own right and in collaboration with her husband. Her friend Mary Delany's collection of nearly 1,000 botanical illustrations made in the art-form she had created of

paper collage, which influenced the instruction given in watercolour manuals for botanical drawing, also went to the museum.[53]

Lady Charlotte Schreiber's benefactions to the British Museum and the Victoria and Albert Museum were not then unprecedented, but as Ann Eatwell shows, the scale of her gifts was considerable. One context from which museum benefactions can be viewed is as a way to establish impeccable social credentials for those whose position is new – as with new commercial or industrial fortunes – or slightly questionable. Lady Charlotte was aware that her second marriage, to a man of gentry background and thus a gentleman, but who had been her children's tutor and was seventeen years her junior, was unusual. Josephine Bowes, whose husband John Bowes was himself an illegitimate though acknowledged member of a well-established landed family in Northumbria and the Borders, also had something to live down, since she was a French actress who had been 'kept' by John in Paris before their marriage. The endowment of their collection at Barnard Castle must have helped give a respectable impression.[54]

Perhaps the Victorian cult of widowhood suggests another context in which the Schreiber gift can be viewed, since the collection was given to commemorate her husband as well as to benefit the nation. Similarly Queen Victoria's continuing support for the development of Albert's vision for South Kensington museum quarter, and the naming of the design museum after them both, was for the public good, but also sanctified his memory.[55]

Not that sorrow at bereavement was a female prerogative: Victorians, who had done so much to sentimentalise marriage, also admired uxorious husbands. Lord Lever named his gallery at Port Sunlight after his wife and dismayed the College of Heralds by insisting that her maiden name, Hulme, be incorporated into his peerage. There is no evidence that Elizabeth advised or bought anything for the collection, nor that, unlike Lady Charlotte when married to John Guest, she knew very much about the business, but to Lever she was ultimately responsible for his success because of the confidence she inspired in him, and he declared the collection would not have come into existence without her.[56] Lever worked in the 'public sphere' of industry while Elizabeth managed their 'private sphere', but in giving this collection to Port Sunlight, he too moved into the public world as a benefactor from the private one of personal collector. In rethinking the categories of 'public' and 'private' we must remember that men's experience of work and the civic sphere also needs to be properly nuanced.

The Lady Lever Art Gallery was an example of the development of philanthropic museums and art galleries, which were founded increasingly toward the end of the Victorian period, parallel with the development of municipal institutions in the main provincial cities. Women were not only benefactresses to these, they were also trustees and helped shape policies for cultural provision. Recent

studies of provincial culture have confirmed the demarcation of separate spheres for men and women as an important perspective through which to understand the role of culture in the provinces, but more remains to be done to illuminate the relationship between rhetoric and reality in different parts of England. Cherry's discussion of the artists Annie Swynnerton Robinson and Isobel Dacre sets them within a Manchester-based feminist context which drew on a sense of those bonds between women that could help them overcome restrictive codes of femininity.[57] T. C. Horsfall's philanthropic museum, the Manchester Art Museum, had a female curator, Bertha Hindshaw, in 1912; Julia Gaskell, a daughter of the novelist Elizabeth Gaskell, was an enthusiastic early supporter.[58] Women in the London context had even more scope to create a role for themselves. Dame Henrietta Barnett's drive to establish the Whitechapel Art Gallery has already been noted. Lady Georgiana Burne-Jones, daughter of a Birmingham Methodist minister, may have begun her married life having her ambitions discouraged by Ruskin, who urged her to put her wood-cut illustrations second after her husband and children, but by the end of it she had emerged as a public figure, sitting as a County Councillor, and serving on the Board of Trustees of the South London Art Gallery, where she was central to the process of easing the institution into proper public ownership. A co-trustee was Mary Watts, the painter's second wife.[59]

One crucial difference between Victorian men and women as museum creators or benefactors, however, was that until the laws on married women's property were finally changed in the 1880s, women did not control their money fully, unless it was safeguarded by trusts. Of course there were couples for whom collecting was a joint preoccupation, though it is not always easy to discern the balance of interest and initiative between husband and wives. In her study of patronage in the North-East, Dianne Sachko Macleod singles out Margaret (Eustachia) Smith, wife of a shipping magnate, as largely responsible for the collection and commissioning of art for their London home; other important women patrons include Lady Pauline Trevelyan and Rosalind, Ninth Countess of Carlisle.[60] Deborah Cherry's essay shows how portraits painted in the context of matronage introduce their own style of visual representation, to celebrate women's interests and achievements.

For collecting-minded women, widowhood could mean an accession of wealth (depending on how many children were to be provided for), and then undivided power to dispose of it. Lady Charlotte's collection was made possible through her inheritance from her first husband. Apparently the decision of Mary Combe to give the collection of Pre-Raphaelite painting she and her husband Thomas had amassed while he was Oxford University Printer was very much her own. A personal pupil of David Cox, whose watercolour manual was

so influential, she never practised her art professionally, but keenly shared her husband's interest in the fledgling PRB, helping them to find the props and costumes for their pictures and acting as a sympathetic friend. How can we characterise this kind of support for the arts? Ruth Perry has used the phrase 'mothering the mind' in a study of various 'significant others' who assisted writers, whether as spouses, lovers or simply friends and confidantes.[61] The phrase could be extended to the art world, perhaps as 'mothering the muse', providing it is distinguished from the role played by the model who is also the mistress and who inspires obsessive depiction.[62] The flamboyant Sara Prinsep, the centre of Little Holland House and its galaxy of painters and writers such as Millais, Burne-Jones, Watts and Tennyson, is better known than Mary Combe as a mother to the muse, providing a home for Watts in the wing of her house.

Sara Prinsep was one of several sisters of the Pattle family who cut a dash in mid-Victorian society, and are a reminder that high society circle were not exclusively aristocratic, but permeable to the mercantile and professional elite: the Pattle fortune came from trade in India. Julia Margaret Pattle married the tea-planter Charles Cameron and was the well-known pioneer photographer, who had several shows at the Bond Street dealer Colnaghi. Her skill and artistry in this new medium, like that of Lady Hawarden, should have been a rebuke to the stale canard that women were incapable of originality. Some of her literary illustrations were to her great friend Tennyson's *Idylls of the King*, based, as already noted, on Lady Charlotte's translations.[63]

It was said of the Pattle sisters that their lives were like a work of art, and their upper-class Bohemian style was tolerated within high society.[64] Nevertheless, although a sophisticated woman like Lady Charlotte enjoyed the atmosphere of Little Holland House, she would not allow her daughters to do so: 'I know there cannot be a worse place to go alone than Little Holland House, amidst artists and musicians, – and all the flattery and nonsense which is rife in that (otherwise) most agreeable society' she declared.[65] Artistic Bohemianism did not always override social prejudice. Evelyn de Morgan's mother looked down on her brother's choice of career as a painter, and resisted her daughter's wish to attend the Slade school, because she still regarded art as a petit-bourgeois trade; and the painter Frederick Herring's daughter recalled that although they mixed socially with theatre people, women were not encouraged to go on stage – at least in mid-century: that too was to change by the 1880s, as the *Punch* cartoon illustrating Jan Marsh's essay suggests. Social maps similar to Lynne Walker's of the West End would be invaluable for artistic neighbourhoods such as St John's Wood, Chelsea, Kensington, Highgate and Hampstead, where various arts professionals – writers, actors, artists – were to be found. They mixed in overlapping circles, linked on the one hand to the demi-monde and

on the other to Bohemian-minded members of high society, with the utterly respectable in between. Romantic or commercial liaisons can link the sexes across these different groups. The rarity of outstanding talent can confer wealth which in turn eases access to higher social levels; the well-born in turn rub shoulders with the merely famous, and entertain the people who depict or amuse them. The social nightmare for a Victorian snob was to be introduced socially to one's tailor, not to one's portrait-painter or art-dealer. Arts professionals have since the eighteenth-century tended to form their own subcultures and to exist in a social borderland, but the Victorian expansion of the arts meant that many Victorian men who earned a living from the arts wished to escape this social limbo and assure themselves they were gentlemen as well as professionals, while women had to reject ladyhood to become professional.[66]

As well as rendering the artistic professions more prestigious and respectable, the nineteenth century also invented the idea of artistic Bohemia, which deliberately stood outside the class categories of Victorian society. I have been suggesting both that women did succeed in feminising the arts professions to some degree, and that the growth of cultural provision, financed by public and private wealth, helped to integrate the arts more fully into Victorian society in a process which also provided more scope for women. But not all English artists wanted this kind of recognition and inclusion. Georgiana Burne-Jones probably enjoyed her title, and the social entrée it conferred, far more than did her husband, who regretted that he had accepted the accolade, and resigned thankfully after a brief stint as President of the Royal Academy.[67] As we have seen, it was harder for women to practise as artists in Bohemia than it was for men. 'Progressive' French artists enjoyed mocking the bourgeoisie and making art a revolt against society, and they were emulated in some English circles. Art Historians Jane Beckett, Griselda Pollock and Deborah Cherry have argued that as artists rewrote the rules of nineteenth-century art and created the canons of modernism, they did so in a way which again stressed the masculine identity of the avant-garde artist, and excluded women. The very success with which some women had entered the Victorian art world and pushed out the boundaries of the possible was turned against them, and their art alongside that of their male counterparts was deemed old-fashioned.[68]

History is often uneven and there is seldom a straightforward linear progression for women. As I have suggested Victorians could imagine themselves to be recovering ground lost since late Georgian times rather than doing something unprecedented. Nonetheless, while twentieth century women undoubtedly faced fresh limitations or new formulations of old ones, the women of the Victorian art world, some of whose lives are discussed in this book, had set precedents for refusing to be limited by the world as they encountered it.

Notes

1 Collections reviewing Victorian values include Eric M. Sigsworth (ed.), *In Search of Victorian Values: aspects of nineteenth-century thought and society* (Manchester, Manchester University Press, 1988); Gordon Marsden (ed.), *Victorian Values: Personalities and Perspectives in Nineteenth-Century Society* (Harlow, Longman, 1990); T. C. Smout (ed.), *Victorian Values* (Oxford, Oxford University Press, 1992).

2 Unfortunately this book went to press before I was able to benefit from the forthcoming symposium from Yale University Press, *Towards the Modern World*, which will examine the transition between the emergence of artistic taste and connoisseurship in the eighteenth century, and the commercialisation and institutionalisation of art in the nineteenth century.

3 Anthea Callen, *Angel in the Studio: Women and the Arts and Crafts Movement* (London, Astragel Books, 1979); for embroidery, Roszika Parker, *The Subversive Stitch* (London, the Women's Press, 1984); Bea Howe, *Arbiter of Elegance* (London, Harvill Publishers, 1967) looks at the life of Mrs Haweis, one of the style-pundits of her day; Mark Girouard touches on the contribution of women like the cousins Agnes and Rhoda Garrett to the design and decoration movement known as 'Queen Anne' favoured by the progressive middle classes in Girouard, *Sweetness and Light: The 'Queen Anne' Movement, 1860–1900* (New Haven, Yale Univesity Press, 1983).

4 Glasgow has been extremely well-served by Judith Birkhauser (ed.), *The Glasgow Girls* (Edinburgh, Canongate, 1990). In Edinburgh, the work of at least one outstanding woman artist in diverse media has recently been reappraised: see Elizabeth Cumming, *Phoebe Anna Traquair, 1852–1936*, Exhibition catalogue, (National Galleries of Scotland, 1993). Regional studies include Alan Crawford, (ed.), *By Hammer and Hand. The Arts and Crafts Movement in Birmingham* (Birmingham, Birmingham Museums and Art Gallery, 1984), and J. Wolff and John Seed (eds.), *The Culture of Capital: Art, Power and the Nineteenth-Century Middle Class* (Manchester, Manchester University Press, 1988).

5 There is an enormous literature on this subject: see particularly Catherine Hall, 'The Early Formation of Victorian Domestic Ideology', reprinted in Catherine Hall, *White, Male and Middle Class: explorations in feminism and history* (Oxford, Polity Press, 1992), and Catherine Hall and Leonore Davidoff, *Family Fortunes: Men and Women of the English Middle Class, 1780–1850* (London, Hutchinson, 1987); Mary Poovey, *Uneven Developments: the Ideological Work of Gender in Mid-Victorian England* (London, Virago Press, 1989). For an extremely judicious examination of the separation of spheres in work, charity and politics see Dorothy Thompson, 'Women, Work and Politics in Nineteenth Century England', in Jane Rendall (ed.), *Equal or Different? Women's Politics 1800–1914* (Oxford, Basil Blackwell, 1987). Jane Rendall also cautions against a simple split between public and private in *The Origins of Modern Feminism: Women in Britain, France and America, 1780–1860* (London, Macmillan, 1985), esp. ch. 7.

6 Judith Schneid Lewis, *In the Family Way* (New Brunswick, NJ, Rutgers University Press, 1986) surveys a sample of aristocratic wives and mothers, and discusses this shift to 'middle-class' norms.

7 The notion of respectability is the organising principle behind the recent synthesis of Victorian social history, F. M. L. Thompson, *The Rise of Respectable Society* (London, Fontana, 1988).

8 Lynda Nead, *Myths of Sexuality* (Oxford, Blackwell, 1988); see also Susan P. Casteras, *Images of Victorian Womanhood in English Art* (Cranbury, NJ, Associated University Presses, 1987), and Jan Marsh, *Pre-Raphaelite Women*, (London, Weidenfeld and Nicolson, 1987).

9 Amanda Vickery, 'Golden Age to Separate Spheres? A review of the Categories and Chronologies of Women's History', in *Historical Journal*, 36:3 (1993), 383–414.

10 Anne Digby, 'Victorian Values and Women in Public and Private', in Smout (ed.), *Victorian Values*.

11 Susan O'Brien, 'Making Catholic Spaces: Women, Decor and Devotion in the English Catholic Church, 1840–1900' in Diana Hinds (ed.), *The Church and the Arts* (Oxford, Blackwell, for the Ecclesiastical History Society, 1992), pp. 449–64, esp. p. 455.

12 See Alex Tyrrell, '"Women's Mission" and pressure-group politics in Britain, 1825–1860', *Bulletin of the John Rylands University Library*, 63 (1980), 194–230; Claire Midgley, *Women Against Slavery* (London, Routledge, 1992); Louis Billington and Rosamund Billington, '"A Burning Zeal for Righteousness": Women in the British Anti-Slavery Movement 1820–1860,' in Rendall (ed.), *Equal or Different*; Perry Williams, 'The Laws of Health: Women, Medicine and Sanitary Reform, 1850–1890' in Marina Benjamin (ed.), *Science and Sensibility: Gender and Scientific Enquiry 1780–1945* (Oxford, Basil Blackwell, 1991); Lilian Lewis Shiman, *Women and Leadership in Nineteenth Century England* (Basingstoke, Macmillan, 1992); Patricia Hollis, 'Women in Council: Separate Spheres, Public Space' in Rendall (ed.), *Equal or Different*.

13 Gillian Darley, *Octavia Hill: A Life* (Constable, London, 1988), quote p. 179; Deborah Cherry, *Painting Women: Victorian Women Artists* (London, Routledge, 1993), pp. 27–8; Frances Borzello, *Civilizing Caliban: the misuse of art, 1875–1980* (London, Routledge and Kegan Paul, 1987); Giles Waterfield, 'Art for the People' in Giles Waterfield (ed.), *Art for the People*, Exhibition catalogue (Dulwich Picture Gallery, London, 1994).

14 Hall and Davidoff, *Family Fortunes*.

15 For a helpful discussion of these class preoccupations, see Paula Gillett, *The Victorian Painter's World* (Gloucester, Alan Sutton, 1990).

16 The key text is Jurgen Habermas, *The Structural Transformation of the Public Sphere: an inquiry into a Category of Bourgeois Society* (Oxford: Polity Press, 1992). J. C. D. Cark, *English Society 1688–1832* (Cambridge, Cambridge University Press, 1985), puts the case for England as an '*ancien régime*' society. Vickery, 'Golden Age to Separate Spheres', p. 393, notes this usage of the term 'public sphere' but does not elaborate on how it might apply to rethinking the study of Victorian women.

17 David H. Solkin, *Painting for Money: The Visual Arts and the Public Sphere in Eighteenth-Century England*, (New Haven, Yale University Press, 1993); cf. Thomas E. Crow, *Painters and Public Life in Eighteenth-Century Paris* (New Haven, Yale University Press, 1985).

18 I am grateful to have been shown some of her notebooks in a private collection, which indicate this.

19 See G. E. Barker-Benfield, *The Culture of Sensibility* (Chicago, University of Chicago Press, 1993); Solkin, *Painting for Money*; Lawrence E. Klein, *Shaftesbury and the Culture of Politeness* (Cambridge, Cambridge University Press, 1994).

20 Linda Colley, *Britons: Forging the Nation, 1707–1837* (New Haven, Yale University Press, 1990), ch. 7.

21 Gary Kelly, *Women, Writing and Revolution 1790–1827* (Oxford, Oxford University Press, 1993); cf. Joan Landes, *Women and the Public Sphere in the Age of the French Revolution* (Ithaca, Cornell University Press, 1988).

22 Tyrrell, '"Women's Mission' and pressure-group politics'.

23 Deborah Cherry illuminates such regional contexts, e.g. the Stannards of Norwich: see *Painting Women*, pp. 23–32.

24 Noel Annan, 'The Intellectual Aristocracy' in J. H. Plumb, *Studies in Social History* (London, Longmans Green & Co, 1955).

25 M. Jeanne Peterson, *Family, Love and Work in the Lives of Victorian Gentlewomen* (Bloomington, Ind, Indiana University Press, 1989).

26 cf. Olive Banks, *Becoming a feminist: the social origins of 'first-wave' feminism* (Brighton, Wheatsheaf, 1986). Philippa Levine, *Feminist Lives in Victorian England: Private Roles, Public Commitment* (Oxford, Basil Blackwell, 1990) came to my attention after I had drafted this introduction. Using a large prosopographical base, she discusses *inter alia* regional and reli-

gious contexts and the influence of reforming family dynasties, and also makes comparisons with Annan's anatomy of the Intellectual Aristocracy.

27 See Thompson, 'Women Work and Politics in Nineteenth-Century England'.

28 For an account of the London season, see Leonore Davidoff, *The Best Circles: Society, Etiquette and The Season* (London, Croom Helm, 1973); Linda Colley is currently engaged on a substantial study of the female elite of eighteenth- and nineteenth-century England. See also Kim Reynolds, 'Politics without Feminism: The Victorian Political Hostess' in Clarissa Campbell Orr (ed.), *Wollstonecraft's Daughters?: The Woman Question in Nineteenth-Century France and England*, (Manchester, Manchester University Press, forthcoming 1995). Shiman, *Women and Leadership* has some useful points about the context of public and private for elite women. Lewis, *In the Family way*, discusses the public observance of birth, marriage and death in elite circles. For Louisa Waterford's awareness that she was at a disadvantage compared with women whose social position gave them access to consistent training, see Pamela Gerrish Nunn, *Victorian Women Painters* (London, The Women's Press, 1987), pp. 174–87. Note that Waterford and Canning's cousin, Eleanor Vere Boyle, was known as a book illustrator, mainly to children's stories.

29 See Cherry, *Painting Women*, pp. 20–5, and Gerrish Nunn, *Victorian Women Artists*, pp. 30–4.

30 Compare, for women and the scientific world, the collection edited by Marina Benjamin, *Science and Sensibility*, including A. D. Morrison-Low, 'Women in the Nineteenth-Century Scientific Instrument Trade'.

31 Details of both marriages are from Jeremy Maas, *Gambart, Prince of the Victorian Art World* (London, Barrie and Jenkins, 1975); see also Cherry, *Painting WomenL*, pp. 96–102.

32 David Alexander, 'Kauffman and the print market in eighteenth century England' in Wendy Wassyng Roworth (ed.), *Angelica Kauffman: A Continental Artist in Georgian England* (London, Reaktion Books, 1992).

33 See Girouard, *Sweetness and Light*.

34 John Christian (ed.), *The Last Romantics: The Romantic Tradition in British Art*, Exhibition catalogue (The Barbican Art Gallery, London, Lund Humphries, 1989) includes examples from the early twentieth century. See also Paul Goldman, *Victorian Illustrated Books, 1850–1870* (London, British Museum Publications, 1994).

35 Women still dominate the field of botanical illustration, which is preferred to photography. Brenda E. Moon *et al.*, *A Vision of Eden: the life and Work of Marianne North*, London, HMSO, in association with The Royal Botanic Gardens, Kew, 1993. The Kew archives would be an invaluable resource for researching the question of women and botanical illustration. Beatrix Potter, as is now well known, illustrated botanical and archaeological subjects before writing her tales for children: Judy Taylor, *Beatrix Potter: artist, storyteller and countrywoman* (London, Warne, 1986). For the linkage of women and botanical culture, see *inter alia* David E. Allen, *The Naturalist in Britain* (Harmondsworth, Penguin, 1976), and Ann Shteir, 'Botany in the Breakfast Room: Women and early nineteenth-century British plant study' in Pinna Abir-Am and Dorinda Outram (eds.), *Uneasy Careers and Intimate Lives: Women in Science 1789–1979* (New Brunswick, Rutgers University Press, 1989).

36 Compare the more conventional attitude of Bessie Rayner Parkes' family with that of Barbara Leigh Smith's, as discussed by Jane Rendall, 'Friendship and Politics: Barbara Leigh Smith Bodichon (1827–1891) and Bessie Rayner Parkes (1829–1925)' in Susan Mendus and Jane Rendall (eds.), *Sexuality and Subordination* (London, Routledge, 1989).

37 I am following here Isaiah Berlin's definition as discussed and developed by Hugh Honour, *Romanticism* (London, Allen Lane, 1979).

38 See Roworth (ed.), *Angelica Kauffman*.

39 See Cherry, *Painting Women*, pp. 65–8, and Roszika Parker and Griselda Pollock, *Old Mistresses: Women, Art and Ideology* (London, Routledge, 1991).

40 See Margaret Lesser, *Clarkey: A Portrait in Letters of Mary Clarke Mohl, 1793–1883* (Oxford, Oxford University Press, 1984).

41 See Paula Gillett's suggestive discussion of his self-portrait as *The Doctor*, in *The Victorian Painter's World*.

42 Reval Guest and Angela V. John, *Lady Charlotte Guest: a biography of the nineteenth century* (London, Weidenfeld and Nicolson, 1989).

43 Susan O'Brien has argued that the newly re-established religious orders were significant architectural patrons, and that they decorated their convents with care: see 'Making Catholic Spaces'. Sheridan Gilley, 'Victorian feminism and Catholic art: the case of Mrs. Jameson' in Childs (ed.), *The Church and the Arts*. Attraction to the social activism of Catholic sisterhoods was a factor in Bessie Rayner Parkes' conversion to Catholicism and may have played the same part in Alice Meynell's conversion.

44 Girouard, *Sweetness and Light;* Cherry, *Painting Women*, pp. 86–91. See Zuzanna Shonfield, *The Precariously Privileged* (Oxford, Oxford University Press, 1987), for how the daughters of John Marshall, Rossetti's physician, went along with the new aestheticism while still remaining essentially conventional.

45 Callen, *Angel in the Studio*; Fiona McCarthy, *The Simple Life: C. R. Ashbee in the Cotswolds* (London, Lund Humphries, 1981); Cherry, *Painting Women*, p. 45–8. In fairness it should be added that Ashbee's mentor, Edward Carpenter, was sympathetic to the problems of 'surplus' middle-class women and that his teaching on human sexuality was meant to lift restrictive stereotypes for both sexes.

46 For Ruskin's treatment of other women artists, see Pamela Gerrish Nunn, 'Ruskin's Patronage of Women Artists', in *Woman's Art Journal*, 2:2 (1981).

47 For a full account of Victoria's additions to the Royal Collection, see Oliver Millar, *The Victorian pictures in the collection of HRH The Queen* (Cambridge, Cambridge University Press, 1992); for matronage, Cherry, *Painting Women*, pp. 102–3; for the royal couple's encouragement of the arts, John Steegman, *Victorian Taste* (London, repr. Century Hutchinson, 1986). Albert's role as a patron is discussed by Asa Briggs in 'Prince Albert and the Arts and Sciences' in John A. S. Phillips (ed.), *Prince Albert and the Victorian Age* (Cambridge, Cambridge University Press, 1981).

48 As far as I can ascertain, women were admitted on equal terms. See Ian Jenkins, *Archeologists and Aesthetes in the Sculpture Galleries in the British Museum, 1800–1939* (London, British Museum Press, 1992).

49 See Jenkins, *Archeologists and Aesthetes*; Gordon Waterfield, *Layard of Nineveh*, (London, John Murray, 1963).

50 Robert Blake, *Disraeli* (London, Metheun, 1966), p. 34; for her support of Layard, see Waterfield, *Layard of Nineveh*.

51 cf. Claude-Anne Lopez, *Mon Cher Papa: Benjamin Franklin and the Ladies of Paris* (New Haven, Yale University Press, 2nd Edition, 1990). Her study of the women associated in Paris with Benjamin Franklin suggests that they are the forerunners of today's literary agents, or administrators of cultural foundations, and so forth – a helpful perspective.

52 Virgina Surtees, *Sir Coutts Lindsay* (London, Michael Russell, 1993).

53 Edward Miller, *That Noble Cabinet* (London, Andre Deutsch, 1973); S. H. Myers, *The Bluestocking Circle* (Oxford, Oxford University Press 1990); Ruth Hayden, *Mrs Delany: Her Life and Her Flowers* (London, British Museum Publications, 1980).

54 John Bowes, theatrical impresario, racehorse-owner and stylish *bon viveur*, is a perfect example of the 'swell' who, as Mark Girouard has suggested, was one type of Victorian masculine ideal, who co-existed with his more earnest respectable counterpart. Both types could be found at varying social income/class levels: 'Victorian Values and the Upper Classes' in Smout, *Victorian Values*. For the Bowes collection, see Charles E. Hardy, *John Bowes and the Bowes Museum* (Newcastle, Frank Graham, 1970). Hardy records an assessment of Josephine

Bowes' own painting that it was on a bold scale. As historians of women frequently find, there are very few documents that have been kept relating to Josephine Bowes.

55 Elizabeth Eastlake wrote a book of consolation for heartbroken widows, *Fellowship: To My Sister Mourners* (London, 1868), dedicated to the Queen.

56 W. P. Jolly, *Lord Leverhulme* (London, Constable, 1976), p. 153.

57 Wolff and Seed, *The Culture of Capital*.

58 Michael Harrison, 'Art and Philanthropy: T. C. Horsfall and the Manchester Art Museum' in Alan J. Kidd and K. W. Roberts (eds.), *City, Class and Culture: studies of social policy and cultural production in Victorian Manchester* (Manchester, Manchester University Press, 1985).

59 Waterfield (ed.), *Art for the People*, esp. essays by Leonée Ormond and Giles Waterfield. Women were also represented as donors to the Gallery.

60 Dianne Sachko Macleod, 'Avant-Garde Patronage in the North East', esp. p. 28, in *Pre-Raphaelites: Painters and Patrons in the North-East*, Exhibition catalogue, Laing Art Gallery (Newcastle, Tyne and Wear Museums Service, 1989). Macleod's forthcoming study, *Art and Money; The Construction of Victorian Culture* will illuminate collecting patterns by both men and women. For Lady Pauline Travelyan, see also Trevor Lummis and Jan Marsh, *The Woman's Domain: Women and the English Country House* (London, Viking, 1990).

61 Ruth Perry and Martine Watson Brownley, *Mothering the Mind: Twelve studies of writers and their silent partners* (New York, Holmes & Meier, 1984). I am indebted to Dianne Sachko Macleod for information on Mary Combe.

62 See Frances Borzello, *The Artist's Model* (London, Junction Books, 1982), for a proper critical account of the Victorian artist's model, and Jan Marsh, *Pre-Raphaelite Sisterhood*, for a feminist interpretation of the women who were models and muses to the PRB.

63 Sara Prinsep's great-niece was Virginia Woolf. Studies have been written to the point of saturation about the Bloomsbury set, and there is more to reconstructing the Victorian art world than recreating further linked biographies of earlier coteries, but some knowledge of connections is helpful. Another Pattle, Virginia, became Lady Somers; her husband's cousins included the watercolour amateurs Lady Louisa Waterford and her sister, Charlotte Canning Vicereine of India; and Sir Coutts Lindsay, proprietor of the Grosvenor Gallery and brother-in-law to Lord Lindsay, whose Arundel Society made available engravings of Early Italian art. Louise Jopling's career as a portrait painter was based on her 'networking' with contacts like Blanche and Coutts Lindsay.

64 Amanda Hopkinson, *Julia Margaret Cameron* (London, Virago, 1986).

65 John and Guest, *Lady Charlotte Schreiber*, p. 202.

66 For St John's Wood, Stella Margetson, *St. John's Wood, Home of Love and the Arts* (London, Home and Law Publishing Ltd, 1988); for Herring's daughter, see A. M. W. Stirling, *Victorian Sidelights* (London, Ernest Benn, 1954). This is an edited version of the memoirs of Jeanie Adams-Acton, whose real father was the Duke of Hamilton and whose adopted father was Fredrick Herring, the animal painter. She married a sculptor. Her editor was the sister of the artist Evelyn de Morgan. Also on St John's Wood, see J. E. Panton, *Leaves from a Life* (London, Eveleigh Nash, 1908), the memoirs of one of W. P. Frith's daughters; for Chelsea and Kensington, *inter alia* Girouard, *Sweetness and Light*; for Evelyn Stanhope, later Evelyn de Morgan, see Cherry, *Painting Women*, p. 32.

67 Marsh, *Pre-Raphaelite Sisterhood*.

68 Cherry, *Painting Women*, pp. 73–7.

PART I

WOMEN, ART AND
THE PUBLIC SPHERE

Art, ambition and sisterhood
in the 1850s

Jan Marsh

'IT is a necessary and warrantable pride to disdain to walk servilely behind any individual', Reynolds told Royal Academy students in *Discourse VI*; 'though he who precedes has had the advantage of starting before you, you may always propose to overtake him . . . you need not tread in his footsteps; and you certainly have the right to outstrip him if you can'.[1]

In our book *Women Artists and the Pre-Raphaelite Movement* (1989) Pamela Gerrish Nunn and I looked at three generations of painters in terms of their achievements and in terms of the obstacles they, like so many other women artists, faced in pursuit of achievement: problems of access to training, exhibition space, critical attention, patronage, domestic demands and familial obligations. Internal obstacles were also important (as they have been for later generations): problems of confidence, motivation, singlemindedness, self-promotion – what in the nineteenth century was termed the necessary 'egotism' required of the artist, and which can be subsumed in the current meaning of ambition as the desire and determination to achieve success and fame.

Ambition was certainly necessary for an artist of either gender who wished to excel. 'Without the love of fame you can never do anything excellent', noted Sir Joshua in the same *Discourse*; and by the middle of the following century Harriet Martineau expressed the generally held view that

> the painter must depend for success and stimulus and for professional rewards on the opinions of others . . . and his position is one which draws attention to the world's opinion of him. He must therefore be strong in his love of art and his self-respect before he commits himself to his career, or he may pass his life in misery and end it in despair.[2]

What happened, however, when the painter was a she?

Given women's different social positioning, their relationship to artistic ambition and success was necessarily different from men's. Contemporary gender theory and custom made what was strongly urged on men equally positively forbidden to women. Nor was this at all a matter of verbal convention, with Martineau's 'he' and Reynolds 'you' including such women as aspired in masculine directions. For, as the great painter put it in *Discourse XII*: 'among the first moral qualities which a Student ought to cultivate, is a just and manly confidence in himself'.[3] Confidence, ambition, self-respect: all were 'manly' virtues, part of the bundle of attributes that defined and distinguished a man from a mouse, a serf, or a woman. Women, by contrast, were counselled to be modest, self-effacing, altruistic; and it is not difficult to see that these qualities will seldom bring the success and fame that depend on professional and public esteem.

One may argue around this assertion – fame can accompany self-denying altruism – but in the nineteenth century artistic success did depend on reputation, and in art this could not generally be obtained by anonymity. Indeed, in modern Western culture it is and has for a long time been almost the first aim of the artist to become famous. History, or artistic biographies at any rate, are full of gifted lads who early in life set their sights on becoming an artist. The story then becomes one of the struggle to realise that potential, that ambition to 'make a name'. In Britain the system of competitive admission to the Royal Academy (RA) Schools, annual prizegivings, gold medals and accolades culminating in election as Academician was precisely designed to foster the pursuit of 'name and fame'.

It was one of the Pre-Raphaelites' achievements that they bypassed this particular system, but their very challenge serves to underline women's position. To succeed when such institutions and ladders were closed to them, women needed double doses of ambition. Well might Anna Howitt, coeval to the Pre-Raphaelite Brotherhood (PRB), write with mixed despair and determination after attending a public lecture at the RA:

> Oh! How terribly did I long to be a man so as to paint there. When I saw in the first room all the students' easels standing about – lots of canvasses reared against the walls, here and there a grand 'old master' standing around, a perfect atmosphere of inspiration, and then passed on into the second room hung with the Academicians' inaugural pictures, one seemed stepping into a freer, larger and more earnest artistic world – a world alas! which one's *woman*hood debars one from enjoying. Oh, I felt quite sick at heart – all one's attempts and struggles seemed so pitiful and vain – for the moment – it seemed as though after all the Royal Academy *were* greater and more to be desired than the Academy of Nature. I felt quite *angry* at being a woman, it seemed to me *such a mistake*.[4]

Howitt's misplaced but understandable anger against her sex indicates how for a woman to express artistic aspiration required a certain degendering, as if it were not possible to be simultaneously female and a serious, 'earnest' artist.

Despite the actual rise in the numbers of professional painters in the national Census from 278 women in 1841 to 1,069 in 1871, it is always somewhat surprising to find any female artists, excluded as they were from training at the Academy Schools and reared in a culture whose standard view was (as Ruskin later acknowledged)[5] that 'no woman could paint' in a way worth attention. Indeed, many of those in the Census were no doubt professional copyists and what the same standard view regarded as other lesser breeds. The vital ingredient of genius was held to be rarely if ever found in female form; as late as 1878 one otherwise intelligent woman could write: 'women are intelligent: they are not creative. That men possess the productiveness which is called genius and women do not, is the one immutable distinction that is bound up with the intellectual idea of sex.'[6]

This notion was sometimes illustrated by reference to the Corinthian maid whom legend made the originator of drawing, as by firelight she took a charcoal ember and traced the profile of her beloved on the wall. Her father, a potter, filled the outline with clay, thus inventing relief sculpture and winning fame and fortune. Inspired by love, the maiden's work was imitation, whereas the man's was creative art, a giant leap for humankind.

Such theories surely discouraged many girls who were gifted with greater dexterity than their brothers yet led to believe they lacked the same potential; for to learn early on that 'no woman can paint' is something of a self-fulfilling statement. A further deterrent was that the artistic requirement to paint for public recognition ran deeply counter to the ingrained proscription on a woman appearing in public, 'putting herself forward', drawing attention, in Martineau's words, to the world's opinion of her. In commending literature as a career, even the progressive *Englishwoman's Journal* noted that 'its successful exercise demands little or none of that moral courage which more public avocations require'.[7]

The tendency towards self-effacement in women can be anecdotally illustrated. Besides forming a band of convivial friendship, the Pre-Raphaelite Brothers aimed to draw attention to themselves and their work; Millais, Hunt, Rossetti and the rest were well aware of the importance of self-promotion as well as of mutual support. The actual formation of the PRB is lost to memory, but it followed hard on the heels of a short-lived literary club, with several of the same members, which was projected in the late summer of 1848. It was assumed that, as a fledgling poet, Christina Rossetti would participate, but she withdrew despite the private nature of the enterprise, reluctant even, as her brother explained, to have her verses read out, 'under the impression that this

would seem like display – a sort of thing she abhors'. And the heroine of a story Christina wrote at this time is fiercely self-critical for this same 'fault' of unfeminine pride, lamenting the failure to avoid putting herself forward and displaying her work.[8]

Now display is integral to artistic practice. If a work is not displayed, exhibited, shown, it may as well not exist. Being seen is what works of art are for, and certainly in the nineteenth century public exhibition was the first goal of the aspiring artist. But girls' upbringing condemned such attention-seeking. They were taught not to 'show off', and especially to shun the exposure of publicity. Their internalised sense of shame in regard to seeking public recognition derived from a still powerful belief that women should not be seen or talked about by strangers – the same belief that restricted them to the home except when decently dressed and veiled. Even when it was their work that was on display rather than their bodies, the sense of exposure to insult was similar and acted as a powerful deterrent. A residue of this is still sometimes heard in the admonition, 'Stop making an exhibition of yourself!'

Women artists had thus to pilot themselves along a narrow channel between the shoals of modesty and the reefs of public visibility. Thanks to feminist scholarship, we are now accustomed to noting the 'anxiety of authorship' and the way women writers struggled to 'break silence', to find a 'voice' and make themselves heard.[9] Women painters had a comparably hard task to push aside the screens of prescribed invisibility and make sure they were seen.

Praiseworthy in men, ambition was a pejorative attribute when applied to women. To digress for another illustration: all four Rossetti siblings shared the same upbringing in a literary-artistic family. All four were urged to excellence, their talents nurtured by maternal pride. Later, Gabriel wrote to a fellow artist on the subject of ambition, defining it as 'the feeling of pure rage and self-hatred when anyone else does better than you do. This in an ambitious mind leads not to envy in the least, but to self-scrutiny on all sides – and that, to something, if anything can'.[10] (This, *pari passu*, is Reynolds' observation on love of fame and the right of every artist to outstrip others). Gabriel's elder sister Maria Rossetti, by contrast, adopted the following moral perspective when advising young women to catechise their faults:

> perhaps I am proud; what tempts me to pride? Is it the praise of others? Then I will never do or say anything in order to obtain praise; I will conceal, as far as I can, whatever might lead anyone to praise me. If I cannot help hearing myself praised, I will inwardly beg God . . . to keep me humble; and I will try to think of my sins or anything else that may humble me.[11]

Nevertheless, despite such gendered prescriptions, the mid-nineteenth century was a moment when women were making tentative steps into the arena

of professional work (the survey of career openings in *Englishwoman's Journal* was one symptom of this) which included art. As the author of *Women Artists in all Ages and Countries*, published in Britain in 1859, put it:

> At the present time, the prospect is fair of a reward for study and unfaltering application in woman as in man; her freedom (without regarding such as the so-called 'emancipation' which would urge her into a course against nature, and contrary to the gentleness and modesty of her sex) is greater, and the sphere of her activity is wider and more effective than it has ever been.[12]

As the convoluted parenthesis demonstrates, the fair prospect was still fraught with difficulties, if to aspire to acclaim was 'against nature' and the innate attributes of femininity. But it was evidently perceived that artistic rewards were possible for women as for men.

For across the cultural obstacles to ambition two other points should be laid. First, artistic skill in women was actively encouraged as a mark of class status. As the middle classes assumed their political place in the governance of Britain in the first half of the century, they also adopted the aristocratic habits of cultivating art and music, which were a badge of wealth and rank. The balance was fine: girls were encouraged to sketch, sing and play well, but not to boast of their accomplishments. Indeed, the very instability of the term illustrates the ambivalence, for when associated with women 'accomplishment' signifies shallow, trivial dabbling, while a man's accomplishments are quite simply his achievements.

Secondly, the rise of the Romantic heroine provided an antidote to the wholly self-effacing female role model. She might live (and die) for love, but she aspired after glory too, and the greatest Romantic heroine was Madame de Staël's Corinne, who is described as 'the most celebrated female in Italy'. In the novel Corinne is an improvisatrice who declaims in public, and is also renowned for music, dance, drama and art. She is intellectually brilliant and incomparably beautiful and loves being a star: 'Genius inspires this thirst for fame', notes her author in Book XVI: 'there is no blessing undesired by those to whom Heaven gave the means of winning it'. All men adore her, but the English milord with whom her fate is entwined has problems with her public appearances, for 'in England Lord Nevil would have judged such a woman very severely'.[13] Yet she offered an inspiring if unrealistic model to generations of Englishwomen; and to illustrate *Corinne*'s impact in Britain one may cite numerous editions and translations as well as imitations such as Letitia Landon's *The Improvisatrice*, published in 1824 and still popular at mid-century, whose heroine is both poet and painter:

> Oh yet my pulse throbs to recall
> When first upon the gallery's wall
> Picture of mine was placed, to share
> Wonder and praise from each one there!

If women students were taught never to seek praise, they nevertheless had vicarious access to it in fictions such as this.

Moreover, like their brothers, they imbibed the bourgeois, Carlylean doctrine of assiduous industry and self-realisation. There were, Carlyle wrote in his essays on Heroes, 'two kinds of ambition; one wholly blameable, the other laudable'. The first was the 'selfish wish to shine over others'; but the second partook of greatness, for

> the meaning of life here on earth might be defined in consisting in this: to unfold your *self*, to work what thing you have the faculty for [is] a necessity for the human being, the first law of our existence . . . This is proper, fit, inevitable; nay, it is a duty and even the summary of duties for a man.[14]

This could hardly be the summary of duties for a woman, given prevailing social theory, but it could be part of them; and against the negative image of ambition respecting women should be placed these positive and enabling aspects.

Anna Howitt was one who benefited from parental encouragement and the opportunity to study, if not at the RA then in private academies in London, and also with Eliza Fox, who organised 'an evening class for ladies, conducted on co-operative principles, for the practice of drawing from life . . . female students having experienced in full bitterness the difficulty of thoroughly studying the human figure concealed by its habilments'[15] – in itself an index of considerable artistic ambition. After this Howitt determined to study abroad and travelled to Munich with fellow student Jane Benham, where she discovered the Academy was also closed to women, but succeeded in obtaining a modest amount of tuition from Wilhelm von Kaulbach, a leading exponent of German Romanticism, which chimed with her own earnest idealism.

In Munich, Howitt wrote, 'the whole joy of the painter's life . . . rose up before me – that life of aspiration, yet of humility . . . that life of eager endeavour, or hope, of onward progress', and on her return she urged her sister artists to emulate

> the strength of determination we admire in men, their earnestness and fixedness of purpose, their unwearying energy, their largeness of vision . . .
> . . . but let us not sigh over their privileges . . . Let such of us who have devoted ourselves to the study of art . . . especially remember that the highest ideal in life as well as art has ever been the blending of the beautiful and the tender with the strong and intellectual.[16]

These were high aspirations, for a woman, even if Howitt's idea of male attributes is exaggerated.

Howitt and Benham were visited in Bavaria by Barbara Leigh Smith,

feminist and aspiring landscapist, and together the three friends dreamt ambitiously of founding an Art Sisterhood, based partly on the PRB – Howitt and Smith had recently met the boys of the Brotherhood – and partly on the religious sisterhoods which were being re-established in Britain for the purposes of female piety and good works. In Howitt's story, aptly titled 'Sisters in Art',[17] the two eponymous painters share a studio, take sketching holidays and find sisterly support so valuable that they open their house to other women and (at this point fantasy takes over from fiction) use a vast bequest to launch an Art College for Women, which shall be all the Royal Academy ought to have been, a monument to altruistic ambition, where 'women, true to the great needs of their age, have risen themselves up out of the old formulas, unselfishly to teach their sex to lead them on the angel way to human good'.

Neither college or sisterhood ever took formal shape, but an informal friendship network not dissimilar to that of the PRB (which itself lasted only a few months, if the truth be told) flourished during the 1850s. It included in its ranks aspiring writers such as Bessie Parkes, who in 1853 accompanied Howitt and Benham on a sketching trip (less a holiday than a summer season of serious work in a country location such as male painters used to prepare for a winter in the studio) from where she exchanged letters with Smith describing their exploits. Versified, these epistles also expressed the ambition that characterised the whole group[18]:

> I paint
> From morn to eve, from morn to eve again
> Striving against the hinderance of time
> And all the weight of custom; and *I will*,
> I tell you, Lilian, that I *will* succeed.

In 1854 Smith and Parkes spent the summer in Wales, and in September 1855 Howitt and Smith pursued their painting on the Sussex coast, in what Howitt dubbed her 'sylvan painting room', a dell to which she daily carried a large canvas and easel and where she was frequently subject to interruptions:

After nearly an hour's infliction of similar gossip close at my ear, behold another set of visitors . . . ascending up the precipitous and treacherous bank! I feel an unaccustomed savageness seize upon me.

'Is it permitted to see your picture?' cries another lady's voice, as a fresh figure emerges upon the narrow platform. 'Is it permitted to see your picture?'

'You may see it in the exhibition', I growl, fiercely.

'May we ask the subject?'

'You will see it in the catalogue!'

Upon this a general retreat ensues, and a blessed silence at length closes upon the scene.[19]

Mutual support and stimulus were essential features of the women's friend-
ship, and such correspondence as survives from this group contains repeated
messages of encouragement. In 1859, consoling Barbara for lack of sales, Bessie
wrote:

> Your pictures and my poems have the cardinal defect (vis à vis the public) of dealing
> with ideas that are profound and in some senses narrow; so that beyond a small
> circle of people they don't tell . . .
>
> But remember, if you and I could make ourselves popular we should have
> shown the highest kind of power, that mixture of the deep and simple that made
> Goethe great; and on a far lower plane, built up the fame of Byron and Scott.
>
> Nay, even Turner painted very plainly at one time[20]

It is somewhat sad to read the great names here invoked, knowing that neither
painter nor poet achieved anything remotely comparable; but their mention
measures the woman's ambition.

Howitt was the first to taste success, with her picture of Margaret from *Faust*,
followed by a scene from the life of Dante and a diptych inspired by Shelley's
Sensitive Plant – all works of high seriousness and idealism and, as far as con-
temporary British painting was concerned, in the vanguard as regards subjects
and treatment. Then came *The Castaway* on the fallen woman theme, which was
contemporaneous with Holman Hunt's *Awakening Conscience* and again excited
attention. The topic of sexual transgression was considered a bold theme for a
female artist – yet at the same time was just the subject to get one's name
noticed.

For the 1856 Royal Academy summer exhibition, Howitt prepared a large
oil painting that was 'to embody her ideals and be her masterpiece', in her
mother's words. 'It is very fine, truly sublime; it is *Boadicaea brooding over her
wrongs.*' William Rossetti, who saw the canvas in April, gave the title as *Boadicaea
meditating Vengeance* and fully expected to see it hung. However, it was rejected
by the RA and sent instead to the Crystal Palace exhibition where, it seems, the
great critic John Ruskin was asked to give his opinion. In the memory of the
Howitt family, his response – 'a severe private censure' according to the artist's
mother – came in a letter containing the words 'What do *you* know about
Boadicea? Leave such subjects alone and paint me a pheasant's wing'.[21] Coupled
with the canvas's earlier rejection, this was believed to have caused the mental
collapse that subsequently afflicted Anna Howitt, and effectively terminated her
career. She laid brushes and palette aside, and with them all desire for fame.
Meeting her thirty years later, fellow painter William Bell Scott wrote sadly that
it was 'instructive to see the enthusiastic girl . . . changed into the idle-handed,
passive woman of fifty-five'.[22]

One may suspect the breakdown had deeper causes, for Howitt delineated

her psychological condition in a short novel called *The School of Life* (1856), in the character of Leonard Mordant, whose pictures as described are those of his author. Leonard wins all the prizes and critical acclaim, but 'each external success brought with it internal woe'; each time, the 'universal response to the excellence of his work' causes a reaction of 'sharp pain and depression'. He both seeks and shuns fame, pulled apart by contradictory impulses, unwilling or unable to acknowledge that the high ideals bestowed on art necessitate a large degree of egotism. He tries to escape into obscurity (the plot is both dense and rambling) until finally, at the height of triumph, Leonard commits suicide – which, in professional terms, is what Howitt did this same year, never again painting for exhibition.

Anna's mother firmly believed that the breakdown was caused by the intensity of artistic aspiration and endeavour, describing it in a letter to Barbara Smith as one of many instances 'in which a noble-minded energetic woman yields under the force of that mental and physical exertion which her better and fuller knowledge and awakened activity have made . . . a necessity of her being'.[23] It must be said that this was not a condition exclusive to women: genius was held to be frequently fatal to mental stability, and indeed numbers of men in the Victorian art world suffered similarly (including Ruskin and Rossetti, incidentally). But one may suspect that there was a greater degree of stress caused by the cultural pressure on women regarding the 'unnatural' and unfeminine pursuit of fame, and that this led not only to the actual collapse but to premature abandonment of ambition and retreat into the private sphere. Public exposure can be scary, and Victorian women were even less well prepared than later generations to outface and respond to having their work criticised or, worse, ignored. Curiously, however, a shadowy echo of the pursuit of fame was recorded when Howitt revisited Germany many years later and plucked up courage to call on her former tutor, now director of the Munich Academy: ' "Ah, those were good days!' said the Master. 'But – but – in those days I was ambitious. I was *sick* with ambition. I have now gained all that I strove after, and I have found it – nothing!" ' Howitt, who had long relinquished her acquaintance with ambition, seems to have found this consoling.[24]

Barbara Smith, who married Eugene Bodichon in 1857 and thereafter spent part of each year in Algeria, did not so much relinquish artistic ambition as spread her energies widely in other fields and thereby forsake the singlemindedness that characterised most successful painters. Her work was well received at the RA in 1856 and enjoyed solo shows in London in 1859 and 1861, which Bessie Parkes described as 'a regular *coup* to have struck . . . when you return you will find that all London has seen your pictures'.[25] The following year, nemesis struck, in Bodichon's own words: 'I have been ambitious and had a

disappointment – refused at the RA – I sent a monster in oil'. By this she meant a large canvas: like painting in oils instead of the more 'feminine' watercolour, size was a recognized mark of ambition. She went on: 'I am not disheartened at all and love my art more than ever';[26] yet she does not appear to have made the attempt again.

Sisterhood continued to inform Bodichon's artistic relationships (as indeed it did the multifarious activities associated with the Langham Place circle in the later 1850s and early 1860s, such as the Social Science Association, the *Englishwoman's Journal*, the Victoria Press and the Langham Place reading room and employment exchange);[27] and she was an active supporter of the Society of Female Artists (SFA) founded in 1857 with the aim of providing a showcase for women's work. The SFA might have been expected to play an active role in respect of artistic sisterhood, providing a site of mutual support where strategies of collective and individual advancement could be developed. As it happened, the Society did not act in this manner, partly because, ironically, the most able and successful women artists desired and were determined to exhibit and succeed in more general, ungendered (or even masculine) forums.[28]

Bodichon continued to promote mutual aid, however, and from 1859 she was prime mover in a loose but regular grouping called the Portfolio Society, which met to circulate and discuss members' work, acting in some degree as a substitute for the unrealised Art Sisterhood. The outlines of the Portfolio Society are vague, but it seems to have been inspired by the Cyclographic Society of the late 1840s in which several Pre-Raphaelite Brothers participated, and the equally shadowy Folio Club of around 1853–54, a similar but mixed group in which Howitt and Smith were involved at some level. The establishment of the Hogarth Club, a private meeting place and exhibition space for painters that excluded women, may also have prompted Bodichon to project the Portfolio, with her sisters Bella Ludlow, amateur artist, and Anne Leigh Smith, aspiring professional. Unlike the SFA, the group was planned to include members working in other media. Writers (Bessie Parkes, Christina Rossetti, Adelaide Proctor and Jean Ingelow among them) soon in fact outnumbered the artists. It was also a mixed society, with several male members; and under the aegis of Bodichon's relative by marriage Mrs William Smith it continued in altered guise into the 1870s, long after Barbara's participation ceased. The Portfolio's existence, however, is additional testimony to the significant role played by friendship in the lives of these mid-century women artists.[29] Without such mutual support the arduous pursuit of excellence and public acclaim would have been much harder.

Further research remains to be done. We need to know more about the motivation and self-image of women (and men) artists in the nineteenth century.

The second volume of Ellen Clayton's *English Female Artists* (1876) gives some glimpses, mainly supplied by the artists themselves. None is more poignant than that of Edith Courtauld (of the textile family) who as a girl in the 1850s suffered, unusually, from over-ambition: 'Hidden away under the bushes in sequestered parts of the garden, she would indulge in resplendent day-dreams, anticipating the coming years, slowly repeating "I am an *Artist!*"' Up to the age of eleven, Edith studied chiefly by copying prints after Rosa Bonheur (horses being her other passion), and at thirteen she completed her first original picture, showing oxen on a canvas five feet wide. At fifteen, she had a picture at the RA and a purpose-built studio of her own, but no tuition (the great Landseer, when consulted, advised against formal instruction), so that for the next four years she made repeated 'splendid beginnings on enormous canvases – all eight or ten feet long – working madly, or passing despairing hours crouched on the floor in a corner, face turned towards the wall, weeping tears of anguish and mortification' owing to the unbridgeable gap between ambition and execution. Her subjects were grandiose – Dante's entrance into Hell, Pharaoh's host in the Red Sea, twilight after battle. Not surprisingly, all were rejected by the Academy, and it was not until the artist studied anatomy and learnt to paint on a smaller scale that she achieved further success.[30] Ambition is necessary, but so are training and professional guidance.

This brings me to the case history of Elizabeth Siddal, an artist in a very different mould, whose career points up some nuances in the story of women and art at mid-century. Siddal, as is well known, was a model who sat to members of the PRB – to Millais for Ophelia, to Hunt for Sylvia, to Rossetti for St Catherine and Beatrice as well as numerous portrait drawings – and finally married Rossetti in 1860. From the account she gave to friends in Sheffield in 1857, however, it appears that before meeting the Brotherhood she was an aspiring artist, who first showed her work to Mr Deverell, principal of the Government School of Design, towards the end of 1849, and through his son Walter met the other young artists.[31] In 1852 Rossetti adopted her as his pupil, in part to camouflage a developing romance but also because of Siddal's declared ambition to be an artist. Under his guidance (which barely amounted to tuition, since Rossetti believed academic instruction and copying fettered the free range of artistic imagination), Siddal produced quaint but striking illustrations, to Tennyson, Browning, Border Ballads. In 1854 Rossetti showed her work to Ruskin, who offered the (large) sum of £30 for the lot and thereafter paid her an allowance of £150 for a year, enabling her to buy materials, travel and live independently. She would have preferred to sell her work as it was produced, rather than be so beholden to a single patron, but, in Rossetti's words, she was coerced into taking the allowance. As Ruskin remarked to fellow patron Ellen

Heaton (whom he hoped to interest in Siddal's work), she was 'as proud as – Flora MacIvor – and would as soon consent to anyone's buying her drawings merely to help her'.[32] In acknowledgement of her independence, Ruskin called Siddal 'Ida', after Tennyson's feminist princess.

Siddal progressed to work in watercolour, and within a few years produced a small but substantive corpus of finished work, constrained by lack of funds and therefore nearly all on a modest scale.[33] Though modestly quiet in company (at least according to most reminiscences), she was conspicuously lacking in diffidence where her art was concerned and – probably owing to ignorance – showed no awe when her work was bought by the premier critic of the day, or when it was exhibited alongside that of Millais, Hunt, Madox Brown and other established artists in the independent Pre-Raphaelite salon in 1857. Owing to the absence of direct evidence, one can only conjecture that her class position as daughter of an upwardly mobile cutler and retailer, who nevertheless had to earn her own living as dressmaker/milliner, protected Siddal from some of the inhibitions of bourgeois femininity concerned with 'pushing oneself forward'. This seems to have helped to make her into an ambitious young woman, who used her skills to gain herself a better position in the world, rather as a talented young man of the same rank might have done.

She had already burnt some bridges in this regard, by pursuing an independent role in art, apparently against family opposition (a familiar, and admired, trope in the biographies of male artists).[34] She displayed ambition and initiative in showing her untutored designs to Mr Deverell, and was even bolder in taking the opportunity provided by modelling to gain access to the studio, which was the only way forward for a woman without money for private lessons. It may be that her aspirations were as much social as artistic, but in her circumstances marriage to a fellow artist was virtually the only means of securing a professional career: for any other husband a wife would have been expected to relinquish her own occupation.

When in 1857 her relationship with Rossetti foundered, Siddal went to Sheffield, her father's birthplace (presumably using the money earned from the sale of *Clerk Saunders* to Charles Eliot Norton of Harvard), and introduced herself to the School of Art there, taking advantage of facilities offered to visiting artists. She was among the group of Sheffield teachers and students on a special excursion to the Art Treasures exhibition in Manchester, according to artist Charles Green, while 'A.S.', an unidentified female fellow student, said it was through listening to the conversations of Miss Siddal and the School principal Young Mitchell that she 'first heard of Ruskin and the Pre-Raphaelites'.[35]

To William Ibbitt, who later wrote an obituary notice of Siddal, she presented herself as the friend and colleague of artists such as Millais, Hunt,

Rossetti; and while there must have been an element of boasting in this, such behaviour hardly betokens a shrinking, self-effacing violet. Rather, by claiming such acquaintance Siddal was asserting her own significance in the world of art – again, much as young men have done down the ages by attaching their fortunes to those of a leading 'star' of the time.

In the end, however, ambition alone was not sufficient. Siddal failed to acquire the high degree of technical skill required for success in the Victorian art world, and with the end of her relationship to Rossetti, her career was effectively eclipsed. From 1858, when they parted, to 1860 there is no surviving record of her whereabouts or her work. Despite her earlier acquaintance with Howitt, Bodichon and Parkes, she had also failed to establish any sisterhood with contemporary women artists, and as a single woman without influential or family connections could not maintain the friendships she had made with men like Ruskin or Hunt. Only on the resumption of her relationship with and subsequent marriage to Rossetti did Siddal gain readmittance to the world of art.

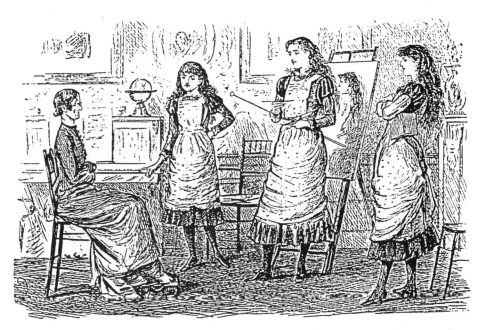

1] *Removal of Ancient Landmarks* by George du Maurier in *Punch* 25 June 1881. The text reads:
Lady Gwendoline: 'Papa says *I'm* to be a great Artist, and exhibit at the Royal Academy!'
Lady Yseulte: 'And Papa says *I'm* to be a great Pianist, and play at the Monday Pops!'
Lady Edelgitha: 'And *I'm* going to be a famous Actress, and act *Ophelia*, and cut out Miss Ellen Terry! Papa says I may – that is, of course, if I *can*, you know!'
The New Governess: 'Goodness gracious, young ladies! Is it possible his Grace can allow you even to *think* of such things! Why, *my* Papa was only a poor half-pay officer, but the bare thought of my ever playing in *public*, or painting for *hire*, would have simply *horrified* him! – and as for acting *Ophelia* – or anything else – gracious goodness, you take my breath away!'

'Indeed and of course my wife does draw still', her husband insisted to Professor Norton early in 1861:

> Her last designs would I am sure surprise and delight you, and I hope she is going to do better than ever now. I feel surer every time she works that she has real genius – none of your make-believe – in conception and colour, and if she can only add a little more of the precision in carrying out which it so much needs health and strength to attain, she will I am sure paint such pictures as no woman has painted yet.[36]

Despite work on *The Woeful Victory*, which looks as if intended for engraving, and plans to illustrate a book of folk tales with Georgiana Burne-Jones (an aspirant wood-engraver), Elizabeth Siddal's promise was unfulfilled. Following the stillbirth of a daughter in 1861, she died tragically of a drug overdose in February 1862, and her artistic career, like that of Anna Howitt, came to an abrupt end.

In Howitt's 'Sisters in Art', the two main characters, Alice and Esther, are joined by a tailor's daughter with a talent for design, named Lizzy (coincidentally or not). Perhaps, had Siddal enjoyed the support of such female friendship, she would not have suffered such professional isolation when her relationship with Rossetti failed. Her class position, however, tended to preclude her from participating in social networks such as the Portfolio Society, with its echoes of eighteenth-century *amateurs*, just as her gender excluded her from more professional groupings like the Hogarth Club.

Researchers into the lives of nineteenth-century women often wish they had been more ambitious, more competitive, more eager for Reynoldsian excellence and fame, so that they might have achieved and painted and published and exhibited more. But there is no denying how difficult and fraught with obstacles such a path could prove.

Notes

1 Joshua Reynolds, *Discourses on Art*, ed. R. R. Wark, (London, Yale University Press, [1797] 1959), p. 100, lines 257–63.
2 Harriet Martineau, 'The Artist', *Once a Week* (29 Sept. 1860), 371.
3 Reynolds, *Discourses*, p. 211, lines 153–4.
4 Cambridge University Library Add Ms 7621/70, f. 307 (transcript of unlocated original).
5 See John Ruskin's correspondence with Sophia Sinnett and Anna Blunden, discussed in Pamela Gerrish Nunn, 'Ruskin's Patronage of Women Artists', *Woman's Art Journal* 2:2 (1981/2), 8–13.
6 Alexandra Sutherland Orr, 'The Future of Englishwomen', *Nineteenth Century* (June 1878), quoted in Pamela Gerrish Nunn, *Victorian Women Artists* (London, Women's Press, 1987), p. 21. For a contemporary version of the tale of the Corinthian maid, see Elizabeth F. Ellet, *Women Artists in all Ages and Countries* (London, 1859), pp. 4–5.

7 *English Woman's Journal* (Sept. 1858), 5.

8 See *Letters of Dante Gabriel Rossetti*, ed. O. Doughty and J. R. Wahl (Oxford, Clarendon Press, 1960), vol. i, p. 45; and Christina G. Rossetti, *Maude: A Story for Girls* (London, 1897).

9 See Sandra Gilbert and Susan Gubar, *The Madwoman in the Attic* (New Haven, Yale University Press, 1979); *Shakespeare's Sisters: Feminist Essays on Women Poets* (Bloomington, Indiana University Press, 1979), edited by the same authors; and Norma Clarke, *Ambitious Heights: Writing, Friendship, Love* (London, Routledge, 1990), especially ch. 2, 'The Pride of Literature'.

10 *The Family Letters of Dante Gabriel Rossetti, with a Memoir*, ed. W. M. Rossetti (London, 1895), vol. i, p. 422.

11 Maria F. Rossetti, *Letters to my Bible Class* (London, 1870), p. 33.

12 Ellet, *Women Artists*, p. 209.

13 Madame de Staël, *Corinne, or Italy*, transl. Isabel Hill, with metrical versions of the Odes by L. E. Landon and a Memoir of the Author, first published London, 1833, and in numerous subsequent editions. 'There can be nothing more hostile to the habits and opinions of an Englishman than any great publicity given to the career of a woman', remarks the author at the start of Book II. For a discussion of *Corinne*'s impact in Britain see Angela Leighton, *Victorian Women Poets: Writing against the Heart* (London, Harvester Wheatsheaf, 1992), pp. 30–4.

14 Thomas Carlyle, *On Heroes and Hero-Worship*, 1840 and numerous subsequent editions.

15 Ellen C. Clayton, *English Female Artists* (London, 1876), vol. ii, p. 83.

16 A. M. Howitt, *An Art Student in Munich* (London, 1853); for Howitt's career, see Jan Marsh and Pamela Gerrish Nunn, *Women Artists and the Pre-Raphaelite Movement* (London, Virago, 1989), pp. 31–47; and Deborah Cherry, *Painting Women: Victorian Women Artists* (London, Routledge, 1993).

17 A. M. Howitt, 'Sisters in Art', *Illustrated Exhibitor and Magazine of Art*, 2 (1852), 214 ff.

18 Bessie Rayner Parkes, 'Helen's Answer', July 1853, in *Summer Sketches* 3 (1854). In this lightly fictionalised account, Parkes used the name 'Lilian' for herself, 'Helen' for Smith, 'Ella' for Howitt and 'Clare' for Benham.

19 Anna Mary Howitt, 'Unpainted Pictures II: Sojourn in the Farmhouse by the Sea', *The Crayon* (New York, Feb. 1856). In the 'diary' that comprises the essay's structure, this account is dated 18 Sept. 1855.

20 Parkes Papers, Girton College, Cambridge.

21 Amice Lee, *Laurels and Rosemary: the Life of William and Mary Howitt* (London, Oxford University Press, 1955), p. 217. Lee was great-niece to Mary Howitt, with access to family memories and documents. See also *Selected Letters of William Michael Rossetti*, ed. R. W. Peattie (Pennsylvania State University, 1990), p. 66; and Cherry, *Painting Women*, pp. 187–8.

22 William Bell Scott, *Autobiographical Notes* (Edinburgh, 1892), vol. ii, p. 242.

23 Lee, *Laurels and Rosemary*, p. 246.

24 Anna Mary Howitt, *Art Student in Munich* (2nd ed., 1880), Preface.

25 *Barbara Bodichon 1827–1891*, Girton College Cambridge 1991, exhibition catalogue prepared by Kate Perry; see also Parkes Papers, Girton College.

26 *Letters of William Allingham*, ed. H. Allingham and E. B. Williams (London, 1911), p. 75.

27 See Candida Lacey, *Barbara Leigh Smith Bodichon and the Langham Place Group* (London, Routledge, 1986); and Jane Rendall, 'Friendship and Politics', in J. Rendall and S. Mendus (eds.), *Sexuality and Subordination* (London and New York, Routledge, 1989).

28 For SFA see Gerrish Nunn, *Victorian Women Artists*, pp. 72–87; and Cherry, *Painting Women*, p. 67.

29 For more details of the Portfolio Society see unpublished paper by Jan Marsh lodged in Girton College Archive. Far more is known of the literary submissions to the Portfolio than the pictorial ones, which of their nature could not be copied out for circulation. All the themes set were apt for visual as well as verbal depiction.

30 Clayton, *English Female Artists*, vol. ii, pp. 10–20.

31 See Jan Marsh, *The Legend of Elizabeth Siddal* (London, Quartet Books, 1989), pp. 157–8.

32 Virginia Surtees, *Sublime and Instructive: the Letters of John Ruskin to Louisa Marchioness of Waterford, Anna Blunden and Ellen Heaton* (London, Michael Joseph, 1972), p. 182.

33 Jan Marsh, *Elizabeth Siddal: Pre-Raphaelite Artist 1829–1862*, Ruskin Gallery Sheffield, 1991, exhibition catalogue; see also Marsh and Nunn, *Women Artists and the Pre-Raphaelite Movement*, pp. 65–73.

34 'While nothing has been more common than to see young men embrace the profession against the wishes of their families and in the face of difficulties, the example of a woman thus deciding for herself is extremely rare': Ellet, *Women Artists*, vol. i, p. 2.

35 See Marsh, *Legend of Elizabeth Siddal*, pp. 69–71.

36 *Letters of Dante Gabriel Rossetti*, vol. i, p. 384.

Women artists and the politics of feminism 1850–1900

Deborah Cherry

In May 1880 members of the Westminster Tailoresses Union marched in procession to central London carrying a yellow silk banner which they had made. Bearing an invitation to attend the National Demonstration of Women and an inscription reading 'We're far too low to vote the tax / But not too low to pay', the banner wove together class and feminist resistance. Prominent at meetings, decorating halls and platforms and carried in processions, such banners were bright with woven, stencilled, stitched and appliquéd mottoes calling for the vote and advocating action.[1] It seems likely that working-class women initiated or at least set precedents for the banners which were so central to the women's suffrage movement in the years 1907 to 1914.[2] By contrast, middle-class women's contributions to the visual spectacle of feminist activism in the later decades of the nineteenth century took place, as did their debates on visual representation, within the arena of high culture.[3] For many women working as professional artists the decision to pursue a career as an artist was motivated and/or paralleled by campaigning for a wide range of women's issues and rights. Art and politics were, on a daily basis, interlinked: working in the studio and supporting a campaign were activities shaped in and by feminism.

Feminism was not a term used in England before 1895, but long before the later nineteenth century there were distinct and identifiable discourses commonly concerned with the 'rights of women'.[4] Mary Wollstonecraft's classic text, *Vindication of the Rights of Woman*, published in 1792, set an agenda for the following century on the subjects of employment, education, civil and legal right, sexuality and the construction of femininity. Nineteenth-century feminism was

by no means unified; there were different and opposing views on women, objectives and politics. In the second half of the century a distinctive change took place with the emergence of an organised movement which undertook public campaigning and single-issue societies, accompanied by the widespread dispersal and debate of feminism. Several interconnected strands have been identified in this period: egalitarian feminism, which had its origins in the civil rights struggles of the 1790s and focused on equal opportunities for women in education, employment and law; social purity feminism, initially organised to secure the repeal of the Contagious Diseases Acts; socialist feminism; and the women's suffrage movement. While the struggle for the vote provided a rallying point for women of different viewpoints and classes it is important, as Carol Dyhouse has indicated, not to define nineteenth-century feminism only in terms of this relatively well-documented campaign.[5] Indeed suffrage was a contentious issue among feminists (as well as among non-feminists), and some held apart from this movement. It would be an oversimplification to perceive these diverse strands as separate or distinct, for feminism was then, as it is today, composed of multiple perspectives and contradictory discourses, which offered competing explanations for women's oppression and widely differing objectives and solutions.

Kate Perry's exhibition of the work of Barbara Bodichon,[6] one of several dedicated to Victorian women artists, can be situated in some twenty years of academic research on women artists in Britain, North America and Europe. An emphasis has been placed on amassing information and assembling the work of women who have been 'hidden from history'. But feminist studies in the history of art have not been satisfied with the simple addition of women artists to existing accounts. The inscription of women's cultural production necessitates profound challenges to the very foundations of the discipline, not only to its scholarly and curatorial procedures, but to its public diffusion in art galleries, magazines, television and film. Feminism's varied and diverse encounters with art history have challenged its agendas, contradicted its dearest values and questioned its definitions of art and the artist. Recognising that the production of knowledge is intimately related to the workings of power, feminist studies have combined documentation with the development of theories of representation and signification. Such sustained analysis forestalls interpretation of art by women as the expression of essential femininity and so springs the trap of the feminine stereotype.

In the context of the deep conservatism of the art world and the educational establishment, the term 'women artists' has seemed to provide a bulwark against the persistent heroisation of masculinity. There has been a necessary solidarity with a phrase which can conjure up an increasing number of well-known figures and thousands of lesser-known practitioners. But there are considerable prob-

lems with such a catch-all. Women artists have differed profoundly in their
alliances and interests; within the same social formation women artists occupied
sharply contradictory positions, which are not reducible to a single or mono-
lithic version of femininity. They are, and have been, unevenly placed in the
social ordering of sexual difference and its intersections with formations of class
and race. Even within contemporary feminist discourses the term 'women artists'
can foreclose discussion of women artists of colour.[7]

Analysis of the diversity of women artists in the past will assist in unsettling
and destabilising uniform categorisations. To research women artists in nine-
teenth-century Britain is to encounter women of radically different political
views: while some were confirmed Tories, others were staunch Liberals and
some ardent socialists. If there were those who were outspoken opponents of
women's suffrage, there were also stalwart supporters. How a woman artist con-
ducted her career, which clients she cultivated, how she dressed and comported
herself, the choices which she made in the modest practices of daily life were
all directly or obliquely informed by political identifications. I am, therefore,
arguing that in the second half of the nineteenth century to engage in politics
was to engage in definitions about femininity and conversely that definitions of
womanhood had political resonances. Women's politics did not take place in a
supposedly neutral realm of ungendered citizenship. On the contrary, to act
politically as a woman, inside and outside the woman's movement, was to act
in and on the social formation of sexual difference.

Theories of subjectivity and authorship are particularly helpful for the
understanding of the complex relationships between women artists and the
women's movement. Recent developments in post-structuralism have countered
liberal humanism's account of a centred, unchanging and essential subject, pro-
posing instead a fragmentary, decentred subjectivity.[8] These theories will help
to explain the ways in which a woman could inhabit quite diverse positions, not
only sequentially but at the same time, and they will assist in elucidating the
non-coincidences or dissonances between a woman's politics and her painting.
Such analysis is necessary if we are to account for the historical formation of
subjectivity underpinning on the one hand a woman artist's career pattern,
choices of subject matter and/or style and on the other her participation at
meetings, in societies and on demonstrations.

With these issues in mind, I will consider some of the links between women
artists and the movement for equal opportunities. Campaigns for work, training
and professional status challenged the contemporary ordering of sexual differ-
ence which, in positioning women in the social roles of wife, mother or daugh-
ter, defined bourgeois femininity in terms of domesticity and dependence and
in contrast to masculinity, which was categorised in relation to paid work, inde-

pendence and public administration. However, from the 1840s onwards the ideals of feminine respectability as domesticity were being undermined by economic pressures for middle-class women to become financially self-supporting; many families did not have the resources to support daughters at home. In artist families, such as the Stannards in Norwich, girls as well as boys were being channelled into what were considered to be appropriate categories of art. While her brothers became landscape painters, Eloise Stannard was trained as a still-life painter and expected to contribute to the 'family exchequer'.[9]

For several young women growing up in the households of progressive intellectuals in the 1840s the issue was not one of parental or financial pressure to contribute to the family business but the free choice of a career and equal opportunities for training and practice. They were particularly inspired by radical women of the older generation like Harriet Taylor, who advocated fine art as the only profession (and with needlework and private teaching among the few occupations) open to women, men having monopolised all the others.[10] Anna Mary Howitt (1824–84), Eliza Fox (?1824–1903) and Barbara Leigh Smith Bodichon (1827–91) founded their determination to take up art professionally on a feminist politics which motivated their active involvement in the emerging campaigns and organisations of the women's movement. All three came from Non-conformist families in which they were given a sound, rational education. As children and young women they met the leaders of the American women's movement and the anti-slavery campaigns as well as radical politicians, writers and thinkers. Barbara Bodichon was independently wealthy, given an allowance by her father. In company with her close friend Bessie Rayner Parkes (1829–1925), she travelled extensively in Europe in 1850. With her aunt, Julia Smith, who was largely responsible for her schooling, Barbara attended Bedford College, established to provide an academic education for women; her studies included art, supplementing private lessons. Although she had little access to formal art training, she determined to pursue a professional career; she sold and exhibited landscapes from 1850 to 1881.[11] By contrast, Anna Mary Howitt was expected to earn her own living and to contribute to the household income. She was trained in London and studied independently from 1850 to 1852 in Munich. Encouraged by her mother, the prolific author and editor Mary Howitt, to write and paint, Anna Mary exhibited subject pictures at London exhibitions in the 1850s, and she published articles and a book of recollections of her visit to the German states.[12] But an interest in radical politics did not necessarily predispose parents to support a daughter's independence and desires for a career. Eliza Fox struggled with her father, a Member of Parliament who was well-known for his support for working-class education and suffrage. He provided books and art materials but disapproved of her having professional training. Eliza gained

support from an older woman artist, Margaret Gillies, and from the feminist writer Harriet Taylor. From 1844 to 1847 Eliza attended Cary's art school in London, going daily with Anna Mary Howitt.[13]

All three artists were highly active in initiating the organised women's movement which emerged during the mid-1850s in connection with the campaign to reform the Married Women's Property Acts. The parliamentary petition, drafted by Barbara Bodichon, argued for change on the grounds that women artists and writers were now earning substantial incomes and therefore needed to control their own earnings.[14] In ten years, with the founding of the feminist paper, the *English Woman's Journal*, in 1858, the Society for Promoting the Employment of Women in 1859 and the campaigns for women's suffrage from 1865, a feminist movement was formed with a distinctive structure of committees and societies and strategies of meetings, public speaking, petitions, pamphleteering and publishing. While they were active in many of these areas, the first campaign organised by and for women artists was for increased access to art education and professional recognition. These were the aims of the petition of 1859 for the admission of women to the schools of the Royal Academy of Arts in London, which since its foundation in 1768 had admitted only male students. In fighting for formal training and status, egalitarian feminists countered prevailing ideals of bourgeois femininity. At the same time, they reshaped and feminised concepts of professionalism which, in reorganising training, the awarding of qualifications and occupational validation to specialist institutions outside the home, had become so central to the public identity of middle-class men.

The campaign to gain access to the Royal Academy schools was underway by the late 1840s/early 1850s, when women artists made their presence known by attending the public lectures at the Academy. Anna Mary Howitt recounted,

> Did I tell you I went one night to hear Leslie. Lecture at the Royal Academy – Oh! how terribly did I long to be a man so as to paint there. When I saw in the first room all the students' easels standing about – lots of canvasses and easels against the walls, and here and there a grand 'old master' standing around, a perfect atmosphere of inspiration, then passed on into the second room hung round with the Academicians' inaugural pictures, one seemed stepping into a freer, larger, and more earnest artistic world – a world, alas! which one's *woman*hood debars one from enjoying – Oh, I felt quite sick at heart – all one's attempts and struggles seemed so pitiful and vain – . . . I felt quite *angry* at being a woman, it seemed to me *such a mistake*, but Eliza Fox, a thousand times worse [than] I said, 'nay rather be angry with men for not admitting women to the enjoyments of this world, and instead of lamenting that we *are* women let us earnestly strive after a nobler state of things, let us strive to be among those women who shall first open the Academy's doors to their fellow aspirants – that would be a noble mission, would it not'.[15]

Anna Mary's letter, written to Barbara Bodichon in about 1848, articulated both a sense of injustice and a strategy for action. 'Woman's mission to women' which usually referred to middle-class women's philanthropic rescue of prostitutes,[16] was in this feminist discourse radically redefined away from charitable benefaction to a politics of equal rights. Ten years later, in 1859, with the imminent move of the Royal Academy to larger premises at Burlington House, feminists organised a carefully orchestrated campaign which demonstrates the skills of the women's movement at this date. Firstly, letters calling for the admission of women were published in the press. In April 1859 a petition signed by thirty-eight women was widely circulated and debated, and copies were sent to the forty Royal Academicians.[17] Its signatories included several women like Barbara Bodichon and Laura Herford who attended Eliza Fox's co-operatively run art classes for women, younger painters then making their reputations such as Anna Blunden, Florence Claxton, Annie and Martha Mutrie, Emily Mary Osborn and Rebecca Solomon alongside distinguished older artists, Anne Bartholomew, Margaret Gillies and Mary Thorneycroft. Laura Herford (1831–70) enlisted the support of feminist writer and political theorist Harriet Martineau, who drew attention to the matter in her lengthy consideration of 'Female Industry' in the *Edinburgh Review* of April 1859 and in her leaders for the *Daily News*, a liberal newspaper.[18] The art historian Anna Jameson, a signatory, addressed the issue in her *Letter to Lord John Russell* introducing the reissue of her lectures. The *English Woman's Journal* frequently commented on the progress of the campaign.

Laura Herford's admission to the Royal Academy schools in July 1860 was not therefore, as has been often assumed, the outcome of individual perseverance. Rather it was the result of a concerted feminist campaign by a broad coalition. Submitting her drawings with her initials, Laura Herford was granted a place before her sex was known to the administration. The door was now open, although only to a few. Women students were admitted to the Antique school and to the Painting school, where they studied the draped model. But throughout the century women students were excluded from the life classes, although some provision was made for them in 1893. Thus, in a period when success as an artist often depended on skill in figure painting, the social structuring of sexual difference positioned women asymmetrically and unequally in relation to art education. This differential access was paralleled in women's struggles to gain medical education: in August 1860 Elizabeth Garrett was admitted to Middlesex Hospital as a nurse, not as a student doctor. Women students consistently campaigned against the limitations imposed on their number by the Royal Academy, and for full access to the curriculum. This situation may well have contributed to the radicalism of the early entrants. Charlotte Babb, a student

from 1861, launched a suffrage campaign for 'no taxation without representa-
tion' in 1871.[19]

The Society of Female Artists was not founded by egalitarian feminists,
although its initiator, Harriet Grote, had links with this network. Established in
London in 1856 to make specific provision for the increasing numbers of women
artists, it became the Society of Lady Artists in 1872 and the Society of Women
Artists in 1899.[20] During the 1850s a new critical category – variously dubbed
'women artist' and/or 'lady artist' – emerged in the literature of art, manifest-
ing a concern to specify women's difference and, in the instability of its nomen-
clature, registering the difficulty of reducing women artists' heterogeneity to a
single term. At the same moment women's membership rights in the art soci-
eties were being eroded. The Old Watercolour Society, for example, ejected
women from full membership in 1850, pushing them first into a ladies section
in 1851 and then into associate membership from 1860 to 1890. The Society of
Female Artists therefore articulated a strategic position in relation to the art dis-
courses and institutions of the mid-century. Many successful women artists
quickly established a pattern of sending larger works to the Royal Academy and
smaller studies and moderately priced works to the society. Its exhibitions pro-
vided a valuable additional outlet, essential for attracting sales and commissions,
and a first venue for artists at the outset of their careers. Women artists con-
nected to the women's movement supported the society. Eliza Fox (who super-
vised the society's art classes in the 1860s) and Margaret Gillies seem to have
sent important works there. Emilia Dilke, a student at the National Art Training
Schools in South Kensington from 1858 to 1861, made her debut there.

As an autonomous organisation set up to promote women's interests, the
Society of Female Artists was similar to egalitarian feminist groups, although it
lacked their focused objectives. The policy of showing a wide range of art
encountered the disapproval of egalitarian feminists who considered that the
exhibitions did not show women's work at its best. Reviews in the
Englishwoman's Journal, *Victoria Magazine* and the *Englishwoman's Review* insisted
on the importance of professional standards, technical skill and high quality.
They urged women to attain what they perceived as value-free and ungendered
standards. These views were consistent with campaigning for equal opportuni-
ties in vocational training and professional recognition and with the strategies
of intervention in dominant institutions. By the 1880s some egalitarian femi-
nists were convinced that to contribute to separatist institutions or publications
was to invite marginalisation. Florence Fenwick Miller, for example, wrote in
her 'Ladies Column' in the *Illustrated London News* in 1889,

> the best work of the most capable women is sure to be given to the general public,
> and not to the more restricted circle. Just as the paintings of the foremost women

artists will go to the Academy, or to the Grosvenor [Gallery, London], or the New Gallery, so the most important work of the best women writers will be sent by preference to the journals that 'everybody reads' . . . the great human interests transcend sex limitations, and will not be successfully dealt with under such conditions as exclusively 'women's papers'.[21]

Egalitarian feminists framed their arguments around the artist rather than around art, arguing for equal competition and against sexual discrimination; they refuted any separate classification of women's art. Their position contrasted with other feminist discourses on art. Writers like Anna Jameson and Frances Power Cobbe, for instance, asserted that there were fundamental differences between women and men; they saw art by women as the expression of true womanhood and so validated the special categorisation of women's art.

In the later nineteenth century many women artists joined the woman's suffrage movement. They were generally not among the prominent leaders, but they held drawing-room and studio meetings, joined and funded the societies and signed petitions. In Manchester and Glasgow, societies of women artists not only provided art classes and exhibition space but were meeting-places for suffragists. Ninety-seven women artists and musicians were among the 2,000 signatories of the Declaration in Favour of Women's Suffrage in 1889. In common with many suffrage petitions of the later decades, the signatures were arranged so as to demonstrate women's participation and responsible work in the public world. The listing of 'Professional – Artist and Musicians' accompanied sections such as social and philanthropic workers, poor law guardians, education and medicine.[22]

The women's movement brought together women of differing attitudes and approaches. Louise Jopling, who founded a successful career on portrait commissions, society connections and skilful socialising, also campaigned for the equal rights of women members of the Society of Portrait Painters.[23] By contrast Emily Ford's interests in women's suffrage were tied to her belief in socialism and her activism, with her sisters Isabella and Bessie Ford, in the labour movement of West Yorkshire. Her vocation as a religious painter and her views on the spiritual values of art were articulated in relation to her belief in socialism and spirituality as well as her opposition to the materialism of late nineteenth-century capitalism.[24]

By the 1880s there was a network of organisations supporting professional women. The societies of women artists in London, Manchester and Glasgow were primarily established to promote professional advancement as much as women's networking. But after 1900 there occurred a radical break in the relations between women artists and the women's movement. With the founding of the Artists' Suffrage League in 1907 and the Suffrage Atelier in 1908 women

artists worked together for the cause, designing banners, art work and goods to support the movement.[25] They worked as artists and designers in the arena of popular culture, whereas in the nineteenth century women artists had laid claim to high culture. Indeed several women artists including Louise Jopling abandoned their careers to work for the movement. The egalitarian feminist discourses on personal attainment were set aside for collective political action which was visibly registered in and signified by the contingents of women artists who marched together 'shoulder to shoulder'.

Barbara Bodichon wrote and lectured on the necessity of changing the social construction of femininity. She was active in the campaigns for women's work, higher education, women's suffrage and legal reform. Feminism informed her pursuit of a career as an artist. Money from her sales, along with her already substantial private income, was channelled into the women's movement, funding the *English Woman's Journal*, the Society of Female Artists and Girton College Cambridge, the first university college for women. Barbara Bodichon painted landscapes, usually in watercolour and occasionally in oils, of scenes in England, particularly in Sussex near her house at Scalands; on her travels in Europe and North America; and in Algeria where she overwintered after her marriage in 1857. These North African views were produced within the growing industries of tourism, itself a component of the discourses of imperialism and orientalism generated around this French colony.

But if Barbara Bodichon rarely exhibited images which countered prevailing definitions of womanhood, such definitions were certainly challenged in the feminist politics of landscape which she developed with Anna Mary Howitt and Bessie Rayner Parkes in the late 1840s and early 1850s in relation to British and European scenery. In going on country excursions immersing themselves in the views, drawing, painting and writing out of doors, the three friends redefined femininity as strong, working and self-determined. 'Reformed' dress and sturdy boots were not only more comfortable but they departed from the restrictive cut and corsetting of fashionable attire which, according to Barbara Bodichon, impeded women physically and psychically. Strenuous physical activity, intense study of the scenery and loose clothing all countered current discourses on feminine weakness and delicacy, rebutted ideas that outdoor work was unsuitable for women and subverted the ideal of the feminine amateur 'sketching from nature', perhaps the most pervasive image of the woman artist at the mid-century.[26]

This feminist politics of landscape is represented in several drawings of these young women in landscape settings which date from c.1847 to 1856. In *Ye Newe Generation* [2] four women in 'reformed' dress who brandish a palette, artists' brushes, an umbrella, a book, a pen and a spear are contrasted to a

conventionally dressed woman who weeps. Three sketches of Barbara Bodichon are inscribed 'in the pursuit of Art', 'in ye breeze', 'absorbed'. Barbara Bodichon's study of Bessie Rayner Parkes [3] shows her astride a mountain gorge, wearing a shortened skirt and her distinctive footwear and clasping her *Poems* (first published in 1852).

The drawings may form part of a broader project in the 1850s to form a feminist politics of visual representation which can be also identified in modern-life and history paintings. Emily Mary Osborn's series of women workers was initiated with *Home Thoughts* (RA 1856, private collection). This depiction of a serious, independent teacher seated in an ordered schoolroom offered an effective contrast to images of the governess which evoked pity for the 'distressed gentlewoman'. The feminine ideal of domesticity was recast in a contribution to the 1858 exhibition of the Society of Female Artists by Margaret Tekusch, a signatory of the 1859 petition and a friend of Eliza Fox. *The Wife* (untraced) portrayed a woman of the eighteenth century transcribing law papers while rocking a cradle. This painting assumed a particular significance within the context of feminist advocacy of such work which took material form when Maria Rye's founded of a Law of Engrossing Office at Lincoln's Inn in London. *The Wife* can also be located in feminist theories of motherhood; Harriet Taylor's powerful essay of 1851, 'The Enfranchisement of Women', firmly refuted notions that motherhood excluded any other activity.[27]

Historical depictions of active, decisive women offered opportunities to contradict assumptions that history was the biography of great men and critical discourses which assigned the lower categories of art to women. Throughout the nineteenth century history painting was a particularly contentious area for women's cultural intervention; it was as history painters that women met the greatest opposition to their training and to their demands to the study of the nude. In 1856 Anna Mary Howitt completed *Boadicea Brooding over her Wrongs* (untraced), sending it to the Crystal Palace exhibition after its rejection by the Royal Academy. Now lost, this large painting showed the warrior queen seated in a clearing in the woods; for some critics Boadicea was meditating revenge.[28] In using as her model the central figure an egalitarian feminist already well-known for her public campaigning for women's property rights, Anna Mary Howitt visually elided the contemporary activist with the warrior queen who defied and outwitted Roman imperialism. *Boadicea* could be read within the context of women's struggles for equal rights to law, education and employment as well as in culture and history. For the community of women who recognised Barbara Bodichon's distinctive appearance, the painting articulated a feminist politics of visual representation.

Egalitarian ideals and feminist support for the anti-slavery movements in

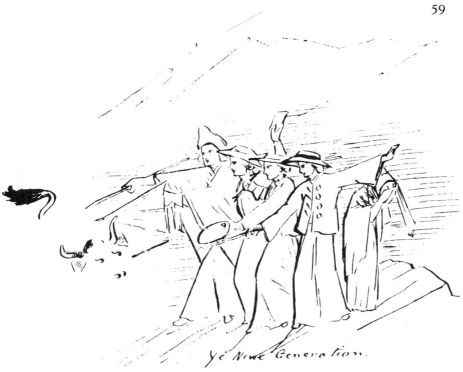

2] Barbara Bodichon, *Ye Newe Generation, c.* 1854, pen and ink on paper, 173 × 112 mm

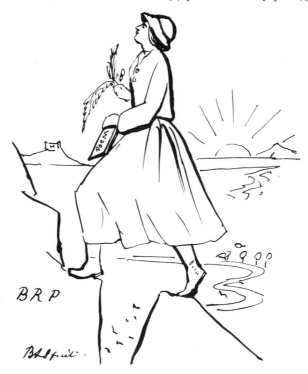

3] Barbara Bodichon, '*BRP*', *c.* 1850, pen and ink on paper, 18 × 12 cm

North America provided the context for Eliza Fox's *St Perpetua and St Felicitas* (Society of Female Artists 1861, untraced) in which the latter was depicted as a black African woman. This picture of two Early Christian martyrs who died in AD 203 drew on the writings of Anna Jameson and on the dramatic poem by the Owenite feminist Sarah Flower Adams, which asserted that although enslaved on earth, St Felicitas was equal in the sight of God.[29]

After the mid-century there were only scattered examples of history paintings by women associated with the women's movement which contradicted the ideals of feminine passivity. One explanation for this scarcity may lie in the frame of respectability within which bourgeois femininity was constituted. Critics tended to view a woman's art as a manifestation of her 'ladyhood'; one of the most powerful comments of disapproval was that the subject was 'unsuitable for a lady'. Such comments undercut the stance of morality and propriety on which women based their practice as artists and their participation in the public world. In 1872 Louise Jopling exhibited *Queen Vashti refusing to show herself to the people* (untraced). Years later she claimed that this queen, who was divorced for disobeying her husband, represented 'the originator and victim of women's rights'.[30] Henrietta Ward's repertory of aristocratic and royal heroines occasionally included Elizabeth Fry, whose example was more likely to inspire philanthropy than feminist activism. The artist was, however, a signatory of the 1859 petition and involved in the women's suffrage movement: a member of the Central Committee of the National Society for Women's Suffrage, she was convinced that the vote 'would be *most desirable* for women in my own profession'.[31] It was as successful public figures and working women that many artists supported the movement, signing petitions in their capacity as professional women artists. This position, which included fighting sexual discrimination, did not necessarily encompass a politics of the visual, the making of images which countered contemporary regimes of representation. Thus, while there can be identified women artists who supported the women's movement in a range of ways from public speaking to signing petitions, holding meetings and subscribing donations, such activities did not necessarily entail the production of images which could be labelled feminist, were concerned with the 'rights of women' or rebutted prevailing portrayals of femininity. Rather than falling into the trap of interpreting art as the outcome of an artist's politics or the expression of her beliefs, it is important to identify two distinct domains – the formation of subjectivity and visual representation.

Where these two registers coincided was in the category of portraiture. This area of art practice was increasingly important in the women's movement from the 1830s to the 1890s and included the making and giving of portraits between women whose friendship was founded on shared politics and the collection of

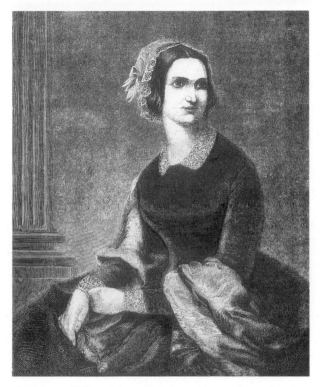

4] Margaret Gillies, *Mary Howitt*, engraving perhaps after the portrait exhibited at the Royal Academy in 1847

portraits by women's colleges, societies and clubs. In portraits by women artists of close women friends, made for specific contexts to be viewed by women, women artists produced works which disrupted the representation and signification of woman. This politics of representation was sustained within specific conditions of viewing and consumption which I have elsewhere referred to as *matronage*, the commissioning and collecting of art by women.[32] I will, therefore, conclude this essay with a consideration of four portraits: Margaret Gillies, *Mary Howitt* (?RA 1847), Emily Mary Osborn, *Barbara Leigh Smith Bodichon* (Grosvenor Gallery 1884), Annie Robinson Swynnerton, *Susan Isabel Dacre* (RA 1880), and Susan Dacre, *Lydia Becker* (Manchester Academy 1886) (Figs. 4, 5, 7, 8).

In the 1830s and 1840s Margaret Gillies painted portraits for a living. Several of her sitters shared her commitment to feminism: Mary Leman Grimstone, an Owenite feminist writer; Mary Howitt, writer and mother of Anna Mary Howitt; Anna Mary Howitt; and Harriet Martineau. While on a simple level these publically circulated portraits functioned to make these women activists visible, they can also be located in the radical politics of a

5] Emily Mary Osborn, *Sketch after a portrait of Barbara Bodichon*, ?1884, pen and ink on board. Prepared by the artist after the 1884 portrait, probably for illustration in Henry Blackburn, *Grosvenor Notes* (1884) and *English Art in 1884* (1885)

period in which a particular social function for art was elaborated. As Margaret Gillies explained in a letter of 1839 to one of her sitters, 'Artists in general seize every opportunity of painting the nobility of wealth and rank'. However she had decided on a different course of action: 'to paint what I conceive to be the *true* nobility that of genius long faithfully and earnestly . . . labouring to call out what is most beautiful and refined in our nature and to establish this as a guide and standard of human action'.[33] Her project therefore was to provide portraits of individuals of a particular intellectual group of the radical thinkers, politicians, women writers, feminist theorists, whose images would render their moral and intellectual capacities visible in and by the visual signs of their physical appearance.

The concept of the inner expressed in the outer was consolidated in the arts and sciences of the nineteenth century. Reading the visual codes of bodily and facial appearance was believed to provide access to the inner traits and to permit the social categorisation of the individual. Artists developed these skills of representation and codification. But within the specific contexts of women's friend-

6] Emily Mary Osborn, *Barbara Bodichon*, before 1891, oil on canvas, 118 × 96 cm

ship and *matronage*, this traffic in signs and the expressive nature of signification were mobilised in specific and different/resistant ways in the making of women's portraits.

The four portraits under discussion here were all made within the contexts of women's friendship in the nineteenth century; the women were friends with each other and shared political commitments to feminism. Annie Robinson and Susan Isabel Dacre were friends in Manchester, they visited Rome together in the 1870s, London and Paris in the 1880s, sharing a studio, models, and working

closely together. With several other women they formed the Manchester Society of Women Painters in 1879. Inscribed 'A mon amie' (to my friend), the portrait of Susan Dacre [7] acquires significance within the rituals of female friendship in which the practice of imaging – drawing and later photographing – each other seems to have been fairly common from 1830 to 1900. One of the structuring rituals of women's friendship, therefore, was the exchange of the visual sign woman. Sometimes these portraits were for the enjoyment and appreciation of the two friends. On other occasions, portraits were made to be publicly exhibited and circulated. Women's friendship was thus not just a private matter but publicly spoken and made visible.

These four portraits also register the problems arising from the visual repre-

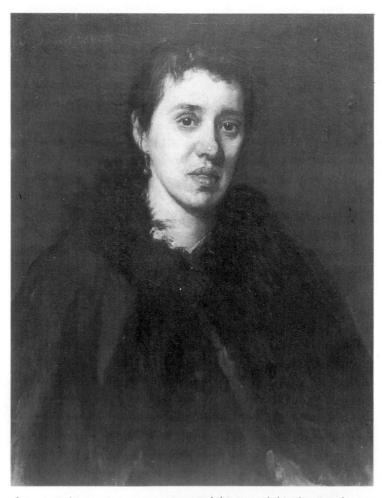

7] Annie Robinson Swynnerton, *Susan Isabel Dacre*, exhibited at Royal Academy 1880, oil on canvas, 703 × 519 mm

sentation of the leaders of the women's movement in a culture which was developing distinctive codes, formats, apparel and attributes for portraiture of academic and professional men. In Emily Mary Osborn's presentation portrait of Barbara Bodichon [5] the draped scarf, as Kate Perry has suggested, echoes an academic hood.[34] In the presumably later portrait now at Girton College [6], the fur borders of Barbara Bodichon's gown have been arranged in a manner of the official robes in which men were painted. It is significant that the founder of this first university college for women was portrayed as an artist, and not as a scholar. The status of women artists in the women's movement undoubtedly contributed to Emily Mary Osborn's decision to depict Barbara Bodichon as an oil painter rather than as a watercolourist. This representation is strengthened

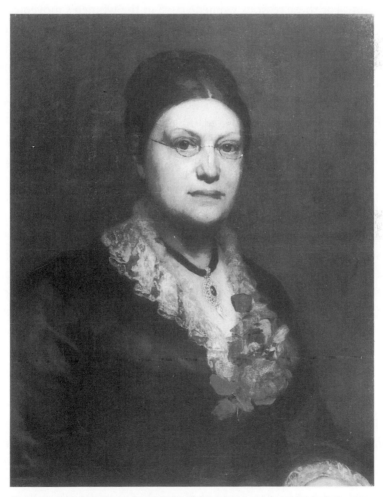

8] Susan Dacre, *Lydia Becker*, exhibited at Manchester Academy of Fine Arts 1886, oil on canvas, 665 × 523 mm

by the conscious evocation of 'old master' paintings. Emily Mary Osborn's two portraits of Barbara Bodichon thus took up a pictorial challenge in the imaging of a public figure who was a prominent feminist campaigner, the founder of the college and a professional woman artist. Margaret Gillies' portrait of Mary Howitt [4], by contrast, draws on traditions established in the previous century for the depiction of the writer, in which the holding of a book indicated the sitter's intellectual capacities and achievements. However, while this format was maintained in the Victorian period, it was not necessarily favoured by or appropriate for the leaders of the organised women's movement. The pressures of feminine respectability, the platform on which middle-class women laid their claim for greater participation in the public world, seem to have contributed to the portrayal of prominent features within portrait formats which signified that respectability. For these reasons women active in the women's movements were often depicted in front of a plain ground, with a simple and conventional attribute which connoted femininity, such as a sprig of flowers.

Across their differences of composition the four portraits under consideration share a particular kind of visual strategy, a calculated resistance to fashionable appearance. All four women are shown with plain, even severe hairstyling. While Barbara Bodichon is depicted in 'aesthetic dress', appropriate for her artistic vocation, Lydia Becker [8] is shown in black, for she like many others considered mourning dress to be most suited for public speaking. She also wears her wire-framed spectacles (an uncommon attribute in portraits of society women). Susan Dacre's face is asymmetrical, her expression tired, her hair wispy. In none of these portraits are women's bodies fashionably or curvaceously styled, as they are in pictures by Tissot, Rossetti, Leighton or Burne-Jones, where supine form, inert pose, elaborate hairdressing, swathes or drapery or elaborately-trimmed costumes combined with schematised renderings of facial features to produce an icon of masculine desire. The specificity with which feminist appearance is rendered suggests a different approach, a refusal of the aesthetic codes which transformed women into the visual spectacle of woman. Rather they propose a resignification of the sign woman for the women's movement. In the circuits of women's friendship, societies and colleges, the sign woman was transformed to signify the foundation of a culture based on relations between women.[35]

Emily Mary Osborn's portrait of Barbara Bodichon was shown at the Grosvenor Gallery in London in 1884 before it was presented to the college. Women's colleges became repositories of women's traditions of learning and gifting, their libraries rich in printed materials donated by women, their rooms adorned with painted, sculpted and photographic portraits of intellectuals and activists. These images not only provided role models, but they also framed

subject positions for women to take up and enact a politics of feminism. Moreover, portraits of campaigners acquired a special significance in the movement long before they were depicted on women's suffrage banners. In 1891 the National Society of Women's Suffrage acquired the portrait of Lydia Becker from the artist for donation to a public institution as a memorial to her life and work.[36] In 1895 Helen Blackburn gave her collection of portraits of eminent women to University College, Bristol.[37]

With the dismantling of the separate spheres during the twentieth century, the collections of Victorian women have been dispersed and many works by women artists have been lost, devalued or damaged. The portrait of Barbara Bodichon now at Girton College [6] is not that which was donated [5], but another perhaps later portrayal by the same artist which was acquired by the college in 1929 after the first had been removed by Barbara Bodichon's descendants.[38] Susan Dacre's portrait of Lydia Becker [8], originally a large three-quarter length, was turned down by the National Portrait Gallery in 1902. It was only accepted, years later, by Manchester City Art Galleries on condition that it was cut down to its present size by the artist, then in her seventies.[39] Margaret Gillies' portrait of Mary Howitt has not been traced. If it is now too late to do anything other than mourn the loss of such works, it is not too late to forge a strategy for the present and the future. There is an urgent need for art galleries and museums to purchase and acquire current feminist art in all its diversity, strength and richness to ensure that one hundred years from now the women who come after us can know and act upon their heritage.

Notes

I am indebted to Bridget Elliott for the invitation to give the first version of this paper in Vancouver in 1990.

1 Deborah Cherry, *Painting Women: Victorian Artists* (London and New York, Routledge, 1993), p. 210.

2 Lisa Tickner, *The Spectacle of Women: Imagery of the Suffrage Movement 1907–14* (London, Chatto, 1987).

3 Discussions of feminist positions, including those articulated within the purity movement, on visual culture will be examined in my forthcoming book on feminism and visual culture in Britain before 1900.

4 Alice S. Rossi, *The Feminist Papers* (New York, Columbia University Press, 1977).

5 Carol Dyhouse, *Feminism and the Family in England, 1880–1939* (Oxford, Blackwell, 1989).

6 Kate Perry, *Barbara Bodichon, 1827–91* (Cambridge, Girton College, 1991).

7 See Maud Sulter, *Passion: Discourses on Blackwomen's Creativity* (Hebden Bridge, Urban Fox Press, 1990).

8 Chris Weedon, *Feminist Practice and Post-structuralist Theory* (Oxford, Blackwell, 1987).

9 *Eastern Daily Press*, 14 Oct. 1910.

10 F. A. Hayek, *John Stuart Mill and Harriet Taylor: Their Correspondence and Subsequent Marriage* (Chicago, Chicago University Press, 1951), pp. 122–3.

11 For a full bibliography, see Perry, *Barbara Bodichon*.

12 Anna Mary Howitt, *An Art Student in Munich* (London 1853); see also Margaret Howitt, *Mary Howitt: An Autobiography* (London, Isbister, 1889) and Jan Marsh and Pamela Nunn, *Women Artists and the Pre-Raphaelite Movement* (London, Virago, 1989).

13 See R. Garnett, *The Life of W. J. Fox* (London, John Lane, 1910) and Ellen Clayton, *English Female Artists* (London, Tinsley, 1876), pp. 80–7.

14 Caroline Cornwallis, 'The property of married women', *Westminster Review* (Oct. 1856), 336–8.

15 Letter from Anna Mary Howitt to Barbara Bodichon, *c.* 1848–52, transcribed in Barbara Stephen's notebook, Cambridge University Library, Add Ms 7621.

16 Lynda Nead, *Myths of Sexuality: Representations of Women in Victorian Britain* (Oxford, Blackwell, 1988).

17 The petition is reprinted in Cherry, *Painting Women*, pp. 224–5.

18 Valerie Sanders (ed.), *Harriet Martineau: Selected Letters* (Oxford, Clarendon Press, 1990); Harriet Martineau, 'Female Industry', *Edinburgh Review* (Apr. 1859), 334.

19 Charlotte Babb was admitted to the RA schools in December 1861, Royal Academy archives. For her campaigning see *Englishwoman's Review*, Jan. 1874, p. 60; Jan. 1907, p. 56; Oct. 1909, p. 283.

20 Pamela Gerrish Nunn, *Victorian Women Artists* (London, Women's Press, 1987); Charlotte Yeldham, *Women Artists in Nineteenth-century France and England* (New York, Garland, 1984).

21 Florence Fenwick Miller, 'Ladies Column', *Illustrated London News* (12 Oct. 1889), 480.

22 *Declaration in Favour of Women's Suffrage* (London, National Society for Women's Suffrage, 1889).

23 Louise Jopling, *Twenty Years of My Life, 1867–87* (London, John Lane, 1925), p. 220.

24 See June Hannam, *Isabella Ford* (Oxford, Blackwell, 1989) and Cherry, *Painting Women*, pp. 91–2.

25 Tickner, *The Spectacle of Women*.

26 See for example, Nunn, *Victorian Women Artists*, plate 1.

27 [Bessie Rayner Parkes], 'The Society of Female Artists', *English Woman's Journal* (May 1858), 207–8. Harriet Taylor, 'The Enfranchisement of Women', *Westminster Review* (1851), reprinted in Alice S. Rossi (ed.), *Essays on Sex Equality* (Chicago, Chicago University Press, 1970), pp. 91–121.

28 *Spectator* (7 June 1856), p. 614; *Athenaeum* (7 June 1856), p. 718.

29 *English Woman's Journal*, Mar. 1861, pp. 59–61; Eliza Bridell-Fox, 'Memories', *Girl's Own Paper* (19 July 1890), 657–61; Sarah Flower Adams, *Vivia Perpetua* (London, privately printed, 1893).

30 Jopling, *Twenty Years* p. 32. The subject, from the Old Testament book of Esther, was also featured in Tennyson's poem 'The Princess'.

31 *Opinions of Women on Women's Suffrage* (London, National Society for Women's Suffrage, 1879).

32 Cherry, *Painting Women*, pp. 102–9.

33 Letter from Margaret Gillies to Leigh Hunt, *c.* 1838–9, University of Iowa, Leigh Hunt Collection Ms L/G 48h.

34 Letter from Kate Perry, 1993.

35 For a fuller discussion of woman as sign see Elizabeth Cowie, *Woman as sign'*, m/f, 1:1, 1979; Deborah Cherry and Griselda Pollock, 'Woman as sign in Pre-Raphaelite literature', *Art History*, 7:2 (1984), pp. 206–24; Cherry, *Painting Women*, pp. 13–14.

36 *Englishwoman's Review* 15 Jan. 1891, p. 55.

37 University College, Bristol, *Report of the Council*, (Bristol, 1893–4), p. 13; Helen Blackburn, *Women's Suffrage* (London, Williams and Norgate, 1902).

38 The original portrait, measuring 40 × 52 in was removed from the college by the sitter's descendants in 1929. Now untraced, it was reproduced in Blackburn, *Women's Suffrage*, facing p. 47. The portrait now at the college was donated in 1963. I am greatly indebted to Kate Perry for access to archival material at the college and for clarification of the portraits by Emily Mary Osborn.

39 Letters from the curator to the artist, archives of Manchester City Art Galleries, kindly made available by Sandra Martin.

Vistas of pleasure: Women consumers of urban space in the West End of London 1850–1900

Lynne Walker

THE theory of gendered spaces – masculine/public spaces and feminine/private spaces – has been a central tool for the analysis of cultural practice, institutions and ideologies from both the historical and contemporary perspective.[1] In the nineteenth century, women's subordinate place in the hierarchy of the sexes, it is understood, was reinforced and reproduced by the doctrine of separate spheres which assigned women to the home and barred them from participating in the public (masculine) world of work and remuneration.

Recent research has shown, however, that the public/private dichotomy is oversimplified and the rigid separation of spheres is overstated.[2] In this essay I want to look at the general theory in the light of the evidence of a particular urban space, the West End of London, in the period between 1850 and 1900, to begin to answer some of the questions that present themselves in relation to women and the use of public space. Were women invariably incarcerated in the home, exiled in the suburbs or chaperoned in the streets of Victorian London? How did women use the public spaces of the West End in the second half of the nineteenth century? Did they use space differently from men? If they were excluded, how was their presence controlled and regulated? What were the contemporary discussions concerning women's use of urban space? What were the effects of class, race, age, time of day, week or season? What structures and institutions facilitated and/or limited women's activities? To what extent did lived experience challenge and erode ideology? What changes were there in ideology and in women's lives over this period?

In taking the built environment – the buildings and the spaces between them – this essay proposes a particular view in which space is not a backdrop, a neutral container of events, or only a 'site' or 'location' of the construction of meaning (as important as that role is). Recognising that there is a need to explore how architecture makes 'a physical representation of social relations in the way it organizes people in space',[3] I also want to examine to what extent these social relations in turn are changed by spatial divisions and material forms of representation.

This view should not imply a direct cause–effect relationship. As Shirley Ardener made clear, when introducing Judy Matthews' study of community action, there is 'cumulative interdependence'[4] between space and social formations:

> social identity is partly determined by 'the physical and spatial constituents of the group's environment; that is to say: space defines the people in it. At the same time (again reflexively), the presence of the individual in space' determines its nature[5]

Social maps of the West End of London

The West End of London was the epicentre of nineteenth-century Britain and the focus of Empire. For the purposes of this discussion, its perimeters are from Regent's Park in the north to Haymarket in the south, and from Holborn in the east to Marble Arch in the west. It contained the central institutions of male power and pleasure, as well as the homes of the leaders of the social, political, and economic establishment.[6] However, if the West End is seen from a feminist perspective, rather than only as the bastion of male establishment power in which women were marginal, auxiliary or excluded, it emerges as the site of a women's community within the urban centre, based on the social networks, alliances, and organisations of the Women's Movement (see Appendix).

Many leaders of the movement not only established and maintained the metropolitan structures and organisations of nineteenth-century feminism in the West End, they lived in central London as well. Barbara Leigh Smith Bodichon, Emily Davies, Elizabeth Garrett Anderson and Agnes and Rhoda Garrett, for instance, were full-time or part-time residents in the West End. Their position in the social order and their presence in the city gave these independent middle-class women access to the public sphere and facilitated their participation in public life. The political activities of the suffrage movement and related campaigns, which culminated just before the First World War, often focused on the capital. However, from as early as 1869, women's right to vote and participation in political life was rehearsed in public elections to local government councils, Poor Law Boards (to which the first woman was elected 1875), and in

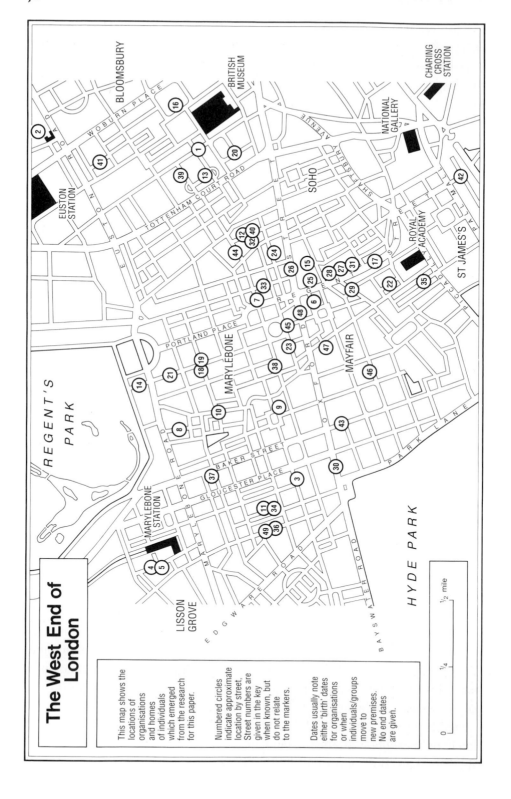

The West End of
London

This map shows the
locations of
organisations
and homes
of individuals
which emerged
from the research
for this paper.

Numbered circles
indicate approximate
location by street.
Street numbers are
given in the key
when known, but
do not relate
to the markers.

Dates usually note
either 'birth' dates
for organisations
or when
individuals/groups
move to
new premises.
No end dates
are given.

9] *facing* Map of West End of London, showing organisational and individual locations

1 *c.*1884 – 2 Gower Street. Home of Millicent Garrett Fawcett and Agnes Garrett, her designer sister, Agnes Garret, who decorated the house with her cousin Rhoda Garrett and worked from it.

2 1874 – Elizabeth Garrett Anderson's New Hospital for Women, 222 & 224 Marylebone Road.

3 1874 – Elizabeth Garrett Anderson, 4 Upper Berkeley Street. Her mansion flat was decorated by Agnes and Rhoda Garrett.

4 1859 – 18 Blandford Square – Emily Davies's address during her London visit.

5 1859 – 5 Blandford Square – Barbara Leigh Smith Bodichon's family home; used as a power base in London even after her marriage.

6 1858 – 14a Princes Street; headquarters of the Langham Circle before the move to Langham Place. Contained the *Englishwoman's Journal*, the Ladies' Institute, the Society for Promoting the Employment of Women (SPEW) and from 1858/59, the Ladies' Sanitary Association.

7 from December 1859 – 19 Langham Place, occupants as No. 6, but also included the Association for the Promotion of Social Science before its move to Waterloo Place in 1861.

8 1860 – 14 Nottingham Place. Octavia Hill's residence.

9 1861 – 22 Manchester Square. Elizabeth Garrett Anderson's Home address.

10 1860's – Paradise Place (now Garbutt Place). Octavia Hill's first housing scheme; note proximity to her house in Nottingham Place.

11 *c.*1860 – St. Mary's Church, Bryanston Square. Meeting place of Henrietta Rowland (later Dame Henrietta Barnett) and the Curate of St. Mary's (later Canon Barnett), founders of Hampstead Garden Suburb.

12 1875 – 22 Berners Street. SPEW.

13 *c.*1890 – Brabazon House, South Crescent, Tottenham Court Road. Accommodation for single women.

14 1853 – 1 Upper Harley Street. Florence Nightingale lived here when she worked around the corner in Harley Street.

15 1869 – 23 Great Marlborough Street. Ladies' Institute.

16 1891 – Russell Square. Mrs. Pankhurst's home and meeting place for suffrage campaigners.

17 1864 – 185–229 Regent Street. Verrey's Cafe and Restaurant, Harriet Verrey, proprietor.

18 1853 – 66 (now 47) Harley Street. Governess's Benovelent Society (f.1843).

19 1848 – Queen's College, 66 (now 47) Harley Street.

20 1849 – Bedford Square. Ladies College (later Bedford College).

21 1853 – Harley Street. Harley Street Nursing Home, Florence Nightingale, superintendent.

22 1893 – Cork Street. Pioneer Club, restricted to active members of Women's Movement.

23 1859 – 16A Old Cavendish Street. Ladies' Sanitary Association.

24 26 Castle Street, Regent Street. The home (?) address of Sarah Lewin, the Secretary of SPEW.

25 1850–1900. Regent Street. In addition to its role as a shopping mecca for women consumers, it was also the site of a large variety of businesses owned and run by women.

26 1860–1900. Oxford Street. Although Regent Street remained important at the upper end of the market, from the 1860's with the development of the department store, Oxford Street became the central location for shopping in London.

27 e.g. 1870 – St. James's Hall, Regent Street. A popular venue in the West End used, for example by the organizers of Girton College for their first appeal meeting.

28 1876 – Regent Street. Liberty's, the ultimate feminised shopping experience.

29 9 Conduit Street. Architectural Union, a venue favoured by women's groups; for instance, an exhibition of the Society of Female Artists (1866).

30 1889 – 448 Oxford Street. Dorothy Restaurant, run by women for women.

31 1891 – 316 Regent Street. YWCA.

32 1874 – 22 Berners Street. Berners Club (formerly Working Women's Club).

33 *c.*1872 – Great Portland Street. School of Midwifery.

34 late 1860's – 69 Bryanston Square. St. Mary's Dispensary for Women and Children.

35 1875 – 25 Albermarle Street. Albermarle Club, for men and women.

36 1878 – 132 Seymour Place. Club for Working Women.

37 1886 – 12 York Place, Baker Street. Lincoln House, one of seven homes for working class working women.

38 1885 – Mortimer Street. Welbeck House. Accommodation and meals for working women with meals available to non-residents.

39 1889 – Chenies Street. Residential chambers for 'ladies'.

40 1890 – 22 Berners Street. *Englishwoman's Review.*

41 1862 – Taviton Street. Emily Faithfull's house.

42 1861 – Waterloo Place. Association for the Promotion of Social Science.

43 *c.* 1890 – North Audley Street. Society for the Sale of Ladies Work.

44 1880's – Mortimer Street. Dorothy Restaurant, sister to Dorothy's in Oxford Street.

45 1891 – Holles Street, Cavendish Square. Ladies Victoria Club.

46 1891 – 12 Grosvenor Street. The Alexandra, club for women.

47 1891 – 31 New Bond Street. The University Club for Ladies.

48 1891 – 231 Oxford Street. Somerville Club.

Based on Godfrey Edition of Old Ordnance Survey map of 1914

School Boards,[7] for which Elizabeth Garrett and Emily Davies, stood success-
fully in 1871 in London.[8]

By eliding the public and private spheres, women negotiated another pow-
erful political space. Emmeline Pankhurst, for instance, adapted her house in
Russell Square, Bloomsbury, for suffrage meetings, such as the conference of the
Women's Franchise League in 1891;[9] while Barbara Bodichon, who was brought
up in London's Blandford Square, used the family home as a power base from
which to organise, recruit and support women for feminist campaigns even after
her marriage.[10] Her cousin Florence Nightingale lived nearby in Upper Harley
Street and did her nursing in Harley Street.[11] When Emily Davies was staying
in Blandford Square, she and Elizabeth Garrett were taken into the heart of the
Women's Movement over tea with Barbara Bodichon and sent along to the
nearby offices of the *English Woman's Journal* in 14a Princes Street, Cavendish
Square.[12] As Dr Elizabeth Garrett Anderson, she would establish her famous
Women's Hospital on various sites in the West End. Shortly afterwards, in
December 1859 the journal and its associated activities promoting women's
employment soon moved around the corner from Princes Street to 19 Langham
Place at the top of Regent Street, becoming 'home' to the Langham Circle. Its
auxiliary organisations, the Society for Promoting the Employment of Women
(SPEW), the Ladies' Sanitary Association and the Association for the Promotion
of Social Science soon spun off into adjoining streets.

The conjunction of home and work – of public and private realm – was not
limited to leaders of the organised Women's Movement. Philanthropy, which
was often an adjunct to the Women's Movement, also provided the first experi-
ence of the public sphere for many women with varied social and political
agendas. Octavia Hill, who opposed votes for women, instigated her first project
for housing London's poor virtually on her own doorstep just off Marylebone
High Street.[13] Many philanthropic bodies had their headquarters and commit-
tee meetings in central London and they relied on the elite band of aristocratic
and upper-class women, like the Duchess of Marlborough and Lady Louise
Egerton, who had townhouses in the West End, to run their organisations or act
as patrons.[4]

The streets of London

In the 1860s, the debate about women's use of urban space was preoccupied
with the disgrace, fear and shame associated with respectable women in the
streets being mistaken for prostitutes.[15] For the middle-class woman, policing
by the male gaze could be translated and extended into an accost with the
slightest provocation. Unwelcome approaches were made all the more possible

by the double mapping of Regent Street, the very heart of the West End, which was by day one of the most elegant shopping streets in the world and at night the haunt of prostitutes, while at its lower end the Haymarket was the centre of licentious London. As Lynda Nead has shown, 'The term "prostitute" connotes a public practice, the regular exchange of sex for money. The combination of cash with the public sphere rendered the prostitute powerful and independent – qualities which were the unique privilege of white middle-class men.'[16] In the same way, working-class women who were employed in the West End were perceived as a threat to middle-class respectability and male authority. Henry Mayhew, the social reformer, signalled a connection between prostitution and 'a large number'[17] of working class women employed in the shops and trades of the West End (milliners, dressmakers, pastry cooks, shop assistants, servants, and so on). Mayhew, in fact, used the phrase 'public women'[18] as a euphemism for prostitutes.

In the discussions concerning women's presence in urban space in the 1860s, codes of dress, demeanour and behaviour, and their consequences, were precise and generally united in their aim, which was to avoid provoking male affrontery. Middle-class women were commonly chaperoned in the 1860s, although some respectable women walked alone in the streets of London. Either way the formula was to keep the eyes downcast, to dress neither too much out of fashion nor too fashionably, and not to dally to look in shop windows or watch the life of the street. The aim of 1860s street sense for women was invisibility: 'Unobstrusive, gentle, womanly, she is just the person to slip through a crowd unobserved, like one of those grey moths in the evening, which come and go upon their way, unseen by men and undevoured by birds.'[19]

To avoid embarrassment and confrontation in 'the gendered and eroticized terrain'[20] of the metropolis, the middle-class desire for segregation and privacy was spatially inscribed through separate rooms for 'ladies' in public buildings.[21] In hotels, railway stations and restaurants, a separate sphere was created for women, to ensure protection, respectability and control within the public realm. These women-only spaces within conventional accommodation encouraged middle-class women's participation in the public sphere but also reproduced the perception that women in public places were interlopers whose daring, foolishness or innocence would be punished, and indeed their femininity removed without a safe place made by men for women in their (male) world.

Women had their own experience of urban space. The growth of women's employment in the second half of the nineteenth century meant that, in addition to those who lived there, thousands of women came into the West End daily on foot and by public transport to work, many as shop assistants, clerks, nurses, telegraphists, teachers and students. Between 1861 and 1900 in England and

Wales the number of women in the workforce rose by almost one million; and between 1881 and 1911 there was a rise of 161 per cent in women workers in middle-class occupations.[22] Through their ordinary daily experience of work, recreation and shopping, the fear of going out in public which regulated and controlled women's use of urban space was dissipated, mediated or quelled. Traversing urban spaces in large numbers and riding on public transport[23] helped normalise the presence of unaccompanied women in the public sphere and provided impetus for changing perceptions and provision. Arguments for building public toilets for women, for instance, were often predicated on the sheer numbers of women thronging into the West End.[24]

Although far from normative, horsewomen were part of the 'dizzying confusion'[25] of Regent Street recorded in 1866 by the *Illustrated London News;* and a representation of Regent Street around 1858 includes a middle-aged woman serenely driving her carriage through the rowdy traffic.[26] In 1862 a young woman wrote to *The Times* that she used Oxford Street every day without problems.[27] In the same year, but more generally, a writer in *Temple Bar* reported 'daily teachers, art-students, "assistants" of every kind, readers at the British Museum, and many other instances of unprotected womanhood'[28] in the streets of London.

Public pleasures

In the 1850s, Jane Welsh Carlyle, a feminist and campaigner for the Married Woman's Property Act, who was also the highly respectable wife of the writer Thomas Carlyle, made it her practice to eat out alone, and well, in West End restaurants, such as Verrey's in Regent Street.[29] The architecture of Verrey's and its surroundings reinforced its image of respectability, safety and protection, as well as that of an elegant and well-located place for dining. The protected environment was well-lit with lamps on the pedestrian island and pavement, and further lights marking the entrance. Layers of protection marked the restaurant off from the street: two lines of bollards, cast-iron fencing, balconies, blinds (on the inside and outside of the building), the window on the entrance front filled with stained glass; and the graphics were very distinct, making it more or less impossible to mistake the restaurant for some less respectable establishment.[30]

The desire to take part in the pleasures of urban life led women to adopt an old strategy – to dress as men. On stage in theatres and music halls, sexual reversal was a common practice for women (many leading female actors' greatest roles were as men)[31] and a familiar entertainment in servants' halls. *The Times* reported women who dressed in men's clothes when attending the theatre and when visiting a famous London pub.[32] As Leonore Davidoff points out with reference to the relationship of Hannah Cullick and A. J. Munby, the transforma-

tion from female to male was not an isolated event.[33] For some women, cross-dressing seems to have been an attempt to move more freely in the evening world of entertainment in theatres and taverns in the 1860s. Their appearance caused consternation, but the sight of working-class women standing at the bar and drinking was not an uncommon one in central London.[34] In the nineteenth century, many working-class women worked and drank in West End pubs, and the introduction in the 1880s of private bars or snugs with their own entrances increased their popularity with women drinkers.[35]

Public (in)conveniences

External controls and regulation of women's access to the public sphere were nowhere more direct than in the refusal of local government to provide public lavatories for women in the West End.[36] In spite of strong representations from women's groups, sanitary and moral reformers, doctors and even entrepreneurs who were willing to take on the financial risk, only male lavatories were built in central London before the 1880s. It took the powers of the London County Council (with the Public Health (London) Act of 1891 and the Metropolitan Management Act of 1855 which extended the Public Health Act of 1848) to provide funds and impetus to the patchwork of vestries (local councils) so that they might build public toilets for women. Before the last decade of the century, women needing a lavatory were forced to go into milliners' shops or to order food in confectioners or restaurants which they often did not want, nor could always well afford.[37] Any expenditure of this sort, for example, at a railway station, was simply out of the question for working-class women.

The incomprehension and inability of the vestries to meet the fundamental needs of women by providing public toilets in the streets of London was based on middle-class attitudes to bodily functions and the necessity of shielding them from the public gaze. The idea of public toilets for women represented women's bodily functions/physicality/sexuality[38] and threatened to disrupt and disorder society. Sexual difference constructed through medical theory gave support to the ideological agenda and to local governments' inaction by scientifically establishing that women's bodies were less physically sensitive than men, so that, by extrapolation, the need to urinate or defecate would not discomfort them.[39]

Towards a public ideology for women

The large numbers of highly visible women shoppers, workers and visitors (to museums, art galleries, concert halls, theatres and hotels) were encouraged, mediated and contained through various strategies. The development of respect-

able, 'protected' accommodation and the provision of segregated women's spaces within mixed accommodation have been mentioned. The Women's Movement, however, campaigned for the provision of refreshment facilities run by women for women. Clubs and restaurants were established in the West End for women of all classes, although social divisions were maintained as educated middle-class women set up their own clubs, such as the feminist Pioneer Club in Cork Street,[40] but also established clubs for working-class and lower middle-class single women, such as the Berners Club.[41] Welbeck House in Mortimer Street, which served 300–400 meals daily, was one of many lodging houses established as a philanthropic venture by the Society for Homes for Working Girls.[42] As a development of the bakers' shops and confectioners which were the conventional but inadequate places for women to eat in London, two institutions of British catering were able to meet women's needs on a commercial basis, the ABC Teashops (*f.* 1864) and Lyons Corner Houses (Piccadilly, 1894).

An index of the presence of women in the centre of the city is the success of the Dorothy chain of restaurants in Oxford Street and Mortimer Street which were run by women for women.[43] Open until 10 p.m., they served highly acceptable food in comfortable dining rooms which were decorated with bright

10] *The Pioneer Club in Cork Street*

red walls and Indian curtains. Typically, in the 1870s and 1880s, the architecture provided for women was the fashionable 'Queen Anne'. This style's daintiness, elegance, and especially its domestic character were considered feminine and therefore appropriate for women. Many new shops built in the West End, such as Thomas Goode's in Mayfair, were feminised through the use of 'Queen Anne' for both interiors and exteriors.[44]

The most significant symbol of the many pleasures of the modern city open to women was the department store, which provided the opportunity for large numbers of women in safety and comfort to exercise their power as consumers of commodities, and of urban space. In the second half of the nineteenth century, London offered the highest concentration of pleasures of any city in the world and department stores were the most successful 'specialized pleasures',[45] complementing the home with a 'total alternative environment'[46], rather than replacing it. The new department stores, which first developed in Manchester and Newcastle, opened in the West End in the 1860s and 1870s: John Lewis (1864), Liberty's (1876), and D. H. Evans (1879) joined older stores expanded in the new form, such as Marshall & Snelgrove, Debenham and Peter Robinson. These department stores provided a setting in the public sphere, 'a meeting place and promenade', which for the first time gave women 'a home away from home'[47], a feeling of being at home in the public sphere, which only men had previously experienced.

By the 1890s, middle-class women were relatively unrestrained compared to the 1860s.[48] Chaperones were a thing of the past in upper middle-class circles, and it was within convention for women to go out from home and traverse the streets alone: to travel, shop, go to their studies, to the doctor, dentist and hairdresser or to work. In the second half of the nineteenth century, women had access to the classed and gendered spaces of such new types of building as restaurants, hotels, railway stations and department stores. Public buildings in the form of women's clubs and restaurants were established in central London, and women used their personal spaces to advance public causes or to experiment with new ways of living. Most significantly during this period, there was a rapid growth in women's unaccompanied presence in the public sphere: in the workforce as users of commercial and public architecture, on public transport and in the streets. Ideologically, however, their expanded presence in the public sphere was not the norm and it perturbed the male occupants.[49] As Griselda Pollock has pointed out women 'were never positioned as the *normal* occupants of the public realm'.[50] Nonetheless, their presence and autonomy in the West End of London toward the end of the nineteenth century engendered a dissonance between ideology and lived experience that made spaces for real change through the development of a public ideology for women.

Notes

This article is reprinted with permission of the Sorella Press, 1992, where it appeared in the collection 'Cracks in the Pavement': Gender/Fashion/Architecture compiled by Lynne Walker from proceedings of a study day of the Design History Society at the Design Museum, April 1992.

1 Leonore Davidoff, Jean L'Esperance and Howard Newby, 'Landscape with Figures: Home and Community in English Society', in Juliet Mitchell and Ann Oakley (eds.), *The Rights and Wrongs of Women* (Harmondsworth, Penguin, 1976), pp. 139–175; Richard Sennett, *The Fall of Public Man* (London, Faber and Faber, 1976) and Shirley Ardener, *Women and Space: Ground Rules and Social Maps* (London, Croom Hill, 1981); Pauline Fowler, 'The Public and the Private in Architecture: A Feminist Critique', *Women's Studies International Forum*, 7/6 (1984), 449–54; Leonore Davidoff and Catherine Hall, *Family Fortunes, Men and Women of the English Middle Class 1780–1850* (London, Hutchinson, 1987); and Griselda Pollock, 'Modernity and the Spaces of Femininity', *Vision and Difference: Femininity, Feminism and Histories of Art* (London, Routledge, 1988), pp. 50–90.

2 Most recently and pertinently, Deborah Cherry, *Painting Women: Victorian Women Artists* (London, Routledge, 1993). Also, Pat Hudson and W. R. Lee (eds.), *Women's Work and the Family Economy in Historical Perspective* (Manchester, Manchester University Press, 1990).

3 Jos Boys, 'Is There a Feminist Analysis of Architecture?', *Built Environment*, 10:1 (1984), 25.

4 Ardener, *Women and Space*, p. 12.

5 *Ibid.*, pp. 12–13. For the social production of spaces which empowered women in suburban Paris in the nineteenth century, see Kathleen Adler, 'The Spaces of Everyday Life: Berthe Morisot and Passy', in T. J. Edelstein (ed.), *Perspectives on Morisot* (New York, Hudson Hills, 1990), pp. 35–44. Tanis Hinchcliffe provides an English example in *North Oxford* (London, Yale, 1992). For distinctions between Paris and London, see Elizabeth Wilson, *The Sphinx in the City: Urban Life, the Control of Disorder, and Women* (London, Virago, 1991).

6 P. J. Atkins, 'The Spatial Configuration of Class Solidarity in London's West End 1792–1939', in R. Rodger (ed.), *Urban History Yearbook, 1990* (Leicester, Leicester University Press) pp. 36–65.

7 F. K. Prochaska, *Women and Philanthropy in Nineteenth-Century England* (Oxford, Clarendon Press, 1980), p. 226, n. 11.

8 A range of political views were represented by the women on School Boards: *Anon.*, 'Women on the School Board', *Queen*, 84 (17 Nov. 1888), 617.

9 Alan Bolt (ed.), *Our Mothers* (London, Victor Gollancz, 1932), p. 165.

10 Barbara Stephen, *Emily Davies and Girton College* (London, Constable, 1927), p. 48.

11 Florence Nightingale, *Florence Nightingale at Harley Street: Her Reports to the Governors of Her Nursing Home 1853–4* (London, J. M. Dent, 1970), p. vii.

12 Jo Manton, *Elizabeth Garrett Anderson* (London, Methuen, 1987), pp. 48–9. The purpose of the visit was for Elizabeth Garrett not only to meet Barbara Bodichon, but also to arrange a meeting with Dr Elizabeth Blackwell to discuss her plans to become a doctor.

13 Gillian Darley, *Octavia Hill: A Life* (London, Constable, 1990), p. 92.

14 Bolt, *Our Mothers*, p. 183.

15 See, for example, correspondence about middle-class women in the streets in *The Times*, 9 and 17 Jan. 1862.

16 Lynda Nead, *Myths of Sexuality: Representations of Women in Victorian Britain* (Oxford, Basil Blackwell, 1988), p. 95. This and other related issues are very usefully detailed in Judith R. Walkowitz, *City of Dreadful Delight: Narratives of Sexual Danger in Late-Victorian London* (London, Virago, 1992).

17 Henry Mayhew, *London Labour and the London Poor* ([London [1861], Dover reprint 1968), vol. iv, p. 217).

18 Mayhew, *London Labour and London Poor*, p. 218.

19 E. L. L. [Elizabeth Lynn Linton], 'Out Walking', *Temple Bar*, 5 (1862), p. 136.

20 Griselda Pollock, 'Feminist Interventions in the Histories of Art', *Vision and Difference*, p. 5.

21 Robert Thorne, 'Places of Refreshment in the Nineteenth-Century City', in A. D. King (ed.), *Buildings and Society: Essays on the Social Development of the Built Environment* (London, Routledge & Kegan Paul, 1980), pp. 228–253; for an example of segregation and specialisation in gendered public spaces, see Oliver Carter, 'The Great Northern and Midland Grand Hotels', in M. Hunter and R. Thorne (eds.), *Change at Kings Cross* (London, Historical Publications, 1990), especially pp. 82–9.

22 Census findings in Lee Holcome, *Victorian Ladies at Work: Middle-Class Working Women in England and Wales 1850–1914* (Newton Abbot, David & Charles, 1973), Tables 6a and 6f.

23 A rise of about 300 per cent in the number of bus and tram journeys in the Greater London area between 1875 and 1900 included the rapidly growing number of women workers, shoppers and visitors: Thorne, 'Places of Refreshment', p. 244; see also, for instance, *Work and Leisure*, Nov. 1883.

24 James Stevenson, M. D., Medical Officer of Health for Paddington, *Report on the Necessity of Latrine Accommodation for Women in the Metropolis*, printed by order of the Vestry, 18 Mar. 1879.

25 Quoted in Hermione Hobhouse, *A History of Regent Street* (London, Macdonald and Jane's, 1975), p. 108.

26 George Augustus Sala, *Twice Around the Clock: Or the Hours of Day and Night in London* (London, Houlston and Wright, 1859), p. 148.

27 Letter from a young women to the Editor, *The Times*, 9 Jan. 1862.

28 E. L. L. 'Out Walking', p. 132.

29 Letter from Jane Carlyle to a friend, 10 Aug. 1852: *Jane Welsh Carlyle: A New Selection of Her Letters*, ed. Trudy Bliss, (London, Victor Gollancz, 1949), pp. 233–4.

30 Photograph No. 2879, C138 in the Victoria Library Archives, Westminster.

31 Jane W. Steadman, 'From Dame to Women: W. S. Gilbert and Theatrical Transvestism', in Martha Vicinus (ed.), *Suffer and Be Still: Women in the Victorian Age* (Bloomington, Indiana University Press, 1972), pp. 20–37.

32 *The Times*, 17 and 19 Oct. 1868.

33 Leonore Davidoff, 'Class and Gender in Victorian England', in J. L. Newton, M. P. Ryan and J. R. Walkowitz (eds.), *Sex and Class in Women's History*, (London, Routledge and Kegan Paul, 1983), pp. 17–71.

34 Stephen Fiske, *English Photographs* (London, Tinsley Brothers, 1869), p. 171; cited in Thorne, 'Places of Refreshment', p. 231.

35 Peter Bailey, 'Parasexuality and Glamour: The Victorian Barmaid as Cultural Prototype', *Gender and History*, 2/2 (Summer, 1990), 148–72. This reference was pointed out to me by Robert Thorne, whose own work ('Places of Refreshment') and advice for this paper were invaluable.

36 Vestry Minutes, St Marylebone, 1850–99, in the Marylebone Public Library Archives; Vestry Minutes, St George's, Hanover Square, 1855–99, in the Victoria Library, Westminster; and Sue Cavanagh and Vron Ware, *At Women's Convenience: A Handbook on the Design of Women's Public Toilets* (London, Women's Design Service, 1990), pp. 9–17.

37 Letter from Rose Adams, Secretary of the Ladies Sanitary Association to the Vestry of St Marylebone, 15 Oct. 1878, in Vestry Mins. 1850–99. For example, in 1887 a public convenience for women in Regent Street, near Oxford Circus, was rejected (*ibid.*, 1887, p. 130).

38 Davidoff, 'Class and Gender', p. 18.

39 Stevenson, *Report on Latrine Accommodation*. Dr Stevenson called this idea 'a mistake' (p. 11). But in 1892 Carlo Lombroso constructed sexual difference around women's supposedly scientifically proven 'inferior sensory irritability', with particular regard to pain; he provided

'corroborating [anecdotal] evidence' that women when operated on or in childbirth 'suffer much less than might be supposed': Carlo Lombroso, 'The Physical Insensibility of Woman', *Fortnightly Review*, 51 (1892), 354–7.

40 *Queen*, 23 (Dec. 1893), 1081.

41 On this point about the Berners Club, see *The Englishwoman's Review*, 7 (July 1871), 185. For more on clubs and related activities, see Martha Vicinus, *Independent Women: Work and Community for Single Women 1850–1920* (London, Virago, 1985), pp. 295–9.

42 *The Englishwoman's Review*, 17 (15 July 1885), 327.

43 *Women's Penny Paper*, 22 June 1889, p. 7, and 13 July 1889, p. 10.

44 The redefinition of urban spaces to attract women consumers is a central theme of Erika Rappaport's doctoral dissertation, 'The West End and Women's Pleasure: Gender and Commercial Culture in London 1860–1914' (1993, Rutgers University). Our meeting amongst the archives of public conveniences was serendipitous.

45 Donald J. Olsen, *The Growth of Victorian London* (Harmondsworth, Penguin, 1976), p. 23. Other useful sources for department stores include Anon., *London: The World's Metropolis* (London, Historical Publishing Co., n.d. (*c*.1888) – I am grateful to Elain Harwood for showing me this book; Alison Adburgham, *Shops and Shopping 1800–1914* (London, Allen & Unwin, 1981); and Elizabeth Wilson, *Adorned in Dreams: Fashion and Modernity* (London, Virago, 1985), especially pp. 134–54.

46 Olsen, *Growth of Victorian London*, p. 125.

47 *Ibid.*

48 Eliza Lynn Linton, 'Unchaperoned', *Queen*, 94 (16 Dec. 1893), 1015; and 'Feminine Independence', *Queen*, 92 (5 Nov. 1892), 751. For Mrs Lynn Linton's views on the matter in the 1860s, see 'Out Walking'. A comparison of the 1850s and 1890s was made by Charlotte Yonge in the *Monthly Packet*; quoted in *Queen*, 89 (31 Jan. 1891), 157.

49 'Female Poaching on Male Preserves', *Westminster Review*, 129 (1888), 293.

50 Pollock, 'Modernity and the Spaces of Femininity', p. 50; my italics.

Appendix. Public/private spaces for women in the West End of London 1850–1900: a social map

This 'map' is not a definitive list, but gives an indication of the location, number and variety of organisations and individuals that made up the social networks and alliances of the Women's Movement in the second half of the nineteenth century in the West end of London. Some related sites are also given. Organisations are generally recorded when founded or first mentioned in contemporary sources and again when they had a change of address.

1850s

18 Blandford Square, rectory, Christ Church, Marylebone. Emily Davies, a frequent visitor here to her rector brother.

5 Blandford Square, family home of Leigh Smiths, regularly used by Barbara Leigh Smith Bodichon as her London base.

Portman Hall School, nr. Edgware Road; *f.* Barbara Bodichon and Elizabeth Whitehead; Octavia Hill taught here; George Eliot a frequent visitor.

1 Upper Harley Street, Florence Nightingale, Barbara Bodichon's cousin, lived here and worked at the Harley Street Nursing Home for Women at No. 90.

14a Princes Street, Cavendish Square housed the *Englishwoman's Journal*, the Society for Promoting the Employment of Women (SPEW) and the Ladies' Institute. Also *c.* 1858/9, Ladies' Sanitary Association.

19 Langham Place (from Dec. 1859), the *Englishwoman's Journal*, the Ladies' Institute, with a lun-
 cheon room and reading room, and the Association for the Promotion of Social Science;
 Jane Crow, Secretary of SPEW lived at No. 19.
Small streets near Langham Place, an area renowned for prostitution.
185–199 Regent Street, Verrey's Cafe and Restaurant. Well-known and respectable place; unac-
 companied women.
Regent Street. Centre of shopping and, especially after dark, prostitution.
Haymarket. Centre of West End night life, including, most notably for nineteenth-century
 reformers, prostitution.
66 (now 47) Harley Street, Governess's Benevolent Society; and from 1848, Queen's College.
Bedford Square, Bloomsbury, Ladies College (later Bedford College) from 1849.
16a Old Cavendish Street, Ladies Sanitary Association.
26 Castle Street, Regent Street, residence of Sara Lewin, Secretary of SPEW.

1860s

19 Langham Place, Ladies' Tracing Society joins the offices of the Langham Circle.
Langham Place, Langham Hotel provided ladies drawing rooms.
68 Regent Street, Cafe Royal. Meeting place for Bohemia.
Various sites, ABC Tearooms. A chain of baker's shops extended to provide light meals.
14 Nottingham Place, Octavia Hill's home address.
2 Paradise Place (now Garbutt Place), Octavia Hill's first housing experiment.
22 Manchester Square, home of Elizabeth Garrett Anderson.
24 Queen's Square, Bloomsbury, Working Women's College.
23 Great Marlborough Street. Ladies Institute and SPEW.
9 Conduit Street, Architectural Union. A venue which was used for an exhibition of the Society
 of Female Artists (1866) and a lecture by Dr E. G. Anderson on physical education for girls.
69 Bryanston Square, St Mary's Dispensary for Women and Children; EGA's first hospital.
Waterloo Place, Social Science Association.
Taviton Street, WC1, Emily Faithfull (res. 1862).
17 Cunningham Place, NW1. (West End margins), Emily Davies.

1870s

222 and 224 Marylebone Road, Hospital for Women.
30 Henrietta Street, Bloomsbury, London School for Medicine for Women.
Euston Road, Midland Grand Hotel. Separate facilities for women.
2 Gower Street, Bloomsbury, residence of Agnes and Rhoda Garrett, which they decorated (after
 the death of Rhoda Garrett and Henry Fawcett in the early 1880s, Millicent Garrett Fawcett
 joined Agnes to live in Gower Street).
4 Morwell Street, Bedford Square, warehouse (i.e. shop), interior design and decoration firm
 Agnes and Rhoda Garrett.
4 Upper Berkeley, the mansion block flat decorated by the Garretts for Dr E. G. Anderson.
14 Nottingham Place, Sophia Jex-Blake and Octavia Hill.
Regent Street, St. James's Hall. Well-known auditorium often used for suffrage meetings and
 demonstrations.
College for Men and Women, 29 Bloomsbury Square.
Working Women's College, 3 Fitzroy Street, Fitzroy Square.
Regent Street, Liberty's Department Store opened 1876.
Oxford Street, Marshall & Snelgrove (f. 1837), new buildings 1876 and 1888.
4 Park Lane, Carlyle Square. Address of T. Nichols, Esq. who formed a company to provide free
 public conveniences for women and children; proposed accommodation would also include

in some instances ladies' waiting rooms, dressing and washing rooms and tea rooms. It failed
due to rejection of the idea by vestries.

22 Berners Street, SPEW.

9 Berners Street, Berners Club (formerly the Working Women's Club).

Great Portland Street, School of Midwifery.

25 Albermarle Street, Albermarle Club.

132 Seymour Place, new club for working women, opened in 1878.

5 Fitzroy Street, Working Men's (originally Working Women's) College, mixed in 1874.

42 Somerset Street, Portman Square, *Woman's Gazette.*

Recommended by the *Woman's Gazette* for ladies to lunch in West End (full list includes six others
in adjoining neighbourhoods):

Vere Street, Biddell's.

Duke Street at Oxford Street, Linscott's.

Oxford Street, Grant's.

Oxford Street, Simpson's.

Old Burlington Street, Blanchard's.

2 Mount Street, Haaer's.

163 Oxford Street, the Vere Hall Rooms. Private rooms for writing and resting with a 'lady super-
intendent'; no charge for rooms but visitors were expected to buy two pounds of tea.

1880s

12 York Place, Society for Homes for Working Girls. Lincoln House – seven homes for working-
class women.

Mortimer Street, Welbeck House, accommodation and meals for working-class women with
available meals for non-residents.

136 Seymour Place, Walmer Castle Coffee Tavern, run by Emma Cons.

Chenies Street, Bloomsbury, Ladies Residential Chambers.

22 Berners Street, *Englishwoman's Review.*

Mortimer Street, Dorothy Restaurant, run by women for women and open until 10.00 p.m.

448 Oxford Street, Dorothy Restaurant.

316 Regent Street, Lotus Club, for 'ladies and gentleman'.

1890s

316 Regent Street, YWCA.

22 Berners Street, *Englishwoman's Review.*

North Audley Street, Society for the Sale of Ladies Work.

Holles Street, Cavendish Square, Ladies Victoria Club.

12 Grosvenor Street, The Alexandra, a club for 'ladies'.

31 New Bond Street, The University Club for Ladies.

231 Oxford Street, Somerville Club.

Piccadilly, J. Lyons & Co. first teashop.

West End Miscellaneous

141–3 Regent Street, Mme Aubert Governess and School Agency (1903).

56 Regent Street, Industrial & Educational Bureau, Miss Faithfull (1882).

62 Regent Street, Restaurant, proprietor, Mme Salome Petrzywalski (1891).

136 Regent Street, Miss Emily Faithfull's Institute.

316 Regent Street, YWCA (1891).

Late nineteenth-century lodgings for working 'ladies'
(LRDC=Ladies Residential Dwellings Company)

Chenies Street Chambers, Bloomsbury.
York Street Chambers, Portman Square (the architects, Ethel and Bessie Charles lived here).
Sloane Gardens House, LRDC.
19 Lexham Gardens.
4 Brunswick Square, WC1.
Brabazon House, South Crescent, Tottenham Court Road.
Oakley Street Flats, Chelsea, LRDC.
Campden Hill Houses, LRDC.
Holbein Houses, Pimlico.
College Hall, Byng Place.
7c Lower Belgrave Street, Gentlewoman's Employment Club
10 St George's Road, Gentlewoman's Employment Club.
Ladies' Residential Club, Kensington Square, LRDC.
Ladies' Residential Club, 40 & 42 Penywern Road, Earls Court, LRDC.
LRDC block planned for 19 Belsize Park (1889).

Other addresses, some outside West End or domestic

Queen's Park Flats, 36 West Kilburn, 'Little houses . . . mere cottages'.
Waterlow Court, Hampstead Garden Suburb, Baillie Scott, architect, 1909.
Great George Street, SW1, Bessie Rayner Parkes' childhood home.
28 Thavies Inn, EC4, Dr Elizabeth Blackwell's digs (1860s).
Onslow Square, Lady Mary Fielding (1876).
9 Upper Phillmore Gardens, Jessie Boucherett (1876).
Leonardslee, Horsham, Louisa M. Hubbard (1876).
22 Berners Street, Sarah Lewin (1876).
90 Harley Street, Miss C. Holland (1876).
Horsell, Woking Station, Miss Veitch (1876).
42 Somerset Street, W., Miss M. E. Phillips (1876).
18 Cadogan Place, Emily Anne Eliza Shirreff.
106 Brompton road, Princess House, restaurant and rooms for 'young women engaged in houses of business' (1878).
42 Queen Anne's Gate, Westminster, Lady Plan Tracers Office (1876).
Greek Street, Club for Working Girls in Soho (1883).
Churchill House, Chiswell Street, Finsbury, ('a restaurant and lodging houses for city work-women' (1886).

CULTURE, CRITICISM AND CONNOISSEURSHIP

The Corinne complex: gender, genius and national character

Clarissa Campbell Orr

IN 1881 Lady Elizabeth Eastlake wrote in the *Quarterly Review*, 'women, especially, are bound to honour Mme de Staël, for there is no female name in literature which does the sex, whether in head or heart, such credit.'[1] What would prompt such a tribute? Few women born untitled were as prominent and successful a part of the Victorian art world as Eastlake, née Rigby. The first woman to review for the *Quarterly*, she contributed significantly through her essays on art and translations of German art criticism to the growth of English art historical scholarship; and as a close collaborator with her husband in the pursuit of paintings for the national collection she can be seen virtually as the co-founder of the institution in its Victorian form. Charles Eastlake was knighted for his services as Director of the National Gallery and President of the Royal Academy, and had been effectively Prince Albert's artistic advisor; Elizabeth wrote the Prince's obituary. De Staël, whose father Jacques Necker was Finance Minister to Louis XVI as the Revolution gathered momentum, wielded her greatest influence as a critic of Napoleon when he exiled her from France and she presided over a circle of liberal intellectuals which included Benjamin Constant.[2] It may be questioned how far Eastlake, so well situated in Victorian Society, might have needed de Staël as a role model.

Nevertheless she was not alone in her appreciation of the French woman's varied achievement as historian, critic, and novelist. The art critic Anna Jameson identified herself strongly with De Staël's range of subject matter and with her fictional heroine Corinne;[3] and when Elizabeth Eastlake's friend Henry Layard, archaeologist and diplomat, was trying to describe his unusually gifted cousin, Lady Charlotte Guest (subsequently Schreiber), the comparison he found most

useful was, 'an extraordinary woman, and her character a remarkable one – in some ways resembling Mme de Staël in the union of feminine and masculine qualities'.[4] Thus Mme de Staël became an emblem of unusual female achievement, especially suggesting one who transgressed received boundaries between male and female spheres but whose achievement was so outstanding, and her social if not her moral status so impeccable, that she could not be derisively dismissed. This was an estimate of women as well as men: Sydney Owenson, Lady Morgan, also described her as combining female and male characteristics, praising her 'genius', and the fact that the 'female enthusiasm' of her views was supported by her 'masculine independence'.[5]

Yet this iconic status may still seem surprising, and comparisons to de Staël unwelcome. Her personal life – her arranged marriage and her liaisons with the Comte de Narbonne and Benjamin Constant, the fathers of her children – and her exercise of political influence with a salon-based culture, placed her in the decadent pre-French Revolutionary world of courtly politics, a world opposed to the values of English Romantics, liberals and feminists.[6] Benjamin Constant cautioned Mary Shelley against writing a full biography, well knowing it would be unsympathetically received in England, and the brief account she did provide followed closely the tactful biographical sketch of de Staël's cousin.[7]

However, the range and variety of de Staël's achievement meant that it lent itself to various constructions. On the one hand there were books such as her survey of German society, literature, and philosophy, *De L'Allemagne* (1811), a personal interpretation of German culture based on her own reading and on extended interviews with significant figures. More than a simple record of a visit, it was a philosophical analysis of the essential character of German society, whose approach was indebted to the sociological theories of Montesquieu and his followers in the Scottish Enlightenment, with their emphasis on describing the interrelationships between culture, society and historical tradition, and on tracing the progress of society through measurable stages of civilised development. This philosophical approach in some ways represented an infringement onto territory considered suitable for a scholarly, masculine, educated writer, from which most women would have been excluded by virtue of their less rigorous intellectual training; an exclusion based on the assumption that a woman's intellect was incapable of precisely this kind of generalised philosophical sweep. Furthermore, by celebrating German culture, the book implied that Napoleonic France could be rivalled in prestige and cultural achievement; it used cultural analysis for political ends, to celebrate the diversity and equal value of European national cultures, and to imply that each should be free to determine its own historical destiny – attitudes central to liberal nationalism in the early nineteenth century.[8]

As a novelist de Staël created the hugely influential figure of Corinne, who was to figure throughout the nineteenth century in many women's imagination as the embodiment of the passionately expressive, artistic female genius, fulfilled by her art but unable to find a romantic partner who can accommodate himself to the demands of her talents or the depths of her soul. Corinne is an improvasitrice – that is to say, a poetess able to improvise verse instantaneously and in public in topics proposed by her audience; she is also a painter and a connoisseur of the arts. She is partly English, partly Italian, and only finds happiness in her art when she has left the confines of English genteel life and settled in Italy. Here she has her love affair with the English milord, Oswald Nevil, to whom she acts as guide and mentor to Italian culture, past and present; but recognising her unsuitability as wife to an English aristocrat, she voluntarily relinquishes Oswald to a marriage with her demurely and correctly English half-sister. Thus as Gutwirth's penetrating discussion of the novel shows, *Corinne* is as much about the limitations of the English squirearchy – its dullness, its rigid etiquette, its devotion to rural pursuits and its mistrust of artistic expression and erotic passion, especially in women – as it is about the collective genius of Italy or the dilemmas facing an exceptionally talented woman.[9]

The persona of Corinne, the embodiment of public female artistic genius, was too highly coloured for some, though as Jan Marsh shows, not for all, and it reinforced the notion that an artistic woman was likely to breach the restraints of respectable womanhood. The roots of this prejudice lie at least a century earlier in English culture; the Bluestocking hostess, Elizabeth Montagu, pronounced in 1750, 'I am sorry to say the generality of women who have excelled in wit have failed in chastity'.[10] Somehow English polite society, unlike French salon culture, failed to allow women to be simultaneously intellectually or artistically gifted *and* sexually attractive *and* socially acceptable. When de Staël described Corinne's gloom in English society, she was undoubtedly recalling her time in exile in England in 1794, when she, her lover the Comte de Narbonne, his friend General D'Arblay and others shared the Surrey mansion Juniper Hall. Fanny Burney, the writer and former lady-in-waiting to Queen Charlotte, was told by her family to discontinue her visits in case they compromised her reputation; and she acquiesced, in spite of the fact that she was a mature woman approaching forty and a published novelist – and had fallen in love with General D'Arblay. Happily for Fanny, she was able to marry her Frenchman, and indeed thrived on his appreciation of her creative gifts. The French ordered things differently.[11]

De Staël's legacy, then, either in life or fiction was not easily copied by women in English culture, but imitation can be selective, and Mme de Staël's life and writing could be variously interpreted. Corinne was too powerful and

dangerous a symbol for widespread acceptance, though her significance to English women poets has recently attracted consideration.[12] But for those who felt more comfortable with the 'prosaic' rather than the 'poetic' aspects of her legacy, de Staël offered a distinguished example in her non-fictional works, which were well received in England, of how women could contribute in genres such as biography and travel-writing to discussions of 'public', 'masculine' topics, without entirely sacrificing the 'proper' character of an English woman writer. Furthermore, even to conservatives, women had a crucial patriotic role, in harmony with their domestic nature, that of nurturing the young and transmitting the nation's customs, even if they were considered ineligible for citizenship. As Eastlake herself wrote, 'Woman, both immediately and ultimately, is [society]'s arbitress and lawgiver.'[13] Thus, by extension of their expertise in child-rearing and guardianship of custom, women writers could find public acceptance when they transformed their regional experience or patriotic sentiments into fiction, and by this means, as Gary Kelly has argued, pioneered the regional and national novel. De Staël, as both critic and novelist, was a preeminent example of how women contributed to the growth of cultural nationalism and the explanation of one culture to another in the nineteenth century. Meanwhile, in the more mundane form of cultural mediation, that of translation, women had an established place.[14]

 The full account of de Staël's iconic status for English women has not yet been written, but pending fuller researches, I want to take four examples of the 'Corinne Complex', by which women assumed the role of interpreters of their national culture, and who can be seen or who were seen at the time as operating within the de Staël tradition. They wrote on a variety of topics and in various genres – fiction, travel, biography, criticism and reviews, children's literature – but I shall concentrate only on their assumptions about gender, artistic genius, whether male or female, and national culture, whether English or foreign. The women I shall discuss were, significantly, often not from England but from the two Celtic kingdoms, a fact which sensitised them to the national dimensions of culture. The political context for their writing was the development of the nation-state in post-Napoleonic Europe, and Britain's own relationship with continental Europe and its Empire. These women addressed themselves directly or by implication to a number of related issues: to the English awareness that the country lagged behind compared with its Continental neighbours in establishing artistic institutions and supporting the arts; to the nature of English artistic genius; and to how women might express artistic genius (all questions posed within the broad cultural discourse of Romanticism). How did configurations of feminine identity intersect with both artistic and national identities? How to reconcile gender, genius and national character?[15] Mme de Staël had only rec-

onciled these demands in her fiction by making Corinne abandon England; but her stance as a critic of Napoleon suggested that the arts flourished best in a liberal state which nurtured but did not dictate its national culture.

Corinne appeared the year after Sydney Owenson, later Lady Morgan, had scored a literary success with her best-selling novel, *The Wild Irish Girl*. Comparisons were inevitably made between the two heroines, the one an improvisatrice, poet, artist, actress and embodiment of Italian culture, the other a harpist, singer of old Irish lays and ardent patriot preserving a derided and almost dying culture. Owenson, daughter of an Irish actor-manager, was dubbed 'the Irish Corinne', although the two stories were written quite independently. Both writers projected themselves subsequently as their fictional personas, with de Staël at her conversazione at Coppet costumed to recall Domenichino's Sibyl, and Owenson dining out in London in the picturesque Irish costume she ascribed to her heroine, Glorvina. Owenson was also dubbed the Irish de Staël.[16]

However, although she remained strongly identified with a kind of Irish nationalism, Owenson did not restrict herself to Irish culture, but included Italian, Greek and Polish patriots in her fiction, and wrote well-received travel books on France and Italy. Here I want to concentrate on a later novel, written in 1835. In *The Princess* she created another variant on Corinne: the Belgian artist, liberal patriot and feminist, Marguerite. Planned as a straightforward travel book, Morgan fictionalised her material when she heard that Frances Trollope, already famous for her account of America, was publishing on Belgium ahead of her. Like much popular fiction, its relative lack of literary merit means its programme is more easily discernible.

The novel is set partly in 'silver-fork' territory, with an anti-hero, Sir Frederick Mottram, an MP associated with the Tories but with leanings toward reform, who moves in snobbish high society. Mottram's silly fashionable wife, from whom he becomes progressively estranged, and her shallow empty-headed friends are the target of some of the most biting satire in the book. The other territory in the novel is Belgium itself – its history, culture and contemporary institutions. The country is really the heroine of the story, which celebrates the 1830 Revolution and the consequent building of a new, nation-state with a liberal constitutional monarchy supported by the people, the intelligentsia and the artistic community. This new nation-state had been constituted with British diplomatic support – but not out of any deep love of Flemish culture, rather because of traditional strategic concerns over the stability of the Low Countries.

Marguerite is an artist and the kind of lay-sister known in the Netherlands as a Béguine. The reader soon guesses that three different female figures who all contribute to Mottram's education and spiritual awakening are the same:

Marguerite; another, more matronly, Béguine, Flemish-speaking Sœur Greite; and the haughty Princess de Schauffenhausen, supposedly the widow of a Count of the Holy Roman Empire, a woman with impeccably legitimist views who allegedly poisoned her husband. It takes Mottram a lot longer to make the connections; moreover, by the middle of volume three it emerges that Marguerite is also Mottram's poor cousin, with Irish and Polish parentage. Brought up by the Belgian Béguines on being orphaned, nature and nurture make her the embodiment of several kinds of liberal nationalist aspirations. Furthermore, before the novel opens she and Frederick had been sweethearts, but their romance was thwarted by the worldly considerations of Frederick's mother. Frederick is thus singularly obtuse: but the novel's plot conventions have to be read in the spirit of Maria Edgeworth's verdict of: 'exceeding amusing, both in its merits and its absurdities – that harlequin princess . . . wonderfully clever and preposterous – a Belgian Corinne. But we must grant a romantic writer a few impossibilities.'[17]

Romantic im/plausibility aside, Mottram's inability to recognise Marguerite, whether from his past or in her present guises, is symptomatic of a fundamental inability to 'see' women in any other light than predatory schemers or easy conquests, the result of his false education and the unmeritocratic values of *ancien régime* England:

> The false institutes of British society, which make wealth and rank the primary points of parental speculation . . . and consider genius, intellect, grace and beauty as matters of suspicion and avoidance, had placed the son of the plebeian Mottram as much within the go-cart of aristocratic prejudice, as if his veins had been filled with 'all the blood of the Howards' . . . He had been taught to believe that the motherhood of Great Britain was in a conspiracy to entrap, and the unportioned daughterhood to seduce him[18]

The remedy for Frederick is to 'look to regenerated Europe, throw away the spectacles of faction, cleanse off the filth of party, break the thralldom of fashion . . . Go forth to the world a man.'[19]

When Marguerite speaks to Mottram as an advocate of her country, she is appropriating an essentially public role, one that steps beyond the private sphere. In her admiring descriptions of Belgian liberal politics, Morgan nowhere suggests that the new constitution should enfranchise women: but if women are not yet full citizens, they *are* patriots. In all the historical set-pieces depicting the revolution women are represented as participants in public actions as well as performing 'feminine' tasks such as succouring the wounded.

As an artist, Marguerite is a history painter, celebrating these recent stirring events, as well as being a portraitist and conservator of Flemish antiquities. When Mottram visits her atelier in Brussels, he sees her partly complete paint-

ing of the Four Glorious Days of the Revolution. This episode was apparently inspired by the visit Morgan made to the studio of an actual woman artist, Fanny Corr, about whom I have so far ascertained nothing further than this tantalising reference.[20] Morgan's decision to use a female rather than a male character to embody the national spirit of the new Belgium may of course have been inspired by Corr's patriotic art, but it also significantly suggests how equal women may be with men in the new bourgeois nation-state, and provides her female readers with a role model. It may also reflect Morgan's feelings about her experience of aristocratic patronage, for she had earlier in her career been a kind of pet writer-in-residence in an Anglo-Irish aristocratic family of the old style. As her biographer suggests, this undoubtedly galled her independent spirit, even while it provided a useful springboard for her debut as a best selling novelist.

Mottram consistently fails to 'see' Marguerite's true character and outlook, and misinterprets what he does know. Told that she has been a protégée of the late Prince de Schaffenhausen and that his wife befriended her, he assumes this must mean that Marguerite has been the Prince's mistress and that the Princess condoned it. When he admits to Marguerite that he loves her, he can only presume that she will still be in need of 'protection' and that she is expecting to be kept as a woman as well as an artist. But part of the reformed Europe he needs to 'see' and comprehend includes a new role for the arts: 'These are not times in which power seeks assistance from the arts to seduce and deceive the senses. They are no longer instruments of Church and Statecraft and their encouragement depends only on individual taste.'[21] Frederick has to learn that Marguerite is an artist in her own terms, patronised by those who genuinely share her values and love her adopted country. In the world of new nationhood men and women alike will be negotiating new identities. Quite the best touch in the novel is the scene where Frederick (now separated), proposes: Marguerite replies, 'I belong to a propaganda, that of the age we live in; and I cannot share my mission with less noble objects'.[22] Morgan's novel does not have the depth and psychological penetration of de Staël's *Corinne*, but in its more light-hearted way it imagines a world where women are not beholden to men – for work, security, love – but choose freely. Marguerite has a public dimension to consider as an artist in a newly free nation, and cannot allow emotional entanglements to compromise her ideals. But the reader knows her heart is not broken.

Lady Morgan wrote as an art critic and historian as well as a novelist. She contributed to the rediscovery of the 'Primitive' masters, and included an appreciation of Memmling in *The Princess* which was in the vanguard of English or even Continental taste. She also wrote a biography of Salvator Rosa, already highly regarded and well-represented in English collections. Morgan makes him into a liberal ahead of his time, anticipating Italy's struggle for liberty from

foreign oppressors, as well as a many-sided genius – artist, poet, actor, com-
poser: 'he stood in the foreground of his times, like one of his own spirited and
graceful figures, when all around him was timid mannerism and grovelling sub-
serviency'. Moreover, her version of his life was at variance with the received
portrayal of him in the Vatican-approved Italian Parnassus, in which he figured
as a disreputable character. Her book was therefore correctly construed by the
Vatican as supporting liberalism and was banned, as her earlier book on Italy,
which was outspokenly anti-Austrian, anti-Spanish and anti-Papal, had been.
Morgan thus copied de Staël's use of cultural criticism for political ends. For the
latter, the target had been Napoleonic tyranny; for the former, it was the reac-
tionary powers restored after 1815, inhibiting the drive toward Italian nation-
hood.[23]

Morgan's novel and biography can both be seen as critical of *ancien régime*
patterns of cultural patronage, against which women as well as men needed to
construct a new relationship with their national audiences. A similar view of the
artist's role in the liberal state belonged to Maria Graham (later Lady Callcott
after her second marriage to the painter Augustus Wall Callcott).[24] Yet at first
glance Graham and her writing may seem a far cry from the romantic extrava-
gances of the Corinne complex.

Her biography of Poussin, published in 1820, makes him into the perfect
nineteenth-century gentlemanly professional, rather than into a Bohemian free
spirit.[25] It was written, she said, to give hope to modern artists lamenting the
lack of state patronage. Poussin should encourage them because he succeeded
with grandeur of thought and design on a small scale, working for 'gentlemen'
who loved his art; his only experience of French patronage had been short-lived
and unsatisfactory. He was a hard-working professional who understood human
nature, as well as having the historical and cultural grounding necessary for his
religious and mythological history paintings. Graham denied that art flourished
best under state patronage from absolute rulers, stressing, good Whig that she
was, that art begins with a free Greece, and that the best Florentine art was
created when Florence was still a republic. She also has robust things to say
about England's inferiority complex toward the Continent: 'No Englishman
could submit to the absolute control of any individual patron; and the
consciousness that he and his work are absolutely free, and only subject to
general opinion, not private and arbitrary authority, ought to be taken as a priv-
ilege.[26] We are not far here from Morgan's insistence on meritocracy within a
modern, liberal society, despite their contrasting views as to the actual charac-
ter of the artist. Graham's criticism of French absolutism also aligns her with de
Staël's liberal rejection of the Napoleonic state, for the 'arbitrary authority'
Graham deplores had its recent as well as its seventeenth-century manifestations.

There are other similarities with de Staël's outlook implicit in Graham's work. *Corinne*, as we have seen, had dramatised the contrast between the stultifying proprieties of English country life and the liberating ambience of Italy. But the fictional Corinne had reflected that she would have found life less stiflingly dull had she lived in Edinburgh. This was the novelist's tribute to the intellectual brilliance of the 'Athens of the North' and to her friends among the writers and founders of the leading liberal periodical, *The Edinburgh Review*, and their Whig associates in London – men like Sydney Smith or James Mackintosh. Just as de Staël was indebted to the Scottish intellectual tradition, so was Maria Graham.[27]

She was from a younger and poorer branch of the distinguished Dundas family, typical of the Scottish gentry and professionals who had done well out of the Union. Her governess in England had known the Burneys, Reynolds and Johnson; her doctor uncle, physician to George III, was a friend of Thomas Lawrence and Samuel Rogers, the Unitarian banker-poet and art-patron. Dogged intermittently by tuberculosis, Graham turned this to advantage by teaching herself classical languages and reading the historian Gibbon while lying on her sofa. Her curiosity and intellectual capacity earnt her the sobriquet 'metaphysics in muslin' when she lived for a time in Edinburgh and moved socially in circles including Dugald Stewart, the influential moral philosopher and teacher. Given that many young men resided with their tutors, their learning experience was as much the informal one of the soirée as the formal one of the lecture room; Graham's opportunities for intellectual discussion were therefore less different from a young man's than women's formal exclusion from university might suggest. Academics like Stewart took her intellectual curiosity seriously and discussed her reading with her. Her Scottish roots, therefore, opened doors for her in ways less easily available perhaps to her English counterparts.

Both *Corinne* and *The Princess* suggested that an artistic woman was not easily partnered – at any rate, not by a well-born Englishman. In this regard, it is significant that Barbara Leigh Smith and Bessie Rayner Parkes, leaders of the Langham Place feminists as well as artistic women, both married Frenchmen. But life does not always imitate fiction, and Graham's suggests that there were congenial opportunities for companionate marriage and broadened horizons possible for some women within the professional and upper middle classes of early Victorian England.

At the age of twenty-four Graham travelled with her father to India, meeting on board the young lieutenant she was to marry on arrival. Her account of India (where the Grahams knew de Staël's friend James Mackintosh) was written in the tradition of Montesquieu and Scottish political economy, and published with her

own illustrations in 1812. It is notable for its attempt to understand the cultural
context of Indian antiquities in their own terms. Later, Graham helped to contrib-
ute to the new appreciation for the early Italian masters by writing a description
of the Giotto frescoes at the Arena chapel, Padua, only rescued from demolition
through Napoleon's personal intervention and still in a sad state of repair; in this
she paralleled Morgan's developing an appreciation for the Flemish
'Primitives'.[28] The German art scholar Passavant paid particular tribute to her
standing as a writer on art during his visit to England in 1833.[29]

Unlike Morgan, Graham did not address herself specifically to the role of
women as artists in the liberal state. It could be argued that in her representa-
tion of the artist as gentlemanly professional she was projecting a distinctively
masculine role, since women found it impossible to gain precisely those profes-
sional credentials – such as membership of the Royal Academy and routine
access to exhibition space – which the early Victorian male artist was keen to
secure as a means of insisting on the respectability of the profession, and of
effecting a definitive separation from lingering associations with artisanal trade.
On the other hand if the artist, male or female, was just another professional
and not a troubled Romantic genius, it was a lot easier to envisage women being
able to aspire to equal participation alongside men: hence the significance of
mid-Victorian attempts to secure entry to the Royal Academy.

Just as Graham, then, in her life and her work aligned herself with the mer-
itocratic ideal of the Victorian professional, so in the next generation, women
such as Barbara Bodichon, Louisa Herford, and Anna Mary Howitt were active
in the campaign to attain the kind of professional status for women artists as had
been achieved to a greater degree for writers. They wanted to move away from
Corinne, the lone genius who lived according to her own rules, and to work col-
lectively with other women, and with sympathetic men, to integrate themselves
within the Victorian art world. Howitt's fable, 'Sisters in Art', idealised this type
of co-operation, and envisaged an essential unity between the fine and applied
arts as well. Since women had conventionally been assigned to the decorative
arts as lady amateurs, or, if they came from a lower middle-class background, to
paid work in the design industries, to propose a unified strategy for the fine and
applied arts was another way of overcoming restrictions imposed on women and
dignifying their work. Howitt's three heroines include a figure named Lizzie
(echoing perhaps Lizzie Siddal), the daughter of a poor tailor, who is sent to a
school of design and then works alongside the more clearly middle-class Alice
and Esther on design projects, 'a formula of art especially [woman's] own'.[30]

Nonetheless, for Howitt the pull of Romantic nationalism which Corinne
embodied remained strong. For her the artist was not merely a professional, but
the bearer of the nation's ideals: an ambitious goal even for a man, for which

artists such as Watts and Leighton struggled throughout their careers, with more ostensible success than Howitt. Both men experienced the strain of their ambitions, but for Howitt, gender was an additional burden, and as Jan Marsh discusses, the scale of her ardent, idealistic aspirations led to a disastrous loss of confidence when Ruskin imposed his estimate of the proper scope for a woman artist upon her. I would also like to explore the nationalist dimension to Howitt's vision – and vision is not too strong a word – of the artist's role, a vision which emerges clearly in her travel writing on Bavarian culture. Howitt, it seems to me, was struggling against some of the limitations placed by English tradition on the arts, as well as trying to articulate how women could be artists.

It was probably inevitable that Anna Mary Howitt would have developed an interest in the general question of national culture, and that, as the daughter of Quaker parents and the beneficiary of their companionate, egalitarian marriage, she would wish to explore the nature of women and national culture as well. Howitt's father, William, was an enthusiast and populariser both of Romanticism and of Englishness, who felt privileged to be acquainted with Wordsworth, although as a radical he was not an uncritical patriot.[31] His books, such as *The Rural Life of England* (1838) and *Visits to Remarkable Places* (1840, 1842), celebrate the English landscape and its influence on English poetry.[32]

The Howitts were internationalists as well as English patriots. They were significant cultural mediators, jointly writing the comprehensive *The Literature and Romance of Northern Europe* (1852) on Scandinavian literature, while Mary translated Hans Christian Andersen and the Swedish feminist novelist, Frederika Bremer. They were thus following directly in the pioneering discussions of de Staël on German and Scandinavian culture in *On Germany*, though in their case the influence can be most clearly demonstrated through their friendship with Anna Jameson, and her emulation of de Staël's explorations of Germany. The Howitts' cultural nationalism equipped their daughter well to write her successful and attractive account of mid-century Munich. She had first encountered this lively cultural centre as an impressionable adolescent, when, armed with introductions from Jameson, the whole family spent three years in Germany to benefit from its cheaper educational facilities. (Their time provided copy for several books on Germany by William.)

The extent to which Howitt represented the artist as both devotee of art and interpreter of national tradition is clearly evident in her account of her lengthy stay in Munich ten years after this first inspirational visit, *An Art Student in Munich*.[33] Her book is explicitly a feminine account of her experiences and her delight in Munich as an art-city. As we have seen, the genre of 'Lady traveller' enabled women to move into 'masculine' territory, and to investigate other cultures in ways that would now be described as anthropological, or even in ways

that constituted a critique of the native realm. But Howitt disavowed the critical spirit of a Frances Trollope or Sydney Owenson and aligned herself at the
most 'feminine' end of the spectrum, reinforcing the identity between femininity, beauty, and virtue:

> Should some readers . . . cavil at what may see a certain couleur-de-rose medium
> through which all objects seem to have been viewed, the writer would simply reply,
> that to her it appears more graceful for a student of art to present herself in public
> as the chronicler of the deep emotions of joy and admiration called forth in her
> soul by great works of imagination, than as the chronicler of what in her eyes may
> have appeared defects and shortcomings.[34]

She celebrates Bavarian national culture: its fine art and architecture,
encouraged by Kings Ludwig I and Maximilian I, who had developed the cultural infrastructure of public museums and galleries and built new churches and
monuments; its religious art, including the rituals and customs associated with
the Christian calendar; and its folk tradition. Howitt was peculiarly fortunate in
her timing: among other events, she was present when the statue representing
Bavaria was consecrated during the 1850 Oktober-fest, and her visit coincided
with the ten-year cycle of the Oberammergau Passion play.

Her account also reflects the family interest in the unity of fine art and
design. The Howitts know Henry Cole, and Howitt was at this time engaged to
his assistant, Edward Bateman. They were all interested in design reform and
the role of the 1851 Great Exhibition in promoting this; Anna interrupted her
Munich idyll in order to visit it. This constellation of interests surely led to her
approving description of how Bavarian artists treat craftsmen as comrades (as
when Kaulbach stands side by side with Ferdinand Miller the foundry master,
when casting Schwanthaler's monumental Sieges-Thor) and are willing to link
art and decoration. Kaulbach designs draperies for an authentic production of
Antigone, and at the artists' ball 'everything is so genuine, so exquisitely beautiful and appropriate in the costumes, so thoroughly artistic, that the groups seem
groups not of maskers, but of beings summoned by an enchanter's spell from
far-off regions and long-departed ages.'[35] Evidently Bavarians lived artistically
at every level. But England was to remain ambivalent about the official structures appropriate for training people to work in the design industries, leaving
visionaries such as Morris to follow their reforming goals for art (or society) on
their own initiative. And although designers like Morris or Christopher Dresser
were to prove extraordinarily versatile, they did not unite the fine and the
applied arts as Schinkel had done in Prussia or the artists of the Viennese
Secession were later to do. The English tradition of separating the fine from the
applied arts was not conducive to this, any more than it was hospitable to
making design a central element to manufacture, as Owen and his circle wanted,

although of course several Pre-Raphaelite artists designed for Morris' firm.[36] Her delight in the way the arts permeated Bavarian culture, and the Bavarians' appreciation of this, implies an ideal the English might well emulate, and perhaps too a frustration with the English way of managing – or failing to manage – art training and patronage, talent and national genius.

As well as admiring Bavaria's national culture, Howitt's book articulates her exalted conception of art and the artist, who should be inspired by both imagination and piety; Kaulbach's studio, where she and Jane Benham had been allowed space to paint and receive occasional criticism from him, was specifically likened to a temple of art, with its owner as high priest. But his œuvre stems from a masculine mind that is nonetheless tender: 'is not that the great and difficult work which we are all striving after, whether in life or in art? Is it not that glorious union, in its perfection, which we adore in Christ?' It seems that mid-Victorian culture, heir alike to evangelicalism and to Romanticism's redefinition of sensibility, accommodated ideals of masculinity whereby men can shed manly tears and express 'feminine' emotions. But as Battersby has shown, ideals of male artistic genius which include and even emphasise the feminine, tend to be asymmetrical: they do not always enable women to appropriate masculinity.[37]

Howitt clearly struggled with the fact that most past artistic achievement was masculine, while taking encouragement from the presence of Old Mistresses in Munich collections. Her view of the artist as a priest may have added to her psychological burdens, given that while women were expected to be pious, men alone were priests. (Like her parents Howitt moved from Quakerism with its lay and egalitarian religious structure.) de Staël's Corinne, by contrast, was identified with the figure of Sibyl, a mouthpiece of the gods and a pagan priestess.[38] Howitt seems unable to imagine any kind of equivalent priest-like role for her modern woman artist; instead she tried to articulate a view of woman not as a chosen prophetess, but as standing humbly alongside men in the joint effort to be the interpreter and reproducer of the work of the Divine Artist, while retaining her essential femininity. Breaking out of the constrictions of the private, lady-like sphere should not lead to women aping men:

> let us bare our souls to God's sunshine of truth and love; . . . and the paltry high heels and whalebone supports of mere drawing-room conventionality and young ladyhood withering up, we shall stand in humility before God, but proudly and rejoicingly at the side of man! Different always, but not less noble, less richly endowed![39]

One cannot help wishing for Howitt that she had been able to identify with the artistic self-confidence of the fictional Corinne, as she had with the Romantic nationalism that was a part of the Corinne complex, instead of trying to adapt it to her ideals of collaborative sisterly endeavour, which retained ele-

ments of deference to male genius. Certainly Howitt's vision of the extensive role art could play in a national state which cherished its traditions while developing new ones implied a contrast with England's less concerted cultural policies. If she was swimming against the tide as a woman, she was also perhaps hindered by being an English woman, who felt a lack of national encouragement for the arts.

Another possible source of strain for Howitt was that, although the Howitt family gave Anna Mary every encouragement, their Quaker background and Nottinghamshire roots gave them no traditions of artistic achievement and appreciation on which to build. This contrasts with Unitarian families such as the Leigh Smiths whom Hirsch discusses, who were not only collectors but linked to Norwich, a city with a strong art culture. This is also a context for understanding Elizabeth Eastlake's cultural self-confidence. She was related to the Unitarian interconnecting families of Norwich such as the Martineaus and Taylors, though her family had become Anglican. But she became an adoptive Scot, finding Edinburgh a congenial place to settle for its cultural ambience after some years spent in Heidelberg with her mother, improving her health and acquiring excellent German. de Staël would surely have understood this choice! In Scotland Eastlake began reviewing for the *Quarterly Review*, at the suggestion of the publisher John Murray, who had published her account of travels to Estonia, in which she discussed manners, morals, culture and politics in the tradition of de Staël.[40]

But for Eastlake, neither art nor artists have to fulfil the role of the moralist, or the priest or the maker of national symbols. Her view that the arts have their own language approaches aestheticism; by extension, then, the artist becomes an amoral figure, whose personality or character may not be wholly admirable, however remarkable the art. In her review of *Modern Painters* she takes issue with Ruskin's belief in the moral purposes of art: the language of painting is not, she asserts, valuable only as a vehicle of thought. What exalts a picture is not its theme but the painter's treatment of it. The painter works with colour, form, light and shade, expression – this is its language; and the greatest art expresses a single idea, not a great number of ideas. 'What Ruskin means by incident is the incident that will bear description, expatiation, and speculation – the incident that will furnish a test for those arbitrary interpretations and egotistical rhapsodies so foreign to the real simplicity of art, which fill Mr. Ruskin's book'. Art cannot bear the burden of religious instruction: 'neither art nor nature herself has ever really taught a man to fear God, love his neighbours, and correct himself'. Nor has art had an elevating effect on Ruskin himself:

> where throughout his writings, do we find one spark of that love for man, woman or child which is foremost among all the precepts and the fruits of religion and

> morality? . . . Mr. Ruskin's intellectual powers are of the most brilliant description;
> but there is, we aver, not one single great moral quality in their application . . . Mr.
> Ruskin's writings have all the qualities of premature old age – its coldness, callous-
> ness and contraction.[41]

Knowing just how callous Ruskin had been to Howitt, the modern reader
cannot but be relieved to find a female reviewer (writing of course anonymously,
following reviewing convention) being so dismissive of him.

The artist may have the skills of his profession, then, but good artists might
not be good men. Despite her considerable knowledge of German culture and
her role as a translator of German connoisseurship, she was not an uncritical
admirer of contemporary German trends. Of the Dusseldorf school of historical
painters, adherents, like Kaulbach, of Nazarene ideals of brotherhood, piety, and
religious art, she writes:

> four or five artists work together on one picture like brethren, and nestle two
> together in one atelier like doves, and praise and admire indiscriminately all each
> other's performances . . . It is true, too, that they make most excellent husbands and
> that their wives knit them the best possible stockings in return; but if the
> Dusseldorf style of picture be the especial result of all these Christian virtues oper-
> ating in conjunction with the arts, we must say, give us a little more vice![42]

Plainly there is an immense gulf between this astringent urbanity and Anna
Mary Howitt's reverent romantic nationalism. And if Eastlake could suggest
that the moral and aesthetic estimate of an artist need not coincide, it is not sur-
prising that she could find space for such a generous estimate of Mme de Staël,
whose personal life, like that of Corinne's, might not withstand Victorian moral
scrutiny. Even though she did not share all of de Staël's ideas on national
genius, however, she had set a standard against which all other female achieve-
ment could be measured. It is significant that in her memoir of Harriet Grote,
a co-founder of the Society of Female Artists as well as an associate of Langham
Place feminism, Eastlake characterised her friend's intellectual stature not in
relation to any English women, but in comparison with two Frenchwomen –
Mme de Sévigné and Mme de Staël. It is almost as if, paradoxically, Eastlake
could only celebrate the achievements of an intelligent Englishwoman if she
could be assimilated imaginatively into the French tradition. Yet de Staël was
also an acceptable heroine to Victorian liberals, if only for her hostility to
Napoleon – which prefigured Anglo-French liberal dislike of Napoleon III. The
Corinne Complex was, perhaps, part of the broader English struggle to nego-
tiate a relationship with European culture that English woman – and men –
have by no means finished resolving, as well as a framework within which
women could examine the connections between gender, genius and national
culture.[43]

Acknowledgements

I should like to express my thanks to Dr Theodora Zemek, for introducing me to the phrase 'The Corinne Complex' as well as for her grasp of Mme de Staël's stature; and to Dr Felicia Gordon, Dr Jan Marsh, and Dr Jane Rendall, for their helpful comments on earlier drafts of this essay.

Notes

1 'Mme de Staël: A Study of her Life and Times', *Quarterly Review*, 152 (July 1881), 1–49.

2 For Eastlake and her role see John Steegman, *Victorian Taste* (repr. London, Century Hutchinson, 1986), and David Robertson, *Sir Charles Eastlake and the Victorian Art World* (Princeton, Princeton University Press, 1978): for de Staël, J. Christopher Herold, *Mistress to an Age* (London, Hamish Hamilton, 1959).

3 Clara Thomas, *Love and Work Enough* (London, Macdonald, 1967), esp. ch. 4, 7 and 9.

4 Gordon Waterfield, *Layard of Nineveh* (London, John Murray, 1963), p. 184.

5 *France* (London, 1818), vol. ii, pp. 383–4.

6 See Gary Kelly, *Women, Writing and Revolution* (Oxford, Oxford University Press, 1993).

7 Mary Shelley's planned biography is discussed by Emily Sunstein, *Mary Shelley: Romance and Reality* (Boston, Little Brown, 1989). Mary Shelley's sanitised account was in *Eminent Literary and Scientific Men [sic] of France* (2 vols, London 1838–39), in *Lardner's Cabinet of Biography* series. cf. Maria Norris, who in her *Life and Times of Mme de Staël* (London, 1853), explicitly exonerated her subject from impropriety: 'Mme. de Staël was, we believe, as innocent as Queen Charlotte herself, but she would be probably much more demonstrative in love and friendship,' p. 177. The sketch by Albertine Necker de Saussure appeared in the first collected edition of Mme de Staël's writings in 1820. See also Robert C. Whitford, *Mme de Staël's literary reputation in England*, University of Illinois Studies in Language and Literature, vol. iv (Urbana, 1918), no. 1. For a comparison with another daring Frenchwoman's reception in England, see Patricia Thomson, *George Sand the Victorians* (London, Macmillan, 1977).

8 See my essay, 'Romanticism in Switzerland', by Roy Porter and Mikuláš Teich (eds.), *The Romantic Movement in National Context*, (Cambridge, Cambridge University Press, 1988).

9 *Corinne, Or Italy*, first published in France in 1807. For a splendid interpretation of the novel, see Madelyn Gutwirth, *Mme de Staël as novelist: the emergence of the artist as woman* (London, University of Illinois Press, 1978). On Corinne as heroine, see Ellen Moers, *Literary Women* (London, The Woman's Press, 1978). Cora Kaplan's Introduction to Elizabeth Barrett Browning's *Aurora Leigh, with other poems* (London, The Woman's Press, 1978), helpfully explores its debt to *Corinne* and the way it opposes Italy and England as cultures which respectively empower or inhibit female creativity. John Prebble, *The Mediterranean Passion* (Oxford, Oxford University Press, 1988), puts the English love affair with the Mediterranean world into a wide context.

10 Cited by Roy Porter, *English Society in the Eighteenth Century* (Harmondsworth, Penguin, 1982), p. 36.

11 See Linda Kelly, *Juniper Hall, An English Refuge from the French Revolution* (London, Weidenfeld and Nicolson, 1991).

12 See Jan Marsh's essay in this collection; also Angela Leighton, *Victorian Women Poets: Writing against the Heart* (London, Harvest Wheatsheaf, 1992); and Susan P. Casteras and Linda H. Peterson (eds), *A Struggle for Fame: Victorian Women Artists and Authors* (New Haven, Yale Centre for British Art, 1994), esp. pp. 38–9, which discusses how Corinne's symbol of the laurel crown is included in book designs for poems by L. E. L. and Elizabeth Barrett Browning.

13 *A Residence on the Shores of the Baltic* (London, 1841), p. 233. Two of Eastlake's sisters married into the Baltic German nobility; hence her visit.

14 For a stimulating account of the cultural revolution associated with Romanticism and women's role within it, see Kelly, *Women, Writing and Revolution* esp. pp. 178, 184–91. Linda Colley's *Britons: Forging the Nation 1707–1837* (New Haven and London, Yale University Press, 1990), pp. 273–87, evaluates women and patriotism in England. The large Victorian translation industry has been better studied for German–English than other languages: see Rosemary Ashton, *The German Idea: Four German Writers and the Reception of German Thought, 1800–1860* (Cambridge, Cambridge University Press, 1980); and Lotte and Joseph Hamburger, *Troubled Lives: John and Sarah Austin* (Toronto, University of Toronto Press, 1985).

15 On nationalism and Romanticism, see also Eric Hobsbawm, *Nations and Nationalism since 1780: programme, myth, reality* (Cambridge, Cambridge University Press, 1990), and J. L. Talmon, *Romanticism and Revolt: Europe 1815–1848* (London, Thames and Hudson, 1967).

16 See Gutwirth, *Mme de Staël as novelist*, note 9; all information on Lady Morgan's life is from Mary Campbell, *Lady Morgan: The Life and Times of Sydney Owenson* (London, Pandora Press, 1988). Margaret Maison notes the de Staël comparison in her entry on Morgan in Janet Todd (ed.), *Dictionary of British Women Writers* (London, Routledge, 1989).

17 Quoted by Campbell, *Lady Morgan*, p. 222.

18 *The Princess* (London, 3 volumes, 1835), vol. iii, p. 196–7.

19 *Ibid.*, vol. i, p. 181.

20 Lady Morgan, *Autobiography, Diaries and Correspondence*, 2 vols (London, 1862), vol. ii.

21 *The Princess*, vol. i, p. 133.

22 *Ibid.*, vol iii, p. 379.

23 Lady Morgan, *The Life and Times of Salvator Rosa* 2 vols. (London, 1824); *Italy*, 2 vols. (London, 1821); Michael Kitson (ed.), *Salvator Rosa* (London, Arts Council, 1973). But Morgan's portrait of the archetypically Bohemian/Romantic artist is not without historical foundation; the most recent British exhibition devoted to Rosa confirmed him to be a man unusually cavalier to patrons.

24 For biographical information see Rosamund Gotch, *Maria Callcott, the creator of 'Little Arthur'* (London, John Murray, 1937). Gotch was a descendant of Augustus Callcott with access to family papers.

25 *Memoirs of the Life of Poussin* (London, 1820).

26 *Ibid.*, pp. xiv–xv. The cultural taste of the Whigs is discussed by Leslie Mitchell, *Holland House* (London, Duckworth, 1980). Maria became a great friend of Caroline Fox, the invalid sister of the 3rd Lord Holland, in her latter years.

27 See discussion and references in my 'Romanticism in Switzerland'.

28 *Journal of a Residence in India* (Edinburgh, 1812); *A Description of Giotto's Chapel in Padua* (London, 1835). This was not Maria's first Italian visit. She had already published her account *Three Months passed in the Mountains East of Rome in 1819* (London, 1820), of a trip made with her first husband and Charles Eastlake, who illustrated it.

29 J. D. Passavant's *Tour of a German Artist in England*, 2 vols (London, 1836), was translated by Elizabeth Eastlake. Maria's life reminds one irresistibly of Admiral Croft and his intrepid wife in Jane Austen's *Persuasion*. Elizabeth Mavor (ed.), *The Captain's Wife: The South American Journals of Maria Graham* (London, Weidenfeld, 1993), provides a useful edited version of her various writings on South America, with commentary. Graham's other books include *A Short History of Spain*, 2 vols. (London, 1828), *Essays Toward the History of Painting* (London, 1836), and the bestselling children's history book, *Little Arthur's History of England* (1835) and many subsequent editions.

30 Published in *Illustrated Exhibitor and Magazine of Art*, 2 (1852).

31 Information on the Howitts is taken from Amice Lee, *Laurels and Rosemary: The Life of William and Mary Howitt* (London, Oxford University Press, 1955), and Carl Ray Woodring, *Victorian Samplers: William and Mary Howitt* (Lawrence, Kansas University Press, 1952).

32 Howitt believed English writers to be uniquely successful in modern literature in the depiction of the sublime and beautiful in nature. However, notwithstanding William Howitt's feminism, he does not read the history of English poetry as a story of women's, as well as men's, poetic depiction of the landscape, and the outstanding female exponent of this kind of verse, Felicia Hemans, who had also written a poem on Corinne, was not discussed in his books. For Hemans as female Romantic, see Anne K. Mellor, *Romanticism and Gender* (London, Routledge, 1993), esp. ch. 5.

33 Published in 2 vols. (London, 1853; repr. 1880).

34 Preface to *An Art Student in Munich*, p. vii.

35 *Ibid.*, pp. 189–90.

36 For the debate on design and education reform, see Quentin Bell, *The Schools of Design* (London, Routledge and Kegan Paul, 1963).

37 *An Art Student in Munich*, vol. ii, pp. 21, 38; see Christine Battersby, *Gender and genius: towards a feminist aesthetics* (London, Women's Press, 1989); Boyd Hilton, 'Manliness, masculinity and the mid-Victorian temperament' in Lawrence Goldman (ed.), *The Blind Victorian: Henry Fawcett and British Liberalism* (Cambridge, Cambridge University Press, 1989).

38 See Gutwirth, *Mme de Staël as novelist*, n. 9, for a discussion of de Staël's use of this imagery of the sibyl in her fiction and her self-presentation.

39 *An Art Student in Munich*, vol. ii, p. 199.

40 Eastlake, *A Residence on the Baltic*.

41 'Modern Painters', *Quarterly Review*, 98 (Mar. 1856), 384–433; see also her *Five Great Painters* (London, 1883) for her willingness to criticise Da Vinci and Raphael as men less noble than their art.

42 'Modern German Painters', *Quarterly Review*, 77 (Mar. 1846), 323–48.

43 Elizabeth Eastlake, *Mrs. Grote, A Memoir*, London, 1880. For further insights on the perceived contrasts between English and French culture and their bearing on the treatment of women, see Margaret Lesser (ed.), *Clarkey: A Portrait in Letters of Mary Clarke Mohl, 1793–1883* (Oxford, Oxford University Press, 1984). Mary Clarke was a Scots woman who originally settled in France for financial reasons, and who maintained the French salon tradition. She was a sympathetic friend to several English women striving to escape the repressions of English family life and ladyhood, including Barbara Bodichon's cousins Florence Nightingale and Hilary Bonham-Carter, who wanted to be a sculptress. The ennui Clarke experienced on her visits to the English gentry echoes that of Corinne.

Critically Speaking

Pamela Gerrish Nunn

I𝖭 the welter of articles, essays, reviews, comments and letters which appeared in print from the late 1850s on the general theme of women and art (fine and otherwise), the topic of women as art critics practically never occurred. Even in contributions to this subject which included writing in their use of the term 'art', poetry and novels – in short, literature – were the only forms usually considered. At the same time, the more thoughtful of such writings acknowledged the importance of art criticism and the art critic in the Victorian art world and, more precisely, their influence on the artistic achievements of women. F. T. Palgrave's essay 'Women and the Fine Arts', published in *MacMillan's Magazine* in 1865, is the most explicit case in point.[1] An extensive consideration of the theme, this two-part essay – the transcript of a lecture delivered in March 1865 to a select audience at the South Kensington Museum – contended that a crucial point in any discussion of women's achievements in the arts was the reception given to women's intellectual efforts when they were subjected to man's public or private scrutiny:

> Does she write poems or songs, paint or carve, study medicine or science? He declines to test her performance by the regular laws for these matters made and provided, and veils his instinctive contempt for female judgment or genius under a cloud of flattery, which is only one degree less offensive to a woman of spirit than the open scorn that at other times will show itself beneath his tinsel praises . . . [While t]he general laws of criticism, on these points, have been framed with reference to what men have done, and there are several particulars in which, to render them truly applicable to women, they must be modified . . . No compliment, on the other hand, is so gallant as the simple truth.

What he later terms 'want of honest criticism from . . . the unfair sex' is, according to Palgrave, one of the two principal 'hindrances to female success'.

There are reasons why women were as dependent on men's appraisal – of their art and of any other thing about them – as Palgrave implies. The ideology of femininity made women doubt their own judgment and seek men's opinion as not only advantageous but true, and, at the same time, women had a reputation – convincing to men and women alike – that was signally lacking in those qualities ostensibly necessary for the forming and expressing of judgment: reasoning power, objectivity, analytical ability, articulateness. That female judgment existed, as a phenomenon distinct from male opinion, was not disputed. For instance, William Michael Rossetti, noting the response to Millais' *Mariana*, a controversial exhibit in the relatively new Pre-Raphaelite style at the 1851 Royal Academy, observed that the painting appeared to be 'a great favourite with women'.[2] However, the status of female judgment was another matter. Men's proprietorial attitude to art criticism, that is to say their jealousy of the critical faculty and their claim to its practice, was often based on showing *women*'s opinion to lack knowledge, good sense, objectivity – in short, authority. William Frith made such an issue of women's criticism in his 1883 painting *Private View at the Royal Academy, 1881*. This was intended to satirise Aestheticism and mock Oscar Wilde, its chief proponent. Frith's principal point is made by surrounding Wilde with a crowd of female admirers, who are in turn offset by a wider cicle of men looking on in disbelief. The message, that anyone admired so readily by women must be known to men to be meretricious, would be self-evident to the patriarchal mind. In his subsequent account of the painting, the artist referred to 'the folly of listening to self-elected critics', 'a herd of eager worshippers', with 'willing ears'.[3] Demonstrating Simone de Beauvoir's now-famous comment that 'Men describe [things] from their own point of view, which they confuse with absolute truth',[4] this stance of course begs the question of whether men's opinions are any less subjective, but this was a question rarely given a public platform in the Victorian era itself.

Women's participation in the professional criticism of art was limited in nineteenth-century Britain also by the particular character of art, and by the habits of Victorian society. That is to say, art had a cultural status which, at its highest, presumed a level of education and experience which precious few women could claim. Additionally, in its most recognised forms – regular published commentary and the public lecture-art criticism existed in the public domain from which most women, whatever their class or age, were told by convention to shrink. This latter inhibition would apply even though much journalism was published anonymously, and could have been literally enforced by those in a position to allow or prevent public events.[5] Thus, though Claire

Richter Sherman and Adele M. Holcomb, in their groundbreaking anthology *Women as Interpreters of the Visual Arts 1820–1979*, declare, 'In the period 1820 to 1890 women writers made important contributions to art criticism and history',[6] none of the authors they name would have been defined by her contemporaries as an art critic.

However, art criticism was plentiful and influential in Victorian Britain. Its increase during the period echoed the burgeoning of art activity in the public and private domains, spurred largely by the growing commodification of works of art in the form of commercial goods, as well as the expansion of the press and publishing. Art – in fine and popular forms – became interesting to a wider variety of social groups as increasing industrialisation and urbanisation modified the class structure of British society. While there were several kinds of writing for publication which Victorian women practised successfully, and for which, indeed, they became and/or have remained well known, art criticism was emphatically not one. Thus the Victorian art critic's voice as a public noise can be generalised as a male voice, and those individual critics whose voices have been distinguished from the chorus by later generations – including John Ruskin, Philip Gilbert Hamerton, Frederic George Stephens, William Thackeray – were all men. In spite of this, and *pace* Palgrave, it must not be concluded that women did not function as art critics. Feminism has shown why women's activities in fields inharmonious with patriarchy's project will have been systematically distorted or hidden from subsequent generations. In fact, towards the end of the century several women did begin to function as art critics as men defined that term, but, in addition, many women thought and wrote about art throughout the Victorian era. To see them, though, we have to reappraise the term 'art criticism' and the figure of the art critic. Art criticism occurred in a multiplicity of forms and fora, of which the standard version – writer and/or public speaker expressing opinions in newspapers, periodicals, books and lectures – was only one. A picture of art criticism in Victorian Britain which seeks to include women will include additional models of art criticism and the art critic, so as to allow, for instance, Vernon Lee's novel *Miss Brown* (1984) to stand beside, say, Ruskin's *The Stones of Venice* (1851–3) or *The Times*' reviews of the annual exhibitions under the heading 'art criticism'.

To take one example, many women, through a personal interest in cultural matters, carried on a private discussion of art, such as is to be found in correspondence, memoirs, auto/biography and oral recollections. This was an important part of certain – educated, privileged – women's discourse, but falls outside the term 'art criticism' as patriarchally defined. Culture was a field assigned in some ways to women to mind, as part of their task of sweetening the world for men, and in other ways forbidden to women, as part of what was too difficult

and worldly for them to handle without men's mediation or management. Consequently, middle-class women were encouraged to develop taste rather than knowledge; and a tentative interest in fine art, music and poetry, content to stay on the amateur side of the fence, was a sign of desirable refinement.

Two such women were the Hill sisters, Emily (b. 1819) and Ellen (b. 1822), who liked to paint watercolours as a pastime and whose regular activities in their unmarried early middle age included European travel and the London exhibitions, plays and concerts.[7] While their criticism of the art they saw in museums and the art of their own day was formed by several influences, it was genuinely felt, not to say emphatic. At the 1859 Royal Academy, for instance, Ellen 'hated' Millais' exhibit *Apple Blossoms or Spring* – an opinion in which her sister concurred, declaring it 'inconceivably vile, ugly and out of drawing' – and at the Academy of 1867, she found Landseer's portrait of Queen Victoria 'absurd and disagreeable'. These are the alleged hallmarks of women's criticism: women, ran the typical contemporary dismissal of female opinion, were blinded rather than guided by their feelings, more or less ignorant and yet vehement in their judgments.[8] Certainly, the two women had an opinion on every cultural centre they visited, the major artistic questions of the year, the fashionable names of the moment and the many more run-of-the-mill exhibitors they viewed at the various shows. Of Pre-Raphaelitism, for instance, Emily observed in 1863 that it 'very often leads to a total forgetfulness of atmosphere and perspective, the perspective of tint if not of lines, so that the branches at some distance are painted and finished as minutely as if they were on the lawn just in front'.[9] Of Burne-Jones, not yet widely known in 1865, she commented, 'his drawing is false and bad very often, and there is no beauty or conception'.[10] That the Hills' opinions were neither original nor progressive is immaterial in recognising what these writings represent: they were being art critics, even if their judgments went no further than each other, the friends and relatives to whom they wrote, or the faithful pages of their diaries. While the conventionality of their views and the partiality they show to their friends, their tutor or his preferred artists may mark out their criticism as ridiculous and invalid in patriarchal terms, their obvious biases do not necessarily indicate a lack of self-awareness. When they visited Dublin in the summer of 1865, they paid a visit to Ireland's so-called Great Exhibition, and saw there the American sculptor Harriet Hosmer's *Sleeping Faun*. Emily wrote in her diary:

> She must have lost all feeling of womanly modesty, in choosing such a subject. It would really seem that she must have been actuated by a defiant feeling, as the slightest alteration of the leopard skin would have hidden all that is absolutely scandalous and made it comparatively innocent, besides to such prudish women as myself making it less disagreeable to look at."

Of the Hill sisters, it was the would-be artist Emily who exhibited a persistent energy for the criticism of art, and this commitment to art criticism is also to be found in women who had become artists, who were themselves contributing to the mass of material that was 'art'. The opinions of professional female artists have a different motivation from those of amateurs such as the Hills, and might be more informed, but would not necessarily be taken any more seriously by their contemporaries, since they issued from a female sensibility and, moreover, from rivals in the field. In the private expression of their opinions, however, female artists could exercise their professional judgment freely without recourse to strategy. The painter Emma Brownlow, an exhibitor since 1852, went on a working holiday to France in 1863 with her sister Elizabeth.[12] Their destination was Brittany but they stayed in Paris long enough for Emma to visit the Salon: 'To Exposition by carriage, from abt. 12 till past half past 4', she recorded in her diary for 9 June. 'Saw an immense number of pictures, good, bad and indifferent, also a great number of those which had been rejected by the jury, almost without exception to my mind with justice, including one (the only one that I saw by an English artist) by Whistler – it was more like a piece of bad whitewashing than anything else.'[13] When they returned some seven weeks later to Paris for the homeward journey, the Louvre and the Palais de Luxembourg drew Emma's attention. Of the latter she recorded: 'was much pleased with the paintings. There is a very nice Bonheur *Loading a Haycart* which pleased me much'.[14] The diary was, of course, a forum for art criticism in which the critic had complete freedom of expression. She was not accountable, and needed to consult no external frames of reference. She was not required to weigh up the consequences of her views, to have regard to the consistency of her judgments, to determine her language by its accessibility or acceptability.

There were other women writing about art at the time, similar to Brownlow in not being habitually recognised as art critics. They, however, took on the more complex task of putting their opinions before a public. Their reasons were various: in many cases, the motivating factor would have been just what it was to most male critics – the wish to earn a living. Rather than compete as taste-makers and opinion-formers, these women wrote manuals of instruction or advice, essays and anthologies about art of the past, biographies more anecdotal than scholarly. The *Art Journal*'s review pages testify to these women's industry, but also to their lack of reputation. Who now knows of Mrs Mary Philadelphia Merrifield, commissioned by the government in 1845 to research into early Italian art theories and practices and author of the resulting *Original Treatises on the arts of painting in Oil* (1849)? Of Maria Farquhar and her biographical catalogue of the principal Italian painters (1855)? Of Mrs Foster, whose translation of Vasari's *Lives* went into two editions in 1850–2, and 1867? Or of

Mary Constance Clarke, whose 'Oil Painting without a master' appeared in the magazine *Nature and Art* in 1866? Insofar as women's work was considered amateur or interim, their achievements were not likely to be widely acknowledged unless their names came before the public consistently and with the endorsement of men, whose power could shape and direct and whose authority would then define and categorise these activities through which women sought to reach beyond the domestic sphere. While the specific character of such writing has been a pretext for these women's exclusion from the roll-call of Victorian art critics, the tendency for their names to be excluded also from the record of Victorian art historians, or art writers in general, should give the feminist student of nineteenth-century Britain pause.

A handful of these women, however, were recognised by their contemporaries for their industry and learning even if they suffered as any other woman did from their judgments being trivialised. To some extent, Elizabeth, Lady Eastlake, Anna Jameson, Emilia Dilke and Alice Meynell were simply undeniable in an era when the role of woman and her intellectual, political, social and familial status were constantly under scrutiny. While class privilege played a part in their visibility, it is pleasant to be able to acknowledge their achievements in establishing some intellectual credibility for Victorian women.

Elizabeth Rigby (1809–93) was the fifth child of her physician father by his second wife.[15] Her family travelled in Continental Europe while she was young, and she became well informed about the history and culture of various countries, and conversant in their languages. She began a habit of sketching and painting which she retained throughout adult life. In 1838, this unusually cultured background was enhanced by a visit to her sisters in Russia. It seemed obvious, on her return, that her experiences cold interest many others, and she accordingly arranged her letters home for publication. *A Residence on the Shores of the Baltic Told in Letters* appeared in 1841, leading to a demand from her publisher John Murray for more. Her next writing appeared in Murray's periodical *The Quarterly Review:* its editor John Lockhart wrote to Elizabeth Rigby inviting her to contribute, 'You are the only lady, I believe, that ever wrote in it except Mrs Somerville . . . I had long felt and regretted the want of that knowledge of women and their concerns, which men can never attain, for the handling of numberless questions most interesting and most important to society.'[16] While review essays formed the principal part of her work in the *Quarterly*, she also began to publish stories elsewhere. The subjects of her regular contributions to the *Quarterly* ranged widely over the fields of culture, history, travel and politics, and it was only with her marriage in 1849 to the painter Charles Eastlake that art took on a certain prominence in her writings. Still, by 'art' should be understood not a narrow preoccupation with painting, but a deep and broad

concern with fine art, architecture, photography and questions of aesthetics. In 1850 she and her husband made a translation of the German critic Kugler's *Handbook of Italian Art*; in 1853 she made on her own a translation of Waagen's *Treasures of Art in Great Britain*; in 1855 she acted as travelling companion to the French painter Rosa Bonheur, who was visiting Britain as both a celebrity and a novelty, the first internationally famous female artist of modern times; in 1856 she helped her friend Mrs Harriet Grote to set up the Society of Female Artists, which became from its first exhibition in 1857 a focus of public debate about the role of women in art; in 1860 she began to edit Mrs Jameson's *History of Our Lord in Art*, left incomplete by its author's untimely death. A book of Elizabeth's own writing, *Fellowship: letters to my sister mourners* (1868), arose from the death of her husband in 1865, and this project was followed by another linked to his memory, a reissue of his 1848 publication *Contributions to the Literature of the Fine Arts* (1870) with a memoir by Elizabeth as his widow. In this same year her *Life of John Gibson, RA, Sculptor* was published, and she was also at this time revising Kugler's *Handbook* (reissued as a fourth edition in 1874 and 1884). In 1878 Harriet Grote died and, as one of her closest friends, Eastlake wrote a memoir, published in 1880. Her journalism was still her most regular writing, and, indeed, she remained a regular reviewer for the *Quarterly* until the year of her death. While her contributions to other periodicals had been sporadic, in the last years of her life she appeared in *Fraser's, Longman's, The Edinburgh Review* and *Murray's*.

Anna Murphy, later Jameson (1794–1860), began her adult life as a governess, and graduated from that situation of ambiguous social station to the position of woman of letters through a gradually accumulated literary achievement.[17] This started in 1926 with *Diary of an Ennuyée*, published anonymously, and continued in the popular vein of biographical anthology with *The Loves of the Poets* (1829), *Memoirs of Celebrated Female Sovereigns* (1831) and *Characteristics of Women* (1832). *Visits and Sketches at Home and Abroad* (1834) and *Winter Studies and Summer Rambles in Canada* (1838) resumed the autobiographical, anecdotal character of her first book, but thereafter her general interest in culture and in artistic questions in particular formed the chief matter of her writings for publication. An introduction to the English publication of G. F. Waagen's *Peter Paul Rubens* in 1840 was followed by a major work of artistic interest, scholarship and criticism, the two-part *Public Galleries* (1842) and *Companion to the Most Celebrated Private Galleries of Art in London* (1844). Between 1843 and 1845 Jameson saw forty-three essays on Italian painters of the past published in *The Penny Magazine* and then collected in a single volume, *Memoirs of the Early Italian Painters* (1845). While a project she had cherished since 1840 on female artists never came to fruition, Jameson combined her passion for the

subject of women's condition with that for fine art, already established publicly, in the collection *Memoirs and Essays illustrative of Art, Literature and Social Morals* (1846). Though her feminism became well known in London society during this decade and linked her with certain women's issues, such as the governess question and the survival of the female School of Art, it was her less controversial books of the last twelve years of her life that sealed Jameson's reputation. *The Poetry of Sacred and Legendary Art*, appearing first in serial form in *The Athenaeum*, was published in two volumes in 1848, followed by its natural extensions *Legends of the Monastic Orders* (1850), *Legends of the Madonna* (1852) and *The History of Our Lord* (published posthumously in 1864). Articles and essays could bear a more polemical tone, insofar as her livelihood perhaps depended less upon them, and her contributions during the 1850s to the *Art Journal, Edinburgh Review* and other periodicals espoused more suggestive views on art and, indeed, on women than her *magnum opus, Legends of The Madonna*. None of her writing on fine art was as explicitly feminist, however, as the pamphlets *Sisters of Charity* (1855) and *The Communion of Labour* (1856), deriving from the public lectures and women's meetings to which she gave increasing time and energy in this decade. Alice Oldcastle, writing in the *Magazine of Art* in 1879, reflected on Jameson's significance as a writer on art:

> Other writers on art have appealed to a class, but her clientele is found everywhere; and she was not so much the most popular writer upon a certain class of subjects as the originator of a new kind of art-teaching . . . All she wrote . . . was written out of the fulness of the heart, and her contemplation of the great works of the great schools was more intelligent than that of men in many ways more learned than she[18]

Emilia Strong, later Mrs Pattison, eventually Lady Dilke (1840–1904), developed, like Jameson, equal attachments to art and to women's equality [11]. While her biographer Betty Askwith may show the biographer's partisan opinion of her subject – 'Not only was she prominent in political life, not only was she one of the first women to interest herself in legislation by and on behalf of women, but she was one of the foremost art critics and art historians of her day'[19] – Emilia Dilke did become one of the most distinguished cultural commentators of the late Victorian period. As a young woman she studied art at the South Kensington Schools, becoming friendly with the Holland House set and its favourite painters G. F. Watts and Frederic Leighton by the time of her graduation in 1861. Her acquaintance with Ruskin and his friend Pauline Lady Trevelyan involved her in the decoration of the latter's home, Wallington Hall, in 1863, along with the Pre-Raphaelite artists Arthur Hughes and William Bell Scott. In this year Mrs Pattison, as she then was, began writing for publication, firstly in the *Saturday Review* and soon after in the *Westminster Review* and the

11] Lady Pauline Trevelyan and L. G. Loft, *Lady Emilia Frances Dilke*, c. 1864, oil on canvas, 25.4 × 18.1 cm.

Academy. While literary and art reviewing was her main preoccupation, by 1871 her taste had settled principally on the Renaissance and on French art. In 1873 she was invited to become art editor of the *Academy*, a position she took up at the expense of her *Westminster Review* column. Her contributions to the *Academy* expanded to include reviewing the Paris Salon, and in 1876 her platform expanded to include the *Athenaeum*. In 1879 she published her first book, *The Renaissance of Art in France*, which established the field in which the remainder of her book-writing would lie.

Emilia continued to find other outlets for her knowledge and opinions, however. From 1879 she contributed to the *Annual Register* and the *Encyclopaedia Britannica*, and from 1881 to the French periodical *L'Art*. In 1881 she wrote a critical biography of Frederic Leighton, published as one in a series of monographs of contemporary artists. Her published writing, where it was not anonymous, was signed E. F. Pattison until her second marriage in 1885 to the MP Charles Dilke. Thenceforth she used the form Lady Dilke, and it was as such that she published a monograph on Claude Lorrain in 1884; *Art in the Modern State* (1888); and a four-volume work on French art, *French Painters of the 18th Century* (1888), *French Architects and Sculptors of the 18th Century* (1890), *French Decoration and Furniture of the 18th Century* (1901) and *French Engravers and Draughtsmen of the 18th Century* (1902). While her commitment to women's political interests and her espousal of the trade union cause did not lead to any publications, it was as much for these radical affiliations as for her connoisseurship that she was known in the last twenty years of her life.

Alice (Thompson) Meynell (1847–1922) is now best known as a poet, but in her lifetime she was seen more generally as a woman of letters.[20] the child of cultured parents, her artistic interests embraced painting (her sister was the painter Elizabeth Thompson, later Lady Butler), architecture, the applied arts, literature and music. Her conversion to Catholicism in 1868 set the tone of her writing, which was always concerned with moral questions whatever its specific matter. She began to write poetry in 1867 and saw her first publication in the collection *Preludes* (1875), illustrated by her sister, who had made her name the year before with her battle-painting *Calling the Roll*. The Catholic paper *The Tablet* was the first forum for her prose, along with *The Architect* in 1876. She rapidly expanded her journalistic output, contributing by the 1880s to more than a dozen British periodicals, including *The World* and the *Daily Chronicle*. She also wrote for some American magazines. Having married a fellow journalist, Wilfrid Meynell, in 1877, she was able to work collaboratively as well as independently. Though a great deal of her work was unattributed, as was still customary in much of the British press, Alice Meynell was a well-known writer by the 1880s.

While her writing on art was at least as substantial as on any other subject – she was a conspicuous contributor to the *Magazine of Art* during the 1880s – she was also drawn to women's issues, especially in the nineties as the suffrage campaign heightened. Although a Catholic, she was an ardent suffragist, of the faction she herself labelled moderate rather than militant. Her contributions to the women's column of the *Pall Mall Gazette* from 1893 and that of the *Daily Chronicle* from 1896 became a forum for her distinctive voice, and in 1897 she was made President of the Society of Women Journalists. In 1900 she was appointed art critic for the *Pall Mall Gazette*, and in this year too she wrote a monograph on Ruskin, of whom she had been a critical admirer for many years. An essay on the paintings of John Singer Sargent appeared in 1903, though poetry and spiritual writings formed her main literary interest in the latter years of her life. A comment in one of the pieces on art included in *Essays* (1923) sums up Meynell's approach. Discussing the vandalism of certain work on St Paul's Cathedral, she declares, 'This is not a matter of art-criticism. It is an ethical question'.[21]

In spite of the achievements of Eastlake, Jameson, Dilke and Meynell – or perhaps because of them, the woman armed with feminist scepticism might suggest – it was more usual for a woman writing about art to disclaim any critical acumen and, at one and the same time, for her work to be attacked for this same lack and held up as alleged proof of women's inherent critical incapability. A case in point is the American Elisabeth Ellet's important book *Women Artists in all Ages and Countries* (London, 1859), which had particular value for female readers: accounts of the book were given in the *Englishwoman's Review* on its publication and extracts published in *The Lady's Treasury* in 1866. In her preface, Ellet wrote:

> No attempt has been made to give elaborate critiques, or a connected history of art. The aim has been simply to show what woman has done, with the general conditions favourable or unfavourable to her efforts, and to give such impressions of the character of each distinguished artist as may be derived from a faithful record of her personal experiences.[22]

Thus, given an inch, most British reviewers of her book took a mile. The *Athenaeum*'s book critic wrote:

> Nothing is easier, or, in general, more unsatisfactory, than this summarizing, significant of a few visits to a public library, the ransacking of one or more bibliographies, with a vague amount of raw reading and discursive transcript. Mrs Ellet, in floating down the current which has set in from the intellect-of-women point of view, and in joining those who appear readier to talk than to act, is purely and simply a collector and assorter of rough materials. Her notices are scarcely at all critical; they run through the centuries, between long piles of local and ephemeral

reputations, with now and then a bright name upon the roll, and the female artists in the category are presented, with rare exceptions, upon one level of frigid and formal excellence.[23]

The second book attempting to write the history of women artists to appear in the Victorian period, Ellen Clayton's *English Female Artists* (1876), was appraised similarly, though its greater immediacy for English readers checked the acerbity of some reviewers. The *Art Journal*, for instance, which had been supportive of women artists in the 1850s and 1860s, chose to patronise from a proprietorial position rather than insult from an ostensibly neutral one: 'Without any attempt at Art-Criticism, Miss Clayton tells the stories, long or brief as they may happen to be, of our Art sisters very pleasantly and very creditably both to them and to herself'.[24] It was not until the 1880s that a number of female art journalists became conspicuous by their assertiveness, contrasting with their early Victorian predecessors not only in the relatively uncontroversial status that they enjoyed but in their lack of or disdain for a feminist or woman-identified stance. Thus, typically, Katharine de Mattos writing in the *Magazine of Art* in 1883 on flower-painting,[25] a subject well within the traditional female ghetto:

> Many women are impelled to believe seriously that, because they are women, they must have an innate comprehension, a special instinct, which helps them to a right interpretation of floral mystery and beauty . . . In all this there is the confidence of ignorance; for, as a matter of fact, there are many who paint flowers creditably, and only a few, and those not usually women, who paint them worthily.

De Mattos demonstrates how male approval – and, more to the point, the opportunity flowing therefrom – could be bought by denying 'womanliness'. In fear of the secondary rank that women's opinions habitually occupied in Victorian culture, she attempts to reject any alignment with or partiality for women. Other women making forays into art criticism at this time, such as Violet Paget writing under the pseudonym Vernon Lee and Mrs (Emilie) Russell Barrington,[26] could be seen disdaining any subjects but those which male opinion deemed worthy. There were, however, more self-respecting ways of enjoying a public platform as an opinionated woman. This was demonstrated by some of those who, in writing columns or pages designated for female readers of periodicals including newspapers, numbered art among their subjects. Florence Fenwick-Miller, writing in the *Illustrated London News*, and Alice Meynell, writing in the *Pall Mall Gazette*, stood out towards the end of the century as women determined to wrest respect from male and female readers while writing emphatically as women.

The visibility of the female art critic, then, was slight and irregular until the 1880s. This state of affairs was of consequence to female artists, and – it can be proposed, though perhaps with less chance of proving it – to female viewers.

An often cited instance of the critical power of the male voice over women's creativity is that involving the painter Anna Mary Howitt and the pre-eminent critic John Ruskin. Howitt's mother Mary related in her diary, published within her autobiography in 1889, how

> Our daughter had, both by her pen and pencil, taken her place amongst the successful artists and writers of the day, when, in the spring of 1856, a severe private censure of one of her oil paintings by a king amongst critics so crushed her sensitive nature as to make her yield to her bias for the supernatural, and withdraw from the ordinary arena of the fine arts.[27]

Deborah Cherry has pointed out that the work in question was *Boadicaea Brooding over her Wrongs*[28] – a subject that could be read precisely as a challenge to male authority insofar as it recalled a female leader and implied both women's oppression and female resistance.

Another vivid example of the effect on women's art of the habitual use of art criticism to deploy male authority in cultural matters is offered by Jane Benham Hay's 1867 exhibit *The Florentine Procession*, now known as *The Burning of the Vanities* [12]. This work was compared with Frederic Leighton's first Academy showing, *Cimabue's Madonna being led through the Streets of Florence*, which in 1855 had made the twenty-four-year-old artist famous overnight. Leighton's enormous painting (measuring 220 × 520 cm while Benham Hay's measured a comparable 200 × 500 cm) created a sensation amongst the members of the Academy, the critics and the public. The tone of the *Art Journal*'s review is typical of the work's reception:

> There is . . . one picture in the collection that will mark this year – 1855 – as an epoch in British art. The truly great work which bears the name of 'Leighton' cannot fail to attract the attention of all visitors to the Royal Academy . . . Industry and originality of thought, as well as genius of the very highest order, are manifest in the first production he has submitted to public gaze. It is a rare event to find the painter of any country making a position at once, – taking foremost professional rank without having previously 'felt his way', and creating astonishment as well as admiration universally. There has been no production of modern times more entirely excellent than this.[29]

The painting was bought on the first day of the exhibition by Queen Victoria – proof enough for many that this was a remarkable work, and certainty an important imprimatur for any artist at the beginning of their career. The most often quoted opinion on *Cimabue's Madonna* is that of Dante Gabriel Rossetti, who saw Leighton's introduction of a revivified classicism as timely grist to the mill of anti-Realists and, more specifically, those who opposed Pre-Raphaelitism; he wrote, even so, of its 'great qualities'.[30] Ruskin, though ultimately preferring Millais' contribution to the exhibition, stated clearly that 'This is a very

important and very beautiful picture'.[31] Hailed at the time as representing a watershed in British art, it was remembered long afterward by many who had seen it at the 1855 Academy as one of the age's great works of art. Jane Benham Hay's painting was exhibited in 1867, not at the cynosure of the national art world, but at Henry Wallis' French Gallery. She had been seen at the Academy in 1848, 1849, 1859, 1861 and 1862, and had also been one of the artists in Wallis' 'stable' in the late fifties and early sixties. Her recent absence from the London scene was due to her residence in Italy. She, like Leighton before her, had exhibited her new painting first in her adopted city of Florence before exposing it to a British public. Benham Hay's painting proved the drawcard of the entire exhibition at Wallis', attracting attention not only by its size but by virtue of its author's sex: 'The most ambitious and at the same time most successful work which, so far as our knowledge extends, ever came from the hand of an

12] Jane Benham Hay, *The Florentine Procession* (*The Burning of the Vanities*), 1867, oil on canvas, 200 × 500 cm

Englishwoman', declared the *Sunday Times*.[32] However, the conclusion of the *Chromolithograph*'s reviewer suggests the carefully qualified approach taken by most mainstream commentators to this challenging work: 'The drawing of the figures in this remarkable picture may be open in some degree to adverse criticism, but there can be but one opinion that it is a fine work of art, trughfully conceived, and worked out with rare artistic skill.'[33] That is to say, while the painting was praised, it was almost palpably as being 'good (for a woman)'. Thus, for instance, the *Illustrated London News*, which began by admitting the peculiar interest of Benham Hay's painting, went on to relate *The Florentine Procession* to *Cimabue's Madonna* by saying it was 'fully as large as the picture which first brought Mr Leighton into note'. After a substantial description of the content, the writer begins on the inevitable caveats: 'While wishing to render full credit to the artist's invention, it may be inferred from this description that much

reliance is placed on conveying meaning through type and emblem. Indeed, fancy rather than deep sympathy seems to have been at play'.[34] The suggestion that the artist lacks the spirit necessary for a grand work of this kind is food and drink to the threatened misogynist, of course, and sounded its sour note in other critics' accounts: 'exactly where the ambitious lady has followed these old worthies [such as Fra Angelico], she has failed most completely', wrote the *Athenaeum*'s reviewer. 'The devotion to lovely and unemasculated types in design, which has misled the able artist whose work is here, should have guarded her against the operatic styles of some of her adult figures . . . an ambitious aim, considerable mental power and highly-wrought feelings on the part of the lady bring her work before lofty critical standards'.[35] Most explicit in this vein was the painter William Holman Hunt, in 1867 travelling in Italy. While Leighton's fellow artists had clamoured their praises of his debut work, and even those who saw him as their rival declared the painting's greatness, there is a nice contrast in the case of Benham Hay's *pièce de resistance*. Rossetti's erstwhile colleague Hunt shows a distinct lack of the generosity of spirit that characterised Rossetti's comment on his brother artist. In a letter from Florence in April 1867 to another former Pre-Raphaelite Brother, F. G. Stephens, he wrote:

> For a woman's picture it is a model of patience and pains-taking: it is about 12 or 15 feet in length and 6 or 7 in height. It represents a procession of people in the time of Savonarolla[*sic*] who are on their way to burn a collection of objects of bad taste – a woman's idea of a fine subject . . . The remarkable fact of the work is that it is an imitation of half a dozen different men – Leighton, Bouvier, Leys, Rossetti, Miss Osborne – and I might add your humble servant[36]

Where Leighton's painting had been linked with questions of national culture and public taste, Benham Hay's work was located within the 'woman question', with some reviewers' comments running to general diatribes on the competing merits of men and women in contemporary society.[37] In further contrast to the way in which art criticism served Leighton's career superbly by its reception, both public and private, of his masterwork, Benham Hay's *Procession* was not followed by many more years of notable critical successes in the London galleries. While her famous painting was recalled when her work came before the London public on subsequent occasions, it was more as a memory of what might have been than as a vindication of early achievement transcended. In 1870, the *Saturday Review* wrote that Mrs Benham Hay 'who won by her *Florentine Procession* a first position in the ranks of Female Artists, sends several examples of her masterful manner, among which should be noted a *Study of a Head* scarcely unworthy of Masaccio and other naturalistic artists of Florence under whose influence it has evidently been painted'.[38] However, the report was of some minor, incomplete works at the by then poorly regarded Society of Female

Artists. Critical support had not propelled her to the forefront of British art as it had so decisively done in the case of Frederic Leighton.

There is only one woman identified as an art critic by that encyclopaedia of the Victorian age, the *Dictionary of National Biography*.[39] This is Lucy Crane (1842–82), whose activities in this field were, indeed, very little known by her contemporaries. Though she had a little poetry and some stories published, her chief claim to the title was a series of six lectures delivered in the last years of her life and published in the year of her death by Macmillan as *Art and the Formation of Taste*, by the efforts of her brothers Thomas and Walter. While it may be sadly symbolic of the overall relation of Victorian women to the practice of art criticism that their single alleged exponent appears to have only really an honorary claim to the identiy of art critic, it can be taken as confirmation of the idea that has shaped this essay, that to expose the true worth of women's work we must rethink the definitions and categories of a patriarchal history – whether that history be of culture or of any other aspect of human experience – and remake them in our own interest.

Notes

1 F. T. Palgrave, 'Women and the Fine Arts', *MacMillan's Magazine* (1865), 118–221.

2 Quoted in William E. Fredeman, *The P. R. B. Journal* (Oxford, Clarendon Press, 1975), p. 91.

3 Quoted in Aubrey Noakes, *William Frith: Extraordinary Victorian Painter* (London, Jupiter, 1978), p. 110.

4 Simone de Beauvoir, *The Second Sex* (Harmondsworth, Penguin, [1953] 1972), p. 175.

5 That is to say, for a woman to get access to a public platform would have been impossible without the co-operation of what would have been either very radical or very mischievous men. Witness the storm caused at the Anti-Slavery Society meeting in London in 1840 when the US delegation was scandalised that its female members were not even allowed to sit with their male colleagues in the main body of the hall, and the progressive/scandalous character enjoyed by the Social Sciences Association (founded 1857) because of its policy of allowing women to address its meetings.

6 Clare Richter Sherman with Adèle M. Holcomb (eds.), *Women as Interpreters of the Visual Arts, 1820–1979* (Westport/London, Greenwood Press, 1981), p. 16.

7 See A. R. Mills, *Two Victorian Ladies* (Letchworth, Garden City Press, 1969)

8 Thus Ruskin writing to his self-appointed protegée Anna Blunden: 'That is the worst of you women – you are always working to your feelings and never to plain firm purpose . . . As far as I know lady painters they *always* let their feelings run away with them', 25 Jan. and Feb. 1857, quoted in Virginia Surtees, *Sublime and Instructive: letters from John Ruskin to Louisa, Marchioness of Waterford, Anna Blunden and Ellen Heaton* (London, Michael Joseph, 1972), p. 90, letters B.10 and B.11.

9 Mills, *Two Victorian Ladies*, p. 89.

10 *Ibid.*, p. 120.

11 *Ibid.*, p. 124.

12 Brownlow's diary is unpublished. I am indebted to her grandson, the late Bill Maddock, for permission to quote from the manuscript, which was in his private papers until his death and is now owned by his daughter Sheila Owen, whom I also thank.

13 J. M. Whistler was not English but American, though he had exhibited in Britain since 1860 and made Britain his adopted country from then. The painting she saw in the Salon des Refusés was *The White Girl* Later known as *Symphony in White no.1.*

14 Brownlow is referring to the French painter Rosa Bonheur (1822–99), by that date famous in Britain as well as in her native country.

15 See Marion Lochhead, *Elizabeth Rigby Lady Eastlake* (London, John Murray, 1961).

16 Quoted in Lochhead, *Elizabeth Rigby*, p. 31.

17 See Clara Thomas, *Love and Work Enough* (Toronto, University of Toronto Press, 1967) and Adele Holcomb, 'Anna Jameson on Women Artists', *Woman's Art journal*, 8:2 (Fall 1987/Winter 1988), 15–24.

18 Alice Oldcastle, 'Mrs Jameson: a biographical sketch', *The Magazine of Art* (1879), p. 123; the author was in fact Alice Meynell, writing under a pseudonym.

19 Betty Askwith, *Lady Dilke, a biography* (London, Chatto and Windus, 1969), p. vii.

20 See Viola Meynell, *Alice Meynell* (London, Jonathan Cape, 1929).

21 Alice Meynell, 'Tithonus', *Essays* (London, Burns Oates and Washbourne, 1923), p. 139.

22 E. F. Ellet, *Women Artists in all Ages and Countries* (London, Bentley, 1859), p. v.

23 *The Athenaeum*, Dec. 24 1859, p. 849.

24 'Art-Publications', *Art Journal* (1 Aug. 1876, p. 256.

25 Katharine de Mattos, 'Flowers and Flower-Painters', *The Magazine of Art* (1883), p. 453–5.

26 Vernon Lee, pseudonym of Violet Paget (1856–1935); Emilie Isabel Wilson, later Mrs Russell Barrington (18??–1933).

27 Margaret Howitt (ed.), *Mary Howitt, an autobiography* (London, Isbister, 1889), vol. ii, p. 117. See also the present author's *Canvassing: recollections by six Victorian women artists* (London, Camden Press, 1986).

28 Deborah Cherry, *Painting Women* (London, Routledge, 1993), p. 187–8.

29 'The Royal Academy', *Art Journal* (1 June 1855), 169

30 Rossetti to William Allingham, 11 May 1855; G. B. Hill (ed.), *Letters of Dante Gabriel Rossetti to William Allingham* (New York, Stokes, 1898), p. 124.

31 John Ruskin, *Academy Notes* in E. T. Cook and A. Wedderburn (eds.), *Library Edition of the Collected Works of John Ruskin* (London, 1903–12), vol. xiv, pp. 26, 33.

32 Quoted in *The Englishwoman's Review* (Jan. 1868), p. 397.

33 'Picture Galleries', *The Chromolithograph* (23 Nov. 1867), p. 431.

34 'The Winter Exhibition, French Gallery, Pall-Mall', *The Illustrated London News* (2 Nov. 1867), p. 478.

35 'The Winter Exhibition', *The Athenaeum* (2 Nov. 1867), p. 578–9.

36 Hunt to Stephens, 10 Apr. 1867, Bodl. MS. Don.e.67 fol.10. I am indebted to Judith Bronkhurst for drawing this letter to my attention.

37 See, for instance, *The Builder's* eccentric digression into women's challenge to male supremacy risking the labelling of the Victorian era by posterity as 'an effeminate age', with references to 'the shaving sex' and Fennimore Cooper's *The Last of the Mohicans:* 'Winter Exhibitions at the French Gallery and the Dudley Gallery', *The Builder* 23 Nov. 1867, p. 846–7.

38 *Saturday Review* (5 Mar. 1870), p. 317.

39 See *Dictionary of National Biography*. (London, Smith, Elder and Co., 1908), vol. v, p. 10–11.

Private pleasure, public beneficence: Lady Charlotte Schreiber and ceramic collecting

Ann Eatwell

THE South Kensington Museum is about to receive an important addition to its collections in a section in which it has hitherto been weak, namely, that of English porcelain, pottery and Battersea enamels. Lady Charlotte Schreiber has presented to the Museum the valuable series of specimens, amounting to some thousands, which she and the late Charles Schreiber had bought together after many years of careful and laborious collection in all parts of England and the continent.[1]

The Schreiber collection, one of the most important gifts of the nineteenth century to the South Kensington (now the Victoria and Albert) Museum, was offered and accepted in 1884. The accompanying published catalogue contains nearly 2,000 entries and the range and quality of the items is, over one hundred years later, still regarded as exemplary. Brought together between the mid 1860s and 1885,[2] the activity of collecting the material was undoubtedly the work of a partnership, but it is arguable that Lady Charlotte was the senior partner. Certainly, the choice of the ceramic items for the museum from a total of nearly 12,000 pieces of English, Continental and Chinese porcelain as well as the selection of glass, enamels and prints was her sole responsibility. To her alone fell the task of compiling the catalogue and initiating the process of donation to the museum. This essay will examine the formation and growth of the Schreiber collection against the backdrop of women's passion for ceramics from the seventeenth century onwards, but within the context of public and private collecting of the applied arts, specifically ceramics, in the nineteenth century.

CHINA. This is a hobby that ladies should cultivate; the exquisite Chelsea and Dresden figures seem to be made especially for the delicate fingers of women to handle. Many of the fair sex have told me that if they possessed the means, china, above all other hobbies, would be their speciality. Women, as a rule, have little taste for collecting books, prints or pictures, but it is a fact that they evince quite an attachment to their ordinary china services; an attachment begets enthusiasm, and then by easy stages, one arrives at the collecting period, and, if the means allowed, ladies would form the finest china cabinets in the kingdom.[3]

Written in 1907, Maurice Jonas' comments on collecting china express an understanding of the bond existing between ceramics, particularly porcelain, and the women who wished to possess it. The fragility and elegance of the material appealed especially to ladies, while the fine forms and fresh colours of the painted designs provided suitable ornaments for cabinet and mantelpiece. The irony was, as he explained, that few could afford to collect. Women had less money than men and less control over it. Money was essential not only to buy the ceramics, which might be expensive, but also to pay for the time of dealers or agents while they hunted for examples. Many great collections of ceramics, such as the Lord Leverhulme collection of Wedgwood, gathered by the dealer Frederick Rathbone,[4] were the result of this type of activity.

A collector with less money but an abundance of time could at least invest that time in accumulating knowledge, expertise and discrimination and, for less cost than through established dealers, in acquiring art objects. To be a successful collector, on the scale achieved by the Schreibers, required time and money. Lady Charlotte, once her responsibilities to her former husband's business, the family estates and her children diminished, had both. The majority of women had neither. Women collectors tended to be spinsters, or the childless, or dowagers, or women with grown-up children. The duties of the domestic sphere, the ill health associated with repeated childbirth and the care of growing families appear to have accounted for women's energies. There may also have been some hesitation on their part to indulge in a pursuit (that of collecting in general) which was not only considered part of the male domain but even within that arena was not wholly approved of. Although the Society of Antiquaries was founded in 1717 to foster interest in, and no doubt to lend respectability to, the collecting of British antiquities, the antiquary was often portrayed as an outsider and an eccentric.[5] Women were more reluctant to be viewed in this way, had less access to a society (such as a specialist club) that would endorse their behaviour and fewer role models to follow.

A limited number of pre-nineteenth-century role models did exist. Some of the best-known lady collectors of the earlier period 'were Queen Mary II

(1662–94),[7] the Duchess of Portland (1714–85),[8] Lady Betty Germaine (1680–1769)[9] and Madame de Pompadour (1721–64).[10] Many of these women were related to men or women who had or did collect. The Duchess of Portland's Harley ancestors' collections formed the nucleus of her own. A relative who had collected, whether male or female, gave the activity greater credibility and validity. This remained true even in the nineteenth century. Lady Dorothy Neville, who was a descendant of the antiquary Horace Walpole, and Mrs Bury Palliser, the sister of Joseph Marryat (author of the first book on ceramic history to be published in English), bear witness to this tendency. Lady Charlotte Schreiber herself may have been influenced in her collecting tendencies by her second husband and by her sons Ivor and Monty, both of whom collected. Monty claimed to have begun amassing ceramics in 1860, before any direct evidence of the Schreibers' involvement with collecting exists.[11]

Before the end of the eighteenth century it is hard to distinguish or classify collectorly behaviour in ceramics in terms of the deliberate choice of second-hand material which could be said to define a nineteenth-century collector. Fashionable patronage was more often the impetus behind the collections of the seventeenth and eighteenth centuries, which were principally concerned with status, interior design and appearance rather than type, provenance and classification.[12] Queen Mary II's Oriental porcelain was described in the early eighteenth century by Daniel Defoe in connection with its influence on fashion.[13] The process of porcelain collecting in England did not begin with Queen Mary. Originally imported in small quantities and displayed in cabinets of curiosity, porcelain had become gradually more available in Europe from the second half of the seventeenth century. John Evelyn recorded in his diary for 19 February 1652 a 'great supper' given in London by Lady Gerrard, 'and all the vessels, which were innumerable, of porcelan'.[14] Towards the end of the century, porcelain was less of a curiosity and more of an item of furnishing. The inventory taken at Burghley House in 1688, some months before the arrival of William and Mary, confirms that Oriental porcelain was already very much part of the decorative display of the nobility. However, Mary's interest in and support for the accumulation of Oriental ceramics must have supplied the role model that women needed to become avid collectors in their own right.

Increasing wealth in the early eighteenth century enabled even the woman of moderate means to indulge in a passion for china. The scale of the obsession can be judged from the numerous allusions to it in the literature of the period. Few of the observers had anything good to say about it. The conspicuous consumpton evident in collecting luxurious goods, such as ceramics, purely for show was generally frowned upon by moralists and satirised by contemporary wits.[15] In the nineteenth century, an attachment to porcelain was still question-

able in some circles, and the historian Macaulay had no hesitation in criticising his forebears: 'Even statesmen and generals were not ashamed to be renowned as judges of teapots and dragons; and satirists long continued to repeat that a fine lady valued her mottled green pottery as much as she valued her monkey, and much more than she valued her husband.'[16] Women were not alone in their appreciation of porcelain but, as Macaulay's comments demonstrate, men were hardly less guilty. While women were condemned for extravagance and slavishly following fashion, however, men were accused of effeminacy. Some men were prepared to own up themselves to this fault. Charles Lamb confessed, 'I have an almost feminine partiality for old china. When I go to see any great house, I inquire for the china-closet, and next for the picture-gallery.'[17]

The craze for ceramics continued unabated throughout the 1700s.[18] The importation of Japanese porcelains peaked in the first half of the century, and although Chinese ceramics continued to reach the West in bulk the wares were of the cheaper, utilitarian sort. While these provided less wealthy men and women with the chance to possess porcelain, the ceramic enthusiasts turned their interest to the newer products now being made in Europe.[19] Meissen, officially opened in 1710, was the first of many Germanic factories, while in France, Chantilly and Vincennes/Sèvres and, in England from the mid 1740s, Chelsea, Derby, Bow and Worcester provided ceramics of varying qualities for the widespread consumer boom. Before the end of the century, thanks to inspired marketing by Josiah Wedgwood, common pottery in the form of cream-coloured earthenware was as fashionable and desirable as porcelain.[20]

Any detailed exploration of and explanation for the very particular attraction that women felt for ceramics in general and for porcelain in particular would be necessarily complex and cannot be fully dealt with here. Fashion (both for the material of porcelain and products of the East), empowerment[21] (both men and women sought the prestige that owning or controlling a porcelain factory could give), social standing (the ownership of porcelain, even utilitarian pieces, enhanced status), and social function (through the rise of polite ceremonies like tea drinking which women controlled and that required new equipment) are all factors which have a bearing on women's romance with ceramics. However, what is evident from contemporary accounts is that they loved all the things that the critics hated: the fragility, the bright colours, the ornamental rather than practical qualities and, no doubt, the extravagance.

By the nineteenth century, greator choice and the availability of second-hand collectibles, together with the growing interest in classifying and categorising objects, resulted in women collectors who were only interested in 'old china'. Before 1850 the type of 'old china' collected is more certain than a knowledge of who the collectors were. From 1800 onwards, old Sèvres, old

Dresden and old Chelsea appear regularly on the catalogue covers of the sale rooms to entice customers. Oriental porcelains were commonly offered, and as the century progressed the inclusion of other European factories in sales suggests that they had also become attractive to collectors. Ceramics could be collected by function rather than by country or factory. Collecting teapots remains to this day an obsession for many, and several pre-1850 collectors are mentioned by Joseph Marryat, including George IV, a Mrs Elizabeth Carter and a Mrs Hawes. The latter, a 'most diligent collector of teapots', bequeathed 300 specimens to her daughter, a Mrs Donkin, who arranged them 'in a room appropriated for the purpose.'[22]

Some indication of the numbers of women involved in collecting can be found in the lists of ceramic collectors published by Joseph Marryat (1790–1876, MP for Sandwich 1826–35) in each of the three editions of his book, *Collections Towards A History of Pottery and Porcelain*, published in London in 1850, 1857 and 1868. As a collector and historian moving in museum and society circles, Marryat was well placed to gauge the extent of the commitment to serious collecting in nineteenth-century England.[23] In 1850, he named some 131 collectors of ceramics, of whom forty-three, perhaps influenced by the taste of George IV, collected Sèvres.[24] Only twelve of Marryat's list were women. Largely of the nobility, these women reflect the preference for Sèvres, although the Dowager Duchess of Cleveland and a Miss Cunder of Basingstoke also collected Chelsea. By 1868, Marryat's complete list of collectors had almost doubled to 243 and he noted thirteen public institutions. The number of women collectors had nearly tripled to reach thirty-three, including Lady Charlotte Schreiber, Mrs Bury Palliser[25] and Lady Dorothy Nevill.[26] The type of ceramics collected had expanded to include the less grand, though worthy, factories of Swansea, Lowestoft and Worcester.

Although the women collectors were far outnumbered by men, the impressive growth of their numbers and diversity of their collections by 1868 demonstrate the expansion of information through museum collections, publications, exhibitions and specialist societies in the mid-century, which generated excitement about, and legitimised interest in, the decorative arts. Public exhibitions of ceramics in London began in the Museum of Practical Geology (founded 1835), which had good collections of largely British examples by the mid-1850s when their first catalogue was issued. Intended to illustrate the use of British minerals, an adventurous acquisition policy enabled the museum's ceramic collection for many years to rival, if not outshine, that of the Museum of Ornamental Art (an early title of the Victoria and Albert Museum) in the area of national material. The gift of the Schreiber collection in 1884 represented an important step in restoring the Victoria and Albert Museum to pre-eminence in

English ceramics. Established mainly through the efforts of Henry Cole (1808–82), the Museum of Ornamental Art, at Marlborough House, was conceived to furnish examples of good design so as to encourage improvements in the country's industry and educate the taste of the public. It had a wide brief, collecting from its inception both modern and antique objects on an international basis but reflecting the fashions of the day in a preference in ceramics for Sèvres, Italian maiolica, Hispano-Moresque and Meissen.[27]

Museum collections and exhibitions, such as those in the Ceramic Court at the Crystal Place in 1856 and, more especially, the Art Treasures of the United Kingdom, an exhibition held in Manchester in 1857, supported the idea that decorative pieces could be perceived as works of art. In addition to halls of paintings, sculptures and watercolours, the so-called Museum of Ornamental Art displayed both public and private collections. Women lenders were in a minority, but Mrs Bury Palliser and Miss Auldjo were doubtless providing ceramics. Lady Charlotte lent three paintings by Penry Williams to the section of Modern Masters. The Schreibers are known to have visited the exhibition on five consecutive days. Lady Charlotte noted the beneficial effect the visit had upon her husband: 'Having no profession, no pursuit at this particular moment, I cannot describe how pleased I was to see how heartily he threw himself into the spirit of all around him.'[28]

While museums and exhibitions displaying ceramics stimulated and authenticated collectors' tastes, museum publications and those of collectors such as Joseph Marryat and dealers like William Chaffers (who published his first book, *Marks and Monograms on Pottery and Porcelain*, in 1863) disseminated information to a wider audience interested in ceramic history. Nearly 150 subscribers listed in the book, some ordering several copies, attest to the eagerness with which such publications were greeted. The Schreibers were not on the list, although A. H. Layard (Lady Charlotte's cousin) was included, along with Mrs Bury Palliser and several other ladies. Information on ceramics was not easy to glean at this period. Chaffers' bibliography offers a mere twenty-one titles, only six of which were in English, and most were concerned with the history of Continental ceramics. In the 1860s[29] and 1870s a rash of publications indicated the new levels of awareness as well as confirming the demands of collectors.

The first guide explaining how to collect ceramics was published in 1875 by Major H. Byng Hall and offers hints on the type of pieces to search for, the kind of expertise would-be collectors will need to develop and the sort of shops and dealers to look out for or avoid, as well as an analysis of the 'hunting grounds' throughout Europe that might prove fruitful. He warns in his Introduction that ceramic collecting 'in days lang syne, was solely a pleasure and possibly a profit to the few, but has now become a positive mania with the

million'.[30] This was written at the very period when the Schreibers were buying heavily both at home and abroad. Byng also mentions the 'absurd taste for that which is called old English china' and the 'present mania for English china'.[31] The Schreibers, buying from about 1865, though sharing the field with other collectors such as Byng were ahead of the more general chinamania which he describes. Similar guides of the 'how to do it type', reflecting the demand from ceramic collectors, were published in the nineteenth and early twentieth centuries.[32]

Marryat claimed in his first book that he had written it to aid the collector who had nothing but dealers' knowledge to assist in unravelling the history of ceramics. However, collectors have always turned to each other for support and to acquire expertise and greater knowledge of their subject. How easy was it for women to use this network both formally and informally? Men could and did meet at specialist societies, such as the Society of Antiquaries, which was by virtue of its age and membership fairly select by the mid-nineteenth century. Women were not admitted until 1920.[33] Charles Schreiber was never a member, although many collectors and curators were. Of the two archaeological societies which offered membership to a more down-market clientele than the Antiquaries, the Royal Archaeological Institute of Great Britain, founded in 1846, admitted women. These societies were more concerned with ancient rather than modern arts, although the range of interests represented by the well-known curators, collectors and art dealers such as William Chaffers and John Webb was surprisingly wide.

What was lacking in the mid-century was a society which would foster the growing specialisms of collectors of the decorative arts. J. C. Robinson, Curator at the Museum of Ornamental Art, described their interests rather apologetically as 'decorative objects of utility, and of those minor productions of great artists, which are not usually thought to deserve the designation of "high art"'.[34] His museum was, however, dedicated to collecting and displaying these types of object, and it was in the interest of Robinson and Henry Cole to promote appreciation and enthusiasm for them. The Collector's Club, or as it soon became known, the Fine Arts Club, was launched to meet precisely this need in February 1857. With Cole and Robinson on the committee and ninety-six curators and collectors of the stature and reputation of the Rothschilds, the curator A. W. Franks and A. H. Layard willing to become members, the club appeared to be a very popular and successful idea. As early as July 1857, Robinson proposed Mrs Palliser as a member but a decision was postponed until the following year, when ladies were admitted as honorary members for the season only. Their membership had to be renewed each year. In 1867, out of a total of 201 members only eight were ladies. Although membership was largely restricted to

men, the meetings were more open, being held in members' homes, and many ladies attended, including Lady Charlotte (Charles Schreiber became a member in 1858). The aims of the club were, through the exhibition of works of art, to increase the knowledge of and taste for them.[35]

The Schreibers were active participants in the club from the early 1860s, although Lady Charlotte never became a member. What they chose to collect must have been influenced by what they saw, learnt or discussed with fellow members and guests. There can be no doubt of the importance of this kind of specialist society in nurturing, directing and supporting enthusiasms. Charles Schreiber exhibited his first objects at a meeting in March 1863. The records do not indicate what they were, but the subjects for the evening included 'English Porcelain and earthenware, and porcelain with unknown marks'. Once the Schreibers had moved to London they began to host meetings. In April 1866, Oriental porcelains and lacquer, medieval jewellery and cutlery were amongst the objects requested for display at their residence. Lady Charlotte's son Ivor exhibited with the Schreibers themselves. In April 1867, forty-six members and visitors were present at the meeting at the Schreibers' house, including Mrs Palliser and A. W. Franks. By the early 1870s, Charles was attending meetings alone and, with many members dead, retired or absconding to the rival Burlington Fine Arts Club, the Fine Arts Club was finally wound up in 1874. Critics of the Fine Arts Club cited an overemphasis on the social aspect of the meetings. It was not unknown for the hosts to invite over a hundred guests of their own to such gatherings. There may have been other reasons. Perhaps the influence of the women hostesses and guests was seen as too strong. Perhaps there was a shift of interest away from the decorative arts towards fine art topics.

Contacts made through this club and through society in general did provide a modest informal network of women collectors, although in comparison with that of the men it would have been small.[36] From the evidence of Lady Charlotte's journals, the meeting of like-minded ladies to discuss art objects, ask for assistance or exchange or sell ceramic pieces would appear to be a not uncommon occurrence. Mrs Haliburton, a collector of Chelsea, from whom Lady Charlotte purchased some pieces for her own collection, was part of the Schreiber ceramic circle from 1869 until at least 1884. By the late 1870s, Lady Charlotte was regarded as something of an expert in ceramic matters, and her journal records the advice she gave to ladies and the errands she would run for them at home and abroad. An extensive acquaintance with professionals, such as curators and dealers, enabled her to get second opinions for some ladies, including Lady Dorothy Nevill. She may have purchased items on her ladies' behalf; and she took under her wing the more inexperienced, as her relationship with Mrs Bloomfield Moore demonstrated. Mrs Moore, let loose in Europe

with £2,000 and a obligation to collect art objects for an American museum to fulfil the terms of her husband's will, was adopted by Charles and Lady Schreiber in 1880. She remained friends with Lady Charlotte long after Charles' death. Lady dealers, as well as collectors, would have formed part of the informal network. Particularly in France and Holland, they were important contacts for their women clients. Whether they offered a different service for women would be debatable but their very presence in the same field would have reassured and supported a woman collector. Lady Charlotte relied on and trusted certain dealers more than others. One of these was a woman, Eva Krug in Antwerp, who acted as one of the Schreibers' agents, packing and dispatching objects home and placing surplus items on the market for them.

Women collectors grew in numbers in the last quarter of the nineteenth century, stimulated by the greater access to information, the apparent respectability of the hobby and their own natural inclination. The genteel pursuit of china painting, which was popularised in the 1870s by exhibitions at Howell and James Art Galleries, Regent Street, London[37], and the publication of manuals for women which advised them to acquire old ceramics for display to improve the appearance of their homes, would have stimulated ceramic collecting amongst the 'fair sex'.[38] Women painters such as Anna Maria Charretie (1819–75) and Ellen Clacy seem to have specialised in romantic depictions of women amidst their china cabinets [13].

Women's collecting patterns demonstrate that they were not always restricted to one material type. Josephine Bowes, the French wife of John Bowes, collected over 15,000 items of Continental decorative and fine art objects in co-operation with her husband. She appears to have been instrumental in committing this collection for public display.[39] In 1869, she laid the foundation stone of their museum at Barnard Castle in County Durham. It opened to the public in 1892, displaying a collection of international significance. Josephine Bowes had collected across a broad spectrum of works of art. This was true of many lady collectors in the nineteenth century. Dorothy Nevill collected ironwork, which she lent to the Victoria and Albert Museum, furniture and glass as well as ceramics. Lady Charlotte, apart from the English enamel collection given to the Victoria and Albert as part of the Schreiber gift, amassed a large collection of fans and playing cards, which were donated to the British Museum. She bought in all areas of the decorative arts from jewellery to lace, if she or Charles thought the object handsome. Generally, the larger the income, the broader the collecting pattern.

As more lower-income middle-class women began to collect, their enthusiasms were constrained by finance to smaller areas of one object type such as ceramics or to one theme or factory within that collecting type. Lack of suitable

examples of the right quality had a determining effect on lady collectors'
predilections. As more dealers scoured Europe for ceramics, as more and more
collectors followed the same routes and as the new money of the American
enthusiast[40] entered this crowded field, so the older collectors moved into less
competitive areas or chose to concentrate on a smaller part of a subject area. Mrs

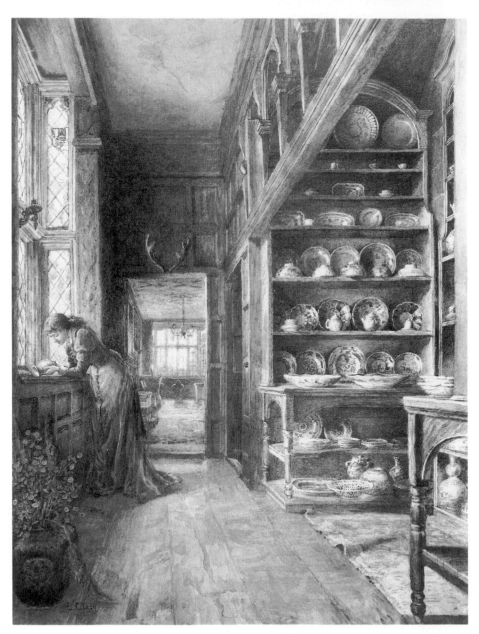

13] Ellen Clacy, *Interior of a country house, c.* 1880, watercolour, 479 × 350 mm

George Preston, Mrs Lawrence Burd[41] and Mr Francis Sibson[42] were some of the numerous ordinary men and women who specialised in collecting the products of the Wedgwood factory in the 1860s and 1870s.

Women's preference in ceramic collecting was directed, in the main, towards porcelain. Sèvres, Meissen and English porcelains, including Chelsea and Crown Derby, were collected by Lady Dorothy Nevill. The women collectors in Marryat's lists, the women lenders to exhibitions and those women who were featured in Chaffer's *The Keramic Gallery* in 1872, were almost all owners of porcelain. Two women, of whom Mrs Palliser was one, were noted as possessing Italian maiolica. This seems to have been unusual. Italian maiolica had been heavily collected by museums in the mid nineteenth century and was more expensive and too closely identified with the academic male world. Possibly women simply liked porcelain as a material. As has been shown, it was a love affair for Western women that had been in progress for almost two hundred years.

Lady Charlotte differs from other women collectors of the nineteenth century, with the exception of Josephine Bowes, in several ways. Firstly, she became well known because of the survival of the collection in the public domain [14]. Secondly, the survival of a collection is in itself unusual. Most collectors still see themselves as merely the temporary hosts to the objects and condone their dispersal to the auction houses to be recycled to other collections.[43] Thirdly, women do not seem to have been as munificent as men in the donation of their collections to public institutions. Charlotte Schreiber and Josephine Bowes were honourable exceptions to this rule. There were, of course, fewer women collectors, many of whom may not have wished or needed to make such a gift. Collecting for women was a means of self-expression, an activity limited by their lifetime. They tended to see their collections in terms of personal effects for the private pleasures of themselves and their families. Their collections were, generally, dispersed amongst their children, as indeed large portions of Lady Charlotte's collection were bequeathed to her own family. They do not seem to have felt that need for self-aggrandisement in death, for the good will of posterity, for that kind of immortality which leaving collections to the nation implies. It is ironic that, having suggested a public purpose for their collection of English ceramics, Charles Schreiber is less famous for it than his wife.

Fourthly, the quality and the quantity of the Schreiber collection creates a largely unapproachable standard compared to what is known of other nineteenth-century women's collections. Fifthly, extensive documentation which describes Lady Charlotte's collecting behaviour and details the collection itself has survived. No other nineteenth-century lady collector is so well documented. Lady Dorothy Nevill has left volumes of autobiographical anecdote rather than

14] Photograph of Lady Charlotte Schreiber surrounded by three generations of her family

the Schreiber accumulation of 1,000 pages of published 'ceramic' journals detailing provenance, price and circumstance of the collections' growth. Sixthly, Lady Charlotte evinced an academic interest in the subject of ceramic history which not only led her to attend specialist society meetings, visit exhibitions and museums and read the available publications on the subject, but also to pursue each avenue of enquiry with vigour.[44] In 1869, Chaffers had announced in the *Art Journal* that Lady Charlotte had recently acquired 'several books formerly in use at the Bow works'.[45] It was Lady Charlotte and her husband who

in 1870 discovered languishing amongst nineteenth-century account books the early records of John Dwight's factory at Fulham.[46] Finally, after her husband's death, Lady Charlotte set about producing a catalogue of their collection for the museum based upon work she had begun earlier and with the assistance of experts of the day such as A. H. Church and A. W. Franks.

Although it is not known why the Schreibers became such ardent ceramic collectors it has been possible to establish when they began to collect. The evidence of the annotated catalogue in the British Museum suggests a date of 1865 for the systematic collecting and recording of ceramic purchases as part of a consistent activity. No. 159, a Bow teapot, was purchased for 5 shillings from Young in Salisbury in November 1865 and is No. 12 in the Schreiber's cataloguing system. By analysing the Schreiber's own numbering system, as revealed in the annotated catalogue, it is possible to see the periods of their greatest activity. The first few years brought a collection of 3,000 objects (between November 1865 and August 1869) while the late 1870s (from 1876 to 1879) would appear to be the busiest period, with over 4,000 objects acquired within three years. The highest number noted is 11,745 in December 1885. Separate numbering systems were used for enamels, glass and prints, and the huge total in ceramics must refer to the excess English pieces, the Continental and the Oriental collections all dispersed to Lady Charlotte's family and through sales.

Although the Schreibers made twenty-four visits to the Continent between 1867 and 1882, the idea that the collection was largely purchased abroad may be an exaggeration. Certainly, some of the most rare and exciting pieces were bought in England. A fine group of Plymouth and Bristol porcelains was acquired through descendants of William Cookworthy (the first manufacturer of hard paste porcelain in England) in Kingsbridge in 1868. The most expensive purchase the Schreibers ever made was of a set of the 'Seasons' in Bristol porcelain from the dealer W. Sanders of Hammersmith for £380; and the Chelsea figure group, 'The Music Lesson', did not cost much less at £364 from a sale at Christie's, London, in 1875 [15].

Through the annotated catalogue, it is possible to see what type of pieces the Schreibers favoured at any given period. In the 1860s, porcelains form the majority of their acquisitions (Chelsea, Bow, Bristol, Plymouth and Worcester), while in the 1870s Staffordshire salt-glaze, Wedgwood, red stonewares and agate bodies were commonly purchased. In some respects, this early interest in English earthenwares, which did not become popular among collectors until the 1890s and the first years of the twentieth century, shows the Schreibers once again ahead of the collecting crowd. The Fine Arts Club, which offered an introduction to such subjects from the 1860s, must have had a formative influence upon them [16].

Collecting, for the Schreibers, was a partnership which enhanced and gave meaning to their relationship. Apart from a brief spell as a MP, Charles did not work. The collecting of ceramics became, rather than a hobby, a worthy occupation for them both. A full day of seven or eight hours, often on foot, was a normal part of any expedition, even in 1882 when Lady Charlotte was almost seventy. Fleas, bedbugs, mosquitoes, pickpockets, stoning by natives, bad food, inadequate transport, sea sickness, poor hotels and in one case no hotel (the

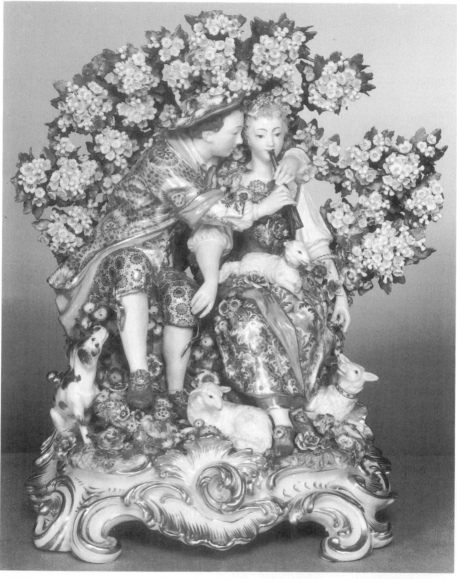

15] 'The Music Lesson', c. 1765, Chelsea figure group after a painting by Francois Boucher

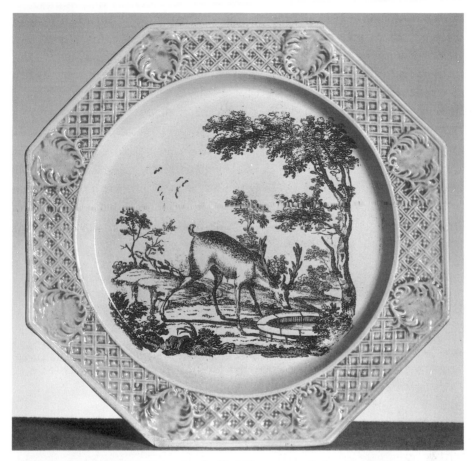

16] 'The stag and the water', *c.* 1760, Staffordshire octagonal plate in salt-glazed stoneware, printed in Liverpool with Aesop's fable

night being spent in a carriage) did nothing to deter Lady Charlotte. She was the stuff of the archetypal Victorian explorer and, if anything, Charles succumbed to illness and fatigue before she did.

The days were spent in the '*chasse*', with often up to fifteen or sixteen shops 'ransacked' by the Schreibers in their quest, whilst evenings were spent washing and writing up the purchases, planning itineraries and catching up with correspondence. Time off was more often than not given over to improvement, visiting local churches, private collections, ceramic factories, palaces and museums. The Schreibers had excellent connections through birth and society and exploited these to good effect. Local consuls in foreign parts, museum directors, dealers and royalty were all used to further the ceramic cause. Guides were hired to save time in finding new shops but dealers were often only too willing to help. In Spain, A. H. Layard took them around himself. Museum directors were

contacted and pressed for information about the objects in their care and for access to collections public and private. If the Schreibers spent their own time in pursuit of ceramics, they also bought the time of others. They had many long-standing relationships with dealers who would look out for items for them. If they paid more dearly for this service, it is doubtful, given their powers of bargaining, that they paid the top prices. They knew what works of art were worth

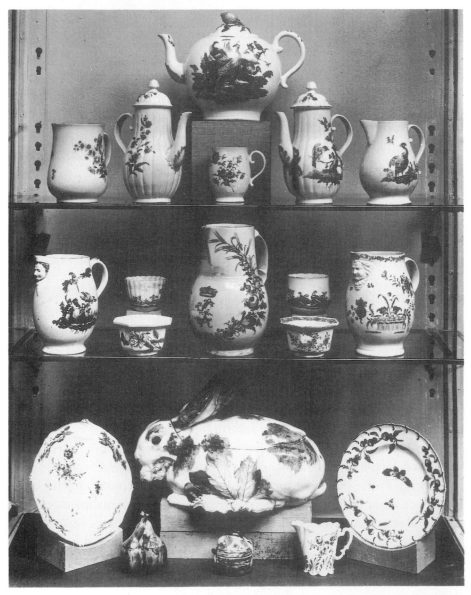

17] Case of domestic ware described as Chelsea, including a large rabbit tureen bought for £4 in Rotterdam in 1876

and often turned down objects they considered too dear. Many of their acquisitions were gained at a third to a half of the first price quoted. The process of examining, agreeing a price and finally purchasing an item often extended over days and sometimes years.

The Schreibers demonstrated an ability to learn and to put that knowledge to good use throughout their ceramic searches. The collections shifted and

18] Case of figures, Derby and Chelsea-Derby, between 1765 and 1785

changed to reflect their increasing understanding. The sale or exchange of objects for better examples was an integral factor in the growth of the collection. The Schreibers bought some underpriced items specifically to sell. They undertook commissions for family and friends and probably for profit. Requests from the London dealers Mortlock's reveal that the Schreibers acted as 'runners', purchasing blue and white ceramics on their behalf in the mid 1870s at the height of the craze for these items in England.[47] Lady Charlotte described this chinamania as a 'ridiculous rage'. She and Charles were more interested in the rare and unusual pieces and in items that their expertise and developing knowledge of the subject revealed to them. Research was a greater influence on their collecting pattern than fashion. For example, they concentrated on the earlier triangle, raised and red anchor wares of Chelsea, rather than the rich and gaudy ground colours and gilt of the gold anchor ornamental vases preferred by collectors such as John Jones and the Earl of Dudley[48] [**17**].

Charles Schreiber died in March 1884, and almost immediately Lady Charlotte was involved with the plans to give their collection of native ceramic products to the nation. On the advice of A. W. Franks, the South Kensington Museum was chosen as the most appropriate location.[49] Lady Charlotte had long been familiar with the staff and the institution itself. She first lent ceramics for temporary display in July 1866. This small loan was returned in December of the same year, but in July 1867 a larger loan of English porcelain was deposited until February 1869. The clerk recorded this loan in Charles Schreiber's name, as he did for the last and largest deposit of 224 pieces of English porcelain from 1869 to 1873, many of which were later to form part of the Schreiber gift.[50] English ceramics was an area in which the museum was so weak that the gift was gratefully received, even under the most stringent terms. The collection was to remain on display together, neither sold, exchanged nor lent. If the conditions were infringed in any way it was to revert to the family. This threat was keenly felt by museum officials and the effect has been to throw a greater focus on the collectors through the preserved entity of their collection[51] [**18**].

The conditions of loan have, therefore, accomplished Lady Charlotte's purpose of consigning the memory of her husband to posterity. Gathered in a gallery in the Victoria and Albert Museum, below mosaic portraits of the collectors themselves, the collection remains a fitting memorial to them both. For it would be wrong to think that Lady Charlotte acted entirely selflessly. She liked to be seen to have done well, if not to have been the best at anything she undertook. The wide scope and the quality of the collection is testimony to that wish and to its fulfilment in her lifetime. It is material evidence of the expertise, knowledge, energy, commitment and stamina of the greatest of the nineteenth-century lady collectors, Lady Charlotte Schreiber.

Acknowledgements

I should like to thank the following for their assistance with this paper: John Mallet, Aileen Dawson, Lionel Lambourne, Katie Coombes, Philippa Glanville, Edward Morris, Clive Wainwright, Craig Clunas and Stephen Calloway.

Notes

1 *The Queen* (31 May 1884), 595.

2 Charles Schreiber died in March 1884 but Lady Charlotte (1812–95) continued to collect to improve the collection until December 1885. An annotated copy of the Schreiber catalogue (1885) in the Department of Medieval and Later Antiquities, British Museum, provides the source of this information

3 Maurice Jonas, *Notes of an Art Collector* (London, Routledge 1907)

4 Ann Eatwell, 'Lever as a collector of Wedgwood and the fashion for collecting Wedgwood in the nineteenth century', *Journal of the History of Collections*, 4:2 (1992), 239–56.

5 Clive Wainwright, *The Romantic Interior* (New Haven and London, Yale University Press, 1989), pp. 5–6, and Bevis Hillier, *Pottery and Porcelain, 1700–1914, England, Europe and America* (London, Weidenfield and Nicolson, 1968), p. 296.

6 All of these women, chosen for their familiarity to a nineteenth-century public, were mentioned in the first book in English to deal with the history of ceramics, which was published by Joseph Marryat in 1850.

7 Joan Wilson, 'A Phenomenon of Taste; The China Ware of Queen Mary II', *Apollo*, 96:3 (Aug. 1972), 116–23.

8 Margaret Cavendish Holles Harley collected on a grand scale, from natural history specimens to objects of art and historical association. The sale of her collection, after her death, lasted for twenty-eight days and included the famous Portland vase (now in the British Museum) as well as a large quantity of 'fine old china'. The inheritance of an income of £12,000 a year upon her mother's death in 1755 and widowhood in 1762 when her children were adult allowed the Duchess of Portland the leisure and means to pursue her collecting proclivities.

9 Lady Betty Germaine, a widow with few responsibilities and a sufficient income, was well placed to collect ceramics. Apart from china she had a predilection for Tudor and Elizabethan relics. Some of her pieces were bought by Horace Walpole, who acknowledged the importance of her collection and that of the Duchess of Portland in the 1784 edition of his 'Description' which detailed his own collections.

10 Madame de Pompadour, the mistress of Louis XV, was not only a collector of French porcelain but through her influence with the King, ensured the financial stability of the Vincennes/Sèvres factory.

11 Montague J. Guest (ed.), *Lady Charlotte Schreiber's Journals; Confidences of a Collector of Ceramics and Antiques throughout Britain, France, Holland, Belgium, Spain, Portugal, Turkey, Austria, Germany, from the year 1869–1885* (London and New York, The Bodley Head, 1911), vol. 1 p. xxvii.

12 One of the very few early examples of a collector attempting to classify her collection of 'old china' can be found in a manuscript detailing the ceramics owned by Lady Banks, which is dated, 1807. See Rose Kerr, 'The Chinese Porcelain at Spring Grove Dairy', *Apollo* (Jan. 1989), 30–4.

13 Daniel Defoe, *A Tour thro' the whole Island of Great Britain* (1724–27), ed. G. D. H. Cole and D. C. Browning (London and New York, 1962), vol. i, p. 166.

14 E. S. De Beer (ed.), *The Diary of John Evelyn* (Oxford, Oxford University Press, 1955), vol. iii,

p. 60. This is thought to be one of the earliest references to the use of porcelain for the table.

15 In the painting *The Spendthrift* by Cornelis Troost (1697–1750), now in the Rijksmuseum, Amsterdam, a woman is condemned for her collecting habits. The room is full of art objects, including china, and she is in the process of receiving a dealer who brings her more.

16 Lord Macaulay, *History of England* 3rd edn. (1855), p. 56.

17 Charles Lamb, *The Essays of Elia* (London, 1903; publ. 1823), p. 332.

18 There are obvious similarities to be found in this century's chinamania and that of the late nineteenth century, when 'blue and white' was all the rage.

19 John Ayers, Oliver Impey and J. V. G. Mallet, *Porcelain for Palaces: The Fashion for Japan in Europe 1650–1750* (London, Oriental Ceramic Society, 1990), p. 24.

20 Neil McKendrick, John Brewer and J. H. Plumb, *The Birth of the Consumer Society* (London, Hutchinson, 1983), pp. 100–45, 1st edn. 1982.

21 Craig Clunas, with the hindsight of a twentieth-century perspective, argues that women bought Oriental goods as a means of claiming a cultural space. See 'Chinease Furniture and Western Designers', *The Journal of the Classical Chinese Furniture Society* (Winter 1992), 58–70.

22 Joseph Marryat, *Collections Towards a History of Pottery and Porcelain* (London, 1850), p. 289. Mrs Hawes was the mother of an MP. Marryat illustrates four Oriental teapots from her collection on p. 239 of the 1857 edition of his book.

23 Marryat's lists were not assembled on any scientific basis and are offered as an indication of the increasing interest in ceramic collecting rather than as a definitive statement.

24 Sèvres was first sold second-hand in 1781. See Gerald Reitlinger, *The Economics of Taste* (London, Barrie and Rockliff, 1963), vol. ii, p. 575.

25 *Dictionary of National Biography* (Oxford, Oxford University Press, 1973), vol. xv, p. 114.

26 Lady Dorothy produced several anecdotal books of reminiscences edited by her son. See also Bevis Hillier, 'The Dolly Monologues', *Cornhill Magazine* (Spring 1967).

27 The museum did acquire two important and more diverse collections of ceramics before 1855. These were a section of the Enoch Wood collection of largely eighteenth-century Staffordshire pottery and over 700 pieces of English, Continental, Oriental and Islamic ceramics from the collection of James Bandinel.

28 Quoted in Revel Guest and Angela V. John, *Lady Charlotte* (London, Weidenfeld and Nicolson, 1989), p. 207. This is the most recent biography of Lady Charlotte Schreiber, examining her background, character and the source of her wealth (her first husband's iron foundry in Wales) within the context of nineteenth-century society.

29 Women writers on ceramic subjects, though not common, could be influential. None was more so that Eliza Meteyard (1816–79), who wrote the standard life of Josiah Wedgwood, published in two volumes in 1865–6. She continued to produce work on the Wedgwood factory until the end of her life.

30 Major H. Byng Hall, *The Bric-A-Brac Hunter; or Chapters on Chinamania* (London, 1875), p. v. Byng appears to claim in his Preface that his book is an enlarged version of an earlier work.

31 Byng, *The Bric-A-Brac Hunter*, p. 284 and p. vii.

32 For example, Alice Morse Earle, *China Collecting in America* (London, 1892), and Charles Edward Jerningham, *Curio Collectors Guide, Being a guide to the Dealers in art, old furniture, curios, old plates, rare books etc.* (London, 1910).

33 Joan Evans, *A History of the Society of Antiquaries* (London, Oxford University Press, 1956), pp. 388–9.

34 J. C. Robinson, *Catalogue of the Soulages Collection* (London, Dec. 1856), p. iii.

35 The minute books, signing books and other documents are in the National Art Library, Victoria and Albert Museum. The Fine Arts Club is the subject of the present author's 'The

Collectors of Fine Arts Club 1857–1874. The First Society for Collectors of the Decorative Arts', *The Decorative Arts Society Journal* (18, 1994), 25–30.

36 An informal ceramic collectors club flourished in America in the 1870s. Largely, though not exclusively, a society of women, its activities were published in 'The Youngest member', *The China Hunters Club* (New York, 1878).

37 Anthea Callen, *Angel in the Studio. Women in the Arts and Craft Movement 1870–1914* (London, Astragal Books, 1979), pp. 53–5.

38 A series of books devoted to the improvement of middle-class household decorative taste appeared in the 1870s. The first volume, W. J. Loftie, *A Plea for Art in the House* (London, 1876), deals exclusively with the beneficial effects of art objects in the home. Furniture, paintings and ceramics are discussed in these terms. The author admits to a preference for Oriental porcelains and warns against turning a home into a museum with crowded shelves of dingy German stonewares or Greek vases.

39 Howard Coutts, 'Cosmopolitan Collectors', *The Antique Collector* (Apr. 1992), 68–73.

40 Lady Charlotte notes American collectors in the field in October 1879: Guest (ed.), *Lady Charlotte Schreiber's Journals*. vol i, pp. 233–4.

41 I am grateful to Mr Woody Johnson for new information on women collectors of Wedgwood.

42 The collection of Francis Sibson MD will form the subject of a forthcoming article by the present author.

43 Lady Charlotte does not include the Worcester vases that she had been given by Mrs Fortescue in the gift to the South Kensington Museum because of the lady's objection. Lady Charlotte commented, 'I do not understand the feeling. They would be much safer there than here – and would remain quite as much mine': Guest (ed.), *Lady Charlotte Schreiber's Journals*, vol i, p. 435.

44 Mrs Palliser was an exception to this. She edited the second edition of her brother's book on ceramic history, translated several works on art and ceramics from French into English and wrote her own collectors guide to ceramics in 1874.

45 *The Art Journal* (1869), 239.

46 Preface to *Schreiber Collection Catalogue of English Porcelain, Earthenware, Enamels, etc.* (London, 1885) p. x.

47 Guest (ed.), *Lady Charlotte Schreiber's Journals*, vol. i, p. 492.

48 This article does not propose to look in detail at the Schreiber collection. Two revised editions of the catalogue were published by Bernard Rackham from 1915 to 1930 and more recent contributions are in the *Antique Dealer and Collector's Guide*, Jul., Aug. and Sept., 1983, under the authorship of Anton Gabszewicz. See also J. V. G. Mallet, 'Collecting and the Study of Chelsea Porcelain' in Margaret Legge (ed.), *Flowers and Fables. A Study Survey of Chelsea Porcelain 1745–69* (National Gallery of Victoria, Australia, 1984).

49 Guest and John, *Lady Charlotte*, p. 227.

50 Art Museum Register of Loans, Books C and D, Victoria and Albert Museum.

51 In contrast, Herbert Allen, who collected specifically to fill in the gaps in the Schreiber collection, and Arthur Hurst, who also assembled and donated a fine group of porcelains to the museum in this century, are largely forgotten men, their gifts dispersed amongst the museum's displays.

PART III

THE MAKING OF
THE WOMAN ARTIST

Amusement or instruction? Watercolour manuals and the woman amateur

Francina Irwin

'IT is with feelings of national exultation that we can ascribe in a great degree this improvement in so elegant a department of the fine arts to our lovely countrywomen.' This ecstatic eulogy on watercolour painting appeared in the introduction to *Ackermann's New Drawing Book of Light and Shadow* published in 1809. It continued: 'It is to the cultivation of the study of drawing in watercolours by the enlightened ladies of our time, that the best artists have owed their encouragement and the patronage of the fair sex has thus produced an epoch in art which will be a lasting honour to the country'. Although this needs to be tempered by the knowledge that Rudolph Ackermann's 'lovely countrywomen' were amongst his best customers, nonetheless his recognition of women's role in the surge of enthusiasm for watercolour painting that hit this country from the 1790s was perceptive.

The firm of Rudolph Ackermann played a significant part in the spectacular expansion of amateur art over the same period. At his Repository of the Arts in the Strand all necessities for painting in watercolour could be found: a variety of paper, brushes, crayons, and paint-boxes. By 1801 he could offer solid cakes of watercolour in sixty-nine different colours, stamped with his trademark. He also stocked a wide range of instructive manuals, in addition to those he published, and hired out prints for copying. A list of painters whose work he offered for sale in 1815 included David Cox, Peter De Wint, Thomas Girtin, J. M. W. Turner and other acclaimed watercolourists. No wonder that his customers were familiar with the latest developments in the professional world.

The instructive manual was by no means a new phenomenon; however, the emphasis on what subjects were considered worthy of study had shifted by 1800.

The Complete Drawing Master, published in 1766 with a hundred plates to be copied, usefully sums up eighteenth-century priorities. Beginning with parts of the human body from eyes and noses to legs and feet, it continues with plates of the 'Passions' illustrating the face overcome by astonishment, rapture, horror and many other emotions. These had been classified by Charles Le Brun in his *Treatise on Expression*, published in France in 1667 at a time when expression played an important role in history painting. The rules were still regarded as significant a hundred years later in Britain. Plates of classical figures both nude and draped follow, leading on to landscape, which was traditionally considered a lesser genre. These mid eighteenth-century landscape plates are of a very different kind from those that appeared in manuals from the 1790s onwards: parkland with strolling figures reminiscent of Watteau; classical ruins; a rural scene with a waterfall and a male figure sketching after Svanveldt. Then come horses, their anatomy analysed with almost the same thoroughness as humans had received. Finally a variety of lighter plates are offered, which could equally well be adapted for embroidery: a playful dog, flower posies, goldfinches perched on a rose spray and a chinoiserie design. By the close of the eighteenth century, manuals had become far more specialised and the text formed an integral part.[1] Books of instruction on landscape or flower drawing outnumbered works dealing with other areas.

Who were the people for whom the instructive manuals on drawing and watercolour painting were written, and why should they have wanted to learn? both sexes practised as amateur artists, and women often chose to have their portraits painted holding a crayon or a brush, pointing to a sketch they had done, thereby demonstrating the importance of their artistic activities in their lives. This identification with the artist helped to narrow the gap between patron and painter. The sitter at such a portrait session is likely to have been given a free lesson or two during the course of the sitting.

Reasons given for men and boys learning to draw were often practical. Drawing was seen as being an additional but wordless means of communication, a 'graphic language'. This was useful in an age when everything was custom-made. Somebody who could sketch their proposed garden pavilion or new library shelving would be far more likely to get what they wanted. The advantages of being able to record territory and buildings were also apparent in the army and navy where drawings were necessary for reconnaissance purposes, a boy who could offer this skill would therefore get a head start when joining up. The first of these reasons applied equally to women, who could sketch a new bonnet for their milliner or decree the shape of a chaise longue.

The expression 'polite accomplishment' has been a disservice to the whole concept of the woman amateur artist, suggesting as it does the acquirement of

a skill for social reasons. A fair number of the girls on whom drawing had been imposed along with the three Rs in the schoolroom would have continued to draw and paint because it gave them pleasure and interest. Pleasure was the impetus that filled the drawing classes run by Alexander Nasmyth and his five daughters in Edinburgh during the period of the Napoleonic Wars.[2] The inaccessability of the Continent boosted attendances, and instruction in the studio was supplemented with rural expeditions to sketch and picnic in the surrounding countryside. As James Nasmyth recalled in his autobiography: 'the Nasmyth classes soon became the fashion. In many cases both mothers and daughters might be seen at work together in that delightful painting room.'

Why was watercolour considered an ideal medium for women? Ridiculous as was the message handed on from an elderly acquaintance by Rose to her sister Agnes in Mary Ward's *Robert Elsmere* (1887), it must surely reflect a more widely held prejudice: 'I informed her, Agnes, that you had given up water-colour and meant to try oils and she told me to implore you not to, because water-colour is so much more lady-like than oils.' Possibly the smell of the oil medium was considered offensive, just as real ladies did not eat strong cheeses.

The portability of watercolours and equipment was much in their favour at a time when landscape painting was burgeoning. Easels were by no means essential for watercolour since a sketch pad or paper stretched on a small board could be held on the knee see [19]. Watercolour gives faster results than oil, and a beginner's progress was more demonstrable. One view could be completed in a single lesson and another begun, allowing errors to be quickly rectified. Moreover, with so many professional watercolour painters practising, there was a wide choice of masters in the medium.

Learning from a professional painter was undoubtedly the best option but, in the absence of a reliable drawing master in the locality, a manual illustrated and often written by an artist of standing was an acceptable substitute. It could also provide instruction between lessons. To judge from the proliferation of these manuals by the start of the nineteenth century, there was an insatiable market ready to welcome them.

Subscription lists for some of the earlier manuals tell us a lot about the readership. Sadly such lists ceased to exist early in the nineteenth century. Among over 200 subscribers for *Dr Brook Taylor's Method of Perspective Made Easy*, published in 1754 with a witty frontispiece by Hogarth, only two were women. Perspective as a subject may have held little appeal for women, since geometry would not normally have been included in a girl's education. The tide was, however, reversed in 1808 when the subscribers' list for Mary Gartside's *Ornamental Groups Descriptive of Flowers, Birds, Shells, Fruit, Insects, etc.*, numbered 151 women out of a total of 193 names.

Mary Gartside had all the right qualifications for both teaching and writing about her speciality of flower painting. She can presumably be identified with the Miss Gartside who showed botanical drawings at the Royal Academy in 1781 and at the Associated Artists in Water Colours in 1808.[3] Her manuals were published between 1805 and 1809. Nothing else is known about her. Of the subscribers for

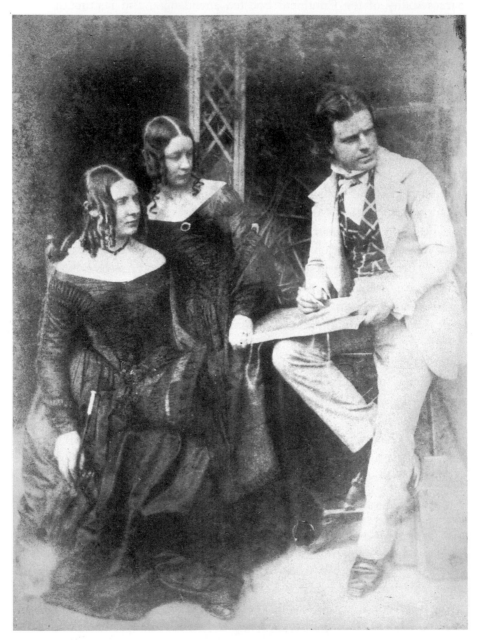

19] David Octavius Hill, *The Sketching Lesson*, mid 1840s, calotype

her book, Queen Charlotte, who was a serious botanical painter, headed the list. She was followed by the Princess of Wales and by Princess Elizabeth, who was noted for her aptitude in drawing. Forty of the other subscribers were titled, including the Duchess of Northumberland and Lady Sophia Grey of Dunham Massey, Cheshire, to whom Mary Gartside had dedicated her earlier book. It was at this level of society that women had the leisure to practise painting.

The geographical spread of the subscribers is of great interest, and it is note-worthy that London, although it accounted for thirty-five names, does not pre-dominate. The cities of Manchester and Liverpool together with the counties of Lancashire and Cheshire produced thirty-seven subscribers between them. Leeds, Wakefield, Pontefract and the county of Yorkshire accounted for eleven, leaving a scattered handful of seventeen shared between Cornwall, Shropshire and Wales. Of course these areas reflect only Mary Gartside's personal sphere of influence. At the same time numerous amateur artists were flourishing in and around Norwich, throughout Scotland and elsewhere.

A number of subscribers may have owned London residences and come to the capital for the season. However, there is evidence that drawing instructors travelled round the country, setting up at a patron's house to teach the family and probably friends and neighbours as well. Mary Gartside herself may have followed this practice; to judge from the liveliness of her ideas as expressed in the text, she would have been a welcome and stimulating visitor to a family where art was taken seriously. Although other women taught drawing, she was unusual in publishing her theories.

Mary Gartside's first book, published in 1805, was *An Essay on Light and Shade on Colours and on Composition in General*. It was dedicated to the Rt. Hon. Sophia Grey and the readership aimed at was 'my pupils'. The second edition of 1808 was considerably expanded and used to further explain the most splen-did of her publications of the same year: *Ornamental Groups Descriptive of Flowers, Birds, Shells, Fruit, Insects etc. and illustrative of a new Theory of Colouring from Designs and Paintings by M. Gartside. The whole engraved and coloured under her immediate inspection* . . . Her system of colour blots was designed to teach pupils to take an overall view with regard to warm and cold colours and effects of light and shade before embarking on a flower composition. 'I shall . . . suppose . . . that each blot is a group of flowers, but must at the same time observe, that they have not been formed with the most distant idea of their being examples in respect to the contour of flowers'. The blots are arranged in varying tones indi-cating light and shade in relation to colour, and each area is given an alphabet letter for reference purposes; they are of course hand coloured. Gartside illus-trates the system by considering the application of a scarlet blot to a group of scarlet flowers:

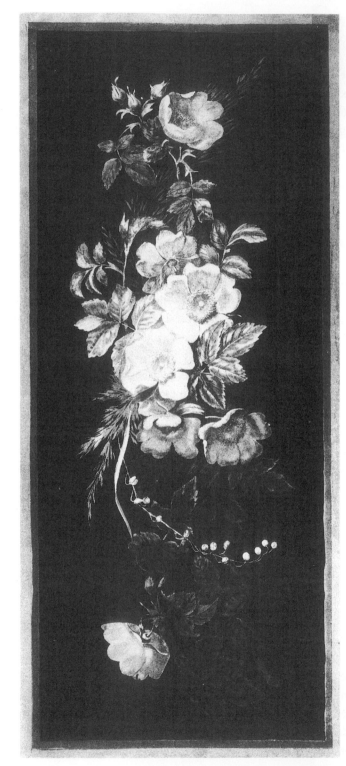

20] Mary Gartside, plate from *Ornamental Groups Descriptive of Flowers, Birds, Shells, Fruit, Insects, etc.* (1808)

Suppose A to be a field poppy so placed that the light shall strike fully upon it and give it all the brilliancy possible; while another part of the flower, without being in shade, should be so much out of the light as to show its true colour . . . At B and C I would place more poppies that should share the light with that of A, but have less brilliancy.

Mary Gartside was very forward-looking in supplying principles which could be adapted to a variety of compositions. Her *Ornamental Groups* carries this a stage further by considering 'Invention and Design' [20]. She admired Hogarth's 'Line of Beauty' and adapted it to her arrangements. His serpentine line lent itself extremely well to the grouping of flowers of different species. Fifteen out of the eighteen plates have dark or black backgrounds. In this she is likely to have been influenced by Mrs Delany, whose enchanting paper collages of natural flowers had delighted court circles until her death in 1788 and who used black grounds almost exclusively to show up her flowers.

Anyone who has attempted to paint flowers will be aware of the infinite gradations of colour in their petals and will not be surprised to learn that flowers often went hand in hand with colour theory. Mary Gartside was knowledgeable about this and referred her readers to Moses Harris' *The Natural System of Colours* (1776).

Another author of popular instruction manuals was the great botanist and botanical illustrator James Sowerby, whose *English Botany* in 36 volumes was published between 1790 and 1814, and who had been a drawing teacher earlier in life. In 1807 the second edition of Sowerby's *A Botanical Drawing Book. An easy Introduction to Drawing Flowers According to Nature* appeared. Two years later he published his *New Elucidation of Colours* (1809). It was not intended for amateur painters and Sowerby did not link up his ideas on colour with what he had written in his *Botanical Drawing Book*. The only page of actual instruction in this flower manual relates to the application of opaque colour commonly known as body colour, the use of which remained controversial in watercolour circles since it counteracts the natural transparency of the medium. Sowerby recommends it as giving 'additional force or finishing to any subject well managed', such as the hairs on the back of a leaf. His delicate watercolour drawings of flowers and their stamens and seed pods and his beautifully depicted fungi are a delight to the eye.

The progressive method to be discussed in relation to landscape was also used for flower painting. Ackermann's manual on flower painting 'upon botanical principles' (2nd edition 1802) presented three stages: firstly an outline drawing, secondly the brushing in of colours and lastly the addition of detail such as spots on a lily or veins on leaves. The botanical approach was new. Eighteenth-century flower exemplars had been loosely arranged posies tied

with ribbon. The flowers, although of recognisable types, were drawn without fresh recourse to nature.

A manual published in 1816 is more remarkable for its title than for its contents; *A New Treatise on Flower Painting or Every Lady her own Drawing Master* brackets 'flowers' and 'ladies' firmly together. Indeed it was botanical drawing that was considered to be an ideal field for women amateurs and a number of manuals were written for them. Regardless of the weather, botanical specimens could be procured for painting indoors, whilst the advance in hothouses and conservatories meant that many blooms were available throughout the seasons. A number of amateurs excelled in this branch; Lady Canning's drawings made in the Botanical Gardens at Calcutta in the 1850s and Marianne North's botanical studies at Kew are two outstanding examples.

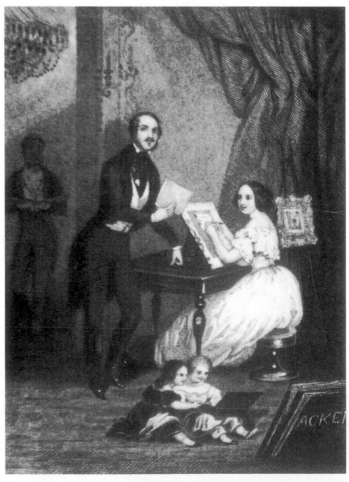

21] *Artium Protectores*, frontispiece in T. H. Fielding, *Ackermann's Manual of Colours used in the Different Branches of Watercolour Painting* (1844)

The word 'progressive' appears in the titles of a number of instructive manuals. It could be applied in more than one context: although it often denotes a progression from easy lessons to more difficult ones, its use can also mean that the author was following the essential stages in a specific order. Such stages conformed to the more traditional contemporary practice in landscape painting. Broadly speaking they included outline, laying-in of shadowed areas and application of colour. *Ackermann's Lessons for Beginners in the Fine Arts*, published in 1796, is a classic example of the progressive manual. Each landscape plate to be copied is repeated four times and graded from outline, through shading to full colour. The scenes were selected to provide variety, from a stroll in Kensington Gardens to classical ruins in an Italian landscape.

Ackermann's was not alone in the business of selling artists' materials. In 1781 the Society of Arts had awarded their silver palette to Thomas and William Reeves for their improved watercolour paints. Winsor and Newton later joined the field in 1832. Ackermann's was particularly successful in attracting the patronage of the young Queen Victoria. In 1844 the Queen and Prince Albert were represented on the frontispiece of *Ackermann's Manual of Colours used in the Different Branches of Watercolour Painting* by T. H. Fielding [21]. The presence of the Royal pair as 'Artium Protectores' must have greatly boosted sales of this publication, which is as much a catalogue of Ackermann's wares as a manual. An impressive list of what the company could offer by the mid century was tucked into the lid pocket of Queen Victoria's own paint box (now in the permanent collection of the Royal Academy of Arts, London). The box, supplied by Ackermann's, was veneered in rosewood and inlaid with patterns in mother-of-pearl. Its topmost tier contained two cut-glass water jars and the paints themselves laid in neat rows. In drawers below were a porcelain bowl and six mixing palettes.

By the time she owned this box, Queen Victoria was already an experienced amateur painter of more than fifteen years standing. In 1827 she had been given her first lessons in drawing by Richard Westall (1765–1836), an artist much admired by his contemporaries, who was considered a suitable instructor for a royal princess. He was a subject painter and illustrator, and as a watercolourist he was ranked amongst the founders of the new art. A pencil copy by Queen Victoria of a country girl going to market with a basket over her arm survives at Windsor, together with Westall's original outline drawing. This kind of subject may have led to her predeliction for drawing the human figure, a topic which was not covered by the manuals at this time. She was later to make use of her skills in her delightful sketches of her children, many of which were then etched by Prince Albert and herself. They took etching lessons from Edwin and Thomas Landseer.[4]

Queen Victoria was also a competent landscape, painter, numbering amongst her instructors Edward Lear, Edwin Landseer and the Scottish land-scapist William Leighton Leitch. Her views were mostly painted at Osborne House and in the Highlands of Scotland or whilst cruising on the Royal Yacht. Her attention may first have been drawn to landscape painting by a manual published in 1827 and dedicated to the Duchess of Kent by the otherwise scarcely known John Clark. Entitled *A Series of Practical Instructions in Landscape painting in Water Colours; Containing directions for sketching from nature and the application of perspective – progressive lessons in drawing from the tinted sketch to the finished subject – and examples of the introduction of figures, architectural subjects, particular effects, etc. as connected with landscape scenery*, this promised a wealth of information and was prefaced by a somewhat sycophantic dedication: 'Permit me, Madam, to hope that the Progressive lessons on Landscape Painting, may afford amusement if not instruction, to your illustrious Daughters.' The daughters of the Duchess of Kent were Princess Victoria and her half sister Feodora. It is not impossible that Clark was angling for the post of drawing master to the family, but if so he was unsuccessful, for the following year Westall was appointed to teach the future Queen.

John Clark's *Practical Instructions . . .* was the most elaborately produced of all nineteenth-century manuals. It was sold in the form of two sets of four folders, one containing slim texts and the other illustrations. All were encased in a box simulating a leatherbound volume that would slip neatly into a book-case. Each plate was mounted on grey card so that it would not be spoiled by handling and could be propped up for copying purposes. Clark used the language of the eighteenth-century picturesque movement and held up as models for the student's admiration the Dutch seventeenth-century landscape masters, along with Claude Lorraine, Salvator Rosa and others beloved by the eighteenth century. There is no mention of contemporary watercolour painters such as J. M. W. Turner. It is perhaps significant in this context that Queen Victoria added no paintings by Turner to the Royal Collection during her reign.

Great strides had been made in printing techniques since the hard engraved outlines and hatched shading of *The Complete Drawing Master*. Soft ground etching could simulate chalk or crayon. However, it was the invention of aquatint, which came into use in the 1770s, that opened up wider possibilities. Since it could imitate the effect of a watercolour wash, it figured frequently in the teaching manuals, either alone or together with watercolour applied by hand. Both Samuel Prout and David Cox took advantage of aquatint for the illustrations to their most important manuals, which were first published in 1813, an occurrence which indicates the strength of the market.

Cox was primarily a teacher not a theorist, and it was 'The urgent and

22] David Cox, plate 1 from *A Treatise on Landscape Painting and Effect* (1813]

repeated solicitations of many of his pupils that induced the author of this work to submit to the public these remarks. His book was dedicated to a possible pupil, the Marchioness of Stafford, who in 1807 had published her etchings under the title *Views in Orkney and the North Eastern Coast of Scotland*. Book illustration was an area in which women amateurs made a distinct contribution throughout the nineteenth century. *A Treatise on Landscape Painting and Effect in Watercolours from the first Rudiments to the finished Picture with Examples in Outline, Effect and Colouring* by David Cox appeared in twelve monthly parts [22]. It was republished in 1840 to influence another generation of amateurs. As his publisher remarked in a letter dated 31 January 1840, 'It is now six-and-twenty years since we published your work . . . and during this time a new family and many aspirants to the art have appeared, and many are forthcoming . . . Time has passed away and many changes have taken place, but I do not think myself that anything has been added by those who have brought out similar publications.'

Amongst this new generation was Barbara Bodichon, who would have been at the impressionable age of thirteen or fourteen when the new edition of Cox's *Treatise* appeared in 1840. She was presumably a direct pupil since she referred to him as 'Dear old David whom I love so much'. Several of the titles she chose for her watercolours show her interest in depicting 'effect': *Mountainous landscape with stormy sky* and *Afternoon, a sketch*. Closest to Cox is her *Near the Land's End*, in which she captures the effect of a windy day with spray blowing up over the cliffs whilst a solitary figure, hair and dress billowing behind her, seems dwarfed by the immensity of nature. The word 'effect' meant landscape seen at

different times of day, or at different seasons of the year or under varying weather conditions. It could be stretched to cover thunder storms, snow, rainbows and the blustery showers that Cox painted so convincingly. Cox was making a positive attempt to guide the student away from slavish copying:

> The best and surest method of obtaining instruction from the Works of others is not so much by copying them, as by drawing the same subjects from nature immediately after a critical examination of them, whilst they are fresh in the memory. Thus they are seen through the same medium, and imitated upon the same principles, without preventing the introduction of sufficient alterations to give originality of manner, or incurring the risk of being degraded into a mere imitator.

In 1840 when consulted by a college friend on finding a suitable drawing master, Ruskin replied, 'if you take lessons at all, take them from the best. One lesson from them, which will cost you a guinea is worth three from others, which will cost you a shilling each. The choice lies between three – Harding, De Wint and Cox.' He went on to characterise each of the three masters, saying of Cox, 'He is a man of dew: his sketches breathe of morning air, and his grass would wet your feet through . . . His mountains are melting with soft shadows, and his clouds at once so clear and so vaporous, so craggy and so ethereal, that you expect to see them dissolve before you.' Ruskin's attitude to Cox was

23] Samuel Prout, plate from *The Rudiments of Landscape*, (1813)

ambivalant, however, and he advised Peter De Wint as the best master for his friend.

In Ruskin's view Samuel Prout was not a colourist like Cox but 'a draughts-man with the lead pencil as Dürer was essentially a draughtsman with the burin'. Prout's view that new buildings were 'unfit for pictorial representation', owing to their regular lines and uniform colour, sent his readers looking for tumble-down cottages with irregular outlines and varied surfaces, brickwork showing through plaster or tiled roofs invaded by moss [23]. His illustrations, with their latticed windows and their emphasis on any decorative stone- or woodwork, look endearingly like gingerbread houses. It was easier to succeed in depicting these rural habitations than to paint a landscape in Cox's manner.

Prout's book of 1813, *The Rudiments of Landscape in Progressive Studies Drawn and Etched in Imitation of Chalk*, was also published by Ackermann in parts. The author's teaching activities put him in a position to be able to state that: 'In every polite family the art of drawing is now cultivated by some of its members and although the greatest love for so pleasing an amusement is evinced, it is to be deplored that so few amateurs excel in this art whilst so many can be found to excel in the science of music'. He did not specify which sex predominated amongst his pupils; however in 1813–14 he was teaching the Misses Barlow to draw and supplying them with numbers 2 and 3 of *The Rudiments*.

Prout provided numerous practical hints to help his pupils. He advocated the dating of drawings so progress could be measured. He advised building what he called a grammar of the art, by drawing from nature such subjects as hedgerow plants, dock leaves, posts, stiles and railings, in fact anything that might be incorporated in the foreground of a landscape, to be kept for refer-ence.

Although his name is still inevitably associated with English rural architec-ture, he became renowned in his own time for his Continental views, which were widely known through lithographs and the steel engravings in *The Landscape Annual* and other publications. Gallery-goers in London could see his paintings annually displayed at the exhibitions of the Old Watercolour Society. He became an insatiable traveller in Northern Europe and Italy. His way of seeing and representing buildings and streets abroad was of considerable influ-ence on his contemporaries. His prints were to the new wave of travellers after the Napoleonic Wars what Piranesi's views of Roman antiquities had been to the followers of the eighteenth-century Grand Tour. As travel increased and the range of destinations broadened, many women must have been thankful to Prout for showing them a way to record their visual impressions. When Sophia Lady Dunbar was on her sketching tour round Spain and Portugal in 1860–61, she was reminded of the artist by the 'Prout-like houses jutting over the

pavement' in Barcelona. Although Prout himself had never painted in Spain, Lady Dunbar had adopted his way of seeing old buildings and was able to apply the principles wherever she went.

'Leading the student step by step to the power of drawing from nature' was what Prout professed to be doing through his lessons in *The Rudiments of Landscape*. Ruskin would have found this goal sympathetic, but when he came to write *The Elements of Drawing* he reversed the process. Rather than leading his reader gently up to nature, he plunged almost straight in by teaching them to observe the natural world direct: 'Choose any tree that you think pretty, which is nearly bare of leaves and which you can see against the sky . . . it must not be against strong light, or you will find that looking at it hurts your eyes . . . you will see that all the boughs of the tree are dark against the sky, consider them as so many dark rivers to be laid down in a map with absolute accuracy'. This is how the first open-air lesson begins, after the use of the pen and pencils has been discussed and preliminary practice in shading has been mastered.[5]

Ruskin appears to have had the ideal qualifications for writing an instructive manual since he started himself as an amateur took lessons from Copley Fielding and J. D. Harding, studied Prout's manuals and painted with Prout. He was an acclaimed critic and writer on art, and since 1854, had been teaching landscape painting at the Working Men's College in Red Lion Square where Rossetti taught life drawing. The methods used in *The Elements* were related to his live practice, with modifications to allow for the fact that his pupil would be learning in isolation.

When consulted by a young correspondent in 1855 about a suitable drawing manual for her own use, he replied, 'there is in reality no wholesome, elementary book on drawing', and told her that if she would wait four months for the third volume of *Modern Painters* to appear, it 'will tell you better what you want to know than anything else you could get'. His further comment, that 'Soon I hope to be able to organise some system of school teaching and print a little account of it which may help more still', heralds the publication of *The Elements of Drawing* two years later.

The Preface to this work is packed with startlingly unconventional views. Nothing made Ruskin angrier than the teaching of drawing as a graceful accomplishment 'so as to emulate (at considerable distance) the slighter work of our second-rate artists'. Having demolished manuals which pursued such a course, he stated his own aim and beliefs: 'I believe that the sight is a more important thing than the drawing; and I would rather teach drawing that my pupils may learn to love Nature than teach the looking at Nature that they may learn to draw.'

Ruskin's system of instruction was extremely personal and bore little resem-

blance to the accepted methods of introducing amateurs to landscape painting, one of the basic tenets of which was that the study of light and shade should precede, and be detached from, instruction on colour. A given landscape was worked out in varied tints of sepia or indian ink from the sky to the foreground, before colour was even considered. This system was set out in the manuals of both Prout and Cox and in those of other drawing instructors. Cox stated the case clearly and as if there were no alternative:

> The outline being completed in the manner prescribed by the foregoing instructions, LIGHT SHADE and EFFECT, should be studied in sepia or Indian ink, by which a clearer conception of each will be acquired than if practised in colours; the variety of the latter tending to perplex the mind, and to divert it from the main object. Colouring is a distinct and subsequent branch, and is only to be learnt by long and minute observation of the diversified tints and hues of Nature. The principle of Light and Shade, on the contrary, is established by theory.

Ruskin stated emphatically in his Preface to *The Elements of Drawing*: 'I believe that the endeavour to separate, in the course of instruction, the observation of light and shade from that of local colour has always been and must always be, destructive of the student's power of accurate sight'.

Ruskin's abandonment of illustrations as exemplars to be copied was another striking departure from usual manual practice. His sketches are deliberately uncopiable, and in one instance he added a footnote to explain that his figure illustrated in the text was merely 'a facsimile of the sketches I make at the side of my paper to illustrate my meaning as I write, often sadly scrawled'. Instead, he directs the student living in London and learning to draw leaves to 'test your progress accurately by the degree of admiration you feel for the leaves of vine round the head of the Bacchus in Titian's *Bacchus and Ariadne* (National Gallery). A Rembrandt etching and Turner's engraved works, in particular the *Liber Studiorum*, are also suggested as examples for specific exercises. Ruskin's mellifluous prose could make the drawing in pencil of a rounded pebble picked up in the garden an enjoyable game of discovery in observation, with a demonstration to explain reflected light thrown in. He had done the same exercise using a sea urchin, which is illustrated, ensuring that the student can see what he means but cannot copy. 'Now if you can draw that stone you can draw anything,' Ruskin promised: 'All drawing depends primarily on your power of representing roundness . . . for Nature is made up of roundnesses . . . Boughs are rounded, leaves are rounded, clouds are rounded, cheeks are rounded . . . therefore set yourself steadily to conquer that round stone, and you have won the battle.' This lesson teaches students to observe light and shade for themselves and to convey it using a lead pencil in even gradations. The original rounded pebble reappears a few exercises later, this time to be shaded with

washes of colour, the reader having been taught to use a brush.

There was no need to be a prospective student of drawing and watercolour to enjoy reading *The Elements of Drawing*, since it is almost equally concerned with the appreciation of both nature and art. The sections on colour contain some of Ruskin's most poetic passages: 'Of all the great colourists Velasquez is the greatest master of the black chords. His black is more precious than most other people's crimson.' Ruskin's supposed readership for *The Elements of Drawing* was not entirely clear at the time it appeared, as can be seen in his correspondence with Anna Blunden, then in her late twenties.[6] Anna had started her career as a governess, but abandoned this work for the uncertain prospect of painting, inspired by the first volume of *Modern Painters*. She pursued Ruskin by letter, and by 1856 he was giving her advice on her painting career, agreeing the following May to see her with her sketches. She had already been successful in exhibiting at the Royal Academy and the Suffolk Street Gallery (Society of British Artists). Her picture *The Daguerreotype* was hung on the Line at the Royal Academy in 1857, so Ruskin had seen her paintings.

Anna had written to Ruskin about *The Elements of Drawing* in the year it was published and had misconstrued his reply as referring to herself in a derogatory way. Reassuring her on 11 December that year, he wrote:

> I did not mean you when I spoke of idle young ladies, because I never thought of your considering yourself in any way a beginner. The whole plan of the book is rested not on an idea of reteaching persons who have learned to draw already, but of giving simple guidance to those who know nothing of drawing. In general persons who have drawn landscapes have merely blotted – and not drawn anything. And to them the book must imply an entire overturn of all previous thought and practice, if it be accepted at all – but persons who have drawn the figure will generally have got at most of the power it proposes to give, already, and need only take from it such hints as they feel useful.

Many women amateurs would have preferred Aaron Penley's *The English School of Painting in Water-colours . . .* (1861) to Ruskin's inspired but idiosyncratic tuition. Penley was proud of the forty-eight plates reproduced by chromolithography, an advance in colour printing which meant, as the author claimed, that 'We are occasionally in doubt whether we are looking at a drawing or a print.' With this new technique, his skies and mountains were far more atmospheric than those that earlier manuals had been able to achieve. Penley's was a popular manual and went into several editions. Anna Forbes Irvine of Drum Castle, Aberdeenshire, owned the 1868 edition. The survival of her copy, together with her sketch book and paintbox, provides rare concrete evidence of the interrelationship of theory and practice [24].

In addition to those aspects which were taught by manuals, women also

24] Anna Forbes Irvine, *Ballochbuie Forest, Braemar*, 1850, pencil and watercolour, 19 × 25 cm

practised in other areas of amateur art. These included book illustration, whether for personal pleasure or for a publisher. Queen Victoria and her daughters enjoyed doing literary illustration, especially Princess Alice who illustrated several of Tennyson's poems. Louisa, Marchioness of Waterford, published an edition of *The Babes in the Wood* with her own illustrations.[7] Apart from her sister Lady Charlotte Canning, she is perhaps the most highly acclaimed of all British nineteenth-century women amateurs. The murals that she designed and painted in the village school at Ford, Northumberland, on her late husband's estate were begun in 1862. They are the most ambitious of all amateur enterprises and can still be seen *in situ*. Ruskin was both her mentor and a not always kindly critic. He regretted that her talents were being expended on the offspring of Northumbrian farmers when she might be copying the threatened frescoes of Tuscany as a record for posterity. Lady Waterford later reported, 'When I took Ruskin into my school, he only said, "Well, I expected you would have done something better than that."'

Natural history, apart from botany, is another area not covered by the manuals. Brief mention should be made in this connection of Jemima Blackburn, a Scottish amateur whose love of animal drawing earned her the title of 'a Landseer in petticoats' whilst she was still a child. She became renowened for her bird drawings and illustrated several books on natural history including the

often reprinted *The Instructive Picture Book*, for which she designed the cover and which became a nursery and schoolroom classic for the mid nineteenth century.

One of the great pleasures of being a serious amateur artist was the instant camaraderie with other painting women. Sophia Lady Dunbar from Elgin in the north of Scotland, spent a winter in Algiers in the mid 1860s, where she met Barbara Bodichon. They frequently painted in each other's company, either out-of-doors or in Barbara Bodichon's studio. Though Lady Dunbar admired Samuel Prout, whilst Madame Bodichon had been a pupil of David Cox, it seems likely that both were familiar with the manuals written by these artists.

The sisterhood created by a shared love of painting has many strands still to be unravelled. However, it seems clear that the manuals played a key role in spreading an enthusiasm for watercolour painting amongst women in the Victorian art world. The attractive results suggest that careful attention to the instruction offered could lead to many years of amusement, or even to professional advancement.

Notes

1 This essay is based on artists manuals consulted at the British Library and the Yale Center for British Art. Cambridge University Library has more recently been presented with a collection of manuals. Since they are rare and not otherwise easily available, see the useful exhibition catalogue by Peter Bicknell and Jane Munro, *Gilpin to Ruskin. Drawing Masters and their Manuals 1800–1860*. Cambridge, Fitzwilliam Museum, 1988). The manuals will be further discussed in my forthcoming book.

2 For a detailed discussion see Francina Irwin, 'Lady Amateurs and their Masters in Scott's Edinburgh', *Connoisseur*, 187 (Dec. 1974), 230–37.

3 The restrictions on and opportunities for women exhibiting are most usefully discussed in Pamela Gerrish Nunn, *Victorian Women Artists* (London, Women's Press, 1987).

4 For a well illustrated account of Royal amateurs see Jane Roberts, *Royal Artists from Mary Queen of Scots to the Present Day* (London, Grafton Books, 1987).

5 John Ruskin, *The Elements of Drawing*, ed. E. T. Cook and Alexander Wedderburn (London, 1904), vol. xv.

6 For Ruskin's correspondence with three women amateurs, see *Sublime and Instructive, Letters from John Ruskin to Louisa, Marchioness of Waterford, Anna Blunden and Ellen Heaton* ed. Virginia Sutees (London, Michael Joseph, 1972).

7 For a full discussion of Lady Waterford as an amateur painter see Surtees (ed.), *Sublime and Instructive Victorian Women Artists* and Nunn, pp. 174–87.

Barbara Leigh Smith Bodichon: artist and activist

Pam Hirsch

THANKS to the work of feminist historians, Barbara Leigh Smith Bodichon (1827–91) is recognised today as the leader of the Langham Place Group, which for forty years was the centre of feminist agitation in England [25]. During her life, she led four main campaigns: firstly, that married women should be recognised as independent people in law; secondly, that middle-class women should not be debarred from work; thirdly, that women should gain the vote; fourthly, that women should have the same educational opportunities as men, including university education. She helped to found the first university college for women in the country, which began with a rented house and five students at Hitchin in 1869 and developed with her help into Girton College, Cambridge. In her own lifetime, however, she was equally well known both as a landscape painter and as the leader of the women's movement. When Ellen Clayton published her two-volume account of *English Female Painters* in 1876 the first name in the section on Landscape Painters was that of Barbara Leigh Smith Bodichon.

Clayton wrote: 'She has portrayed Nature through the poetical medium of an imaginative spirit, and not from a narrow, artificial, or conventional point of view',[1] This seems especially apt; she was as imaginative in envisioning a full life for women, as she was in her response to nature. Nor, in my view, did she experience any sense of disjunction between her self as artist and her self as feminist activist, despite the fact that the only two biographies fail to give an adequate account of her career as an artist.[2] Yet that is clearly how she identified herself. When she married in 1857 she gave her profession as artist on her marriage certificate. When she died the £10,000 she left Girton came partly from

the paintings she had sold during her lifetime. With the honourable exception of Jacqui Matthews' essay, her diversity of interests tends to be regarded as problematic, rather than as a cause of celebration. In fact Romanticism is the term needed to mediate her ethics and aesthetics; Barbara was a seer in both senses

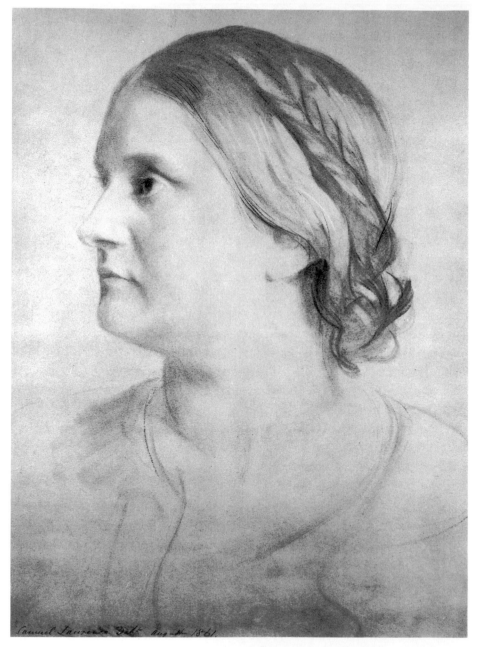

25] Samuel Laurence, *Barbara Leigh Smith Bodichon*, 1861, crayon on buff paper, 35 × 47 cm

of the word, whether she was gazing with righteous anger at the despair of thwarted women or trying to conjure with her brush the movement of water and cloud. Hugh Honour's book on Romanticism shows that there is no simple formula with which we can assign the label 'Romantic', but suggests that it has more to do with 'manière de sentir' (a way of feeling) than any dogma.[3] Further, his dating of Romanticism as contemporary with the French Revolution implies that the Romanticist's rejection of publicly accepted norms and the consideration of new, privately adopted ones may include political as well as aesthetic categories.

To begin with the political, Barbara's activism was learned within the Smith family, one of the First Families of dissent. As Unitarians they were not full citizens in law until 1813, and as a consequence were always at the forefront of campaigns for civil and religious liberty. Barbara's grandfather, William Smith (1756–1835), was the first Unitarian to become a Member of Parliament. He represented Norwich as a Whig for forty-six years, advocating peace with Revolutionary France, parliamentary reform and the removal of religious disabilities. He supported William Wilberforce in Parliament throughout the long campaign against slavery. Barbara's father, Benjamin Leigh Smith (1783–1860) was in his turn Liberal Member of Parliament for Norwich from 1837 to 1847 and was involved with the campaign to repeal the Corn Laws. The family's London house was a centre for radical politicians, American abolitionists and political refugees from Europe. Benjamin's sister, Julia Smith, who helped to raise the Leigh Smith children was a friend of several of the American Women's Rights advocates. Consequently, Barbara grew up knowing as much about framing petitions as framing paintings.

Her career as an artist also began within her family. William Smith was a noted collector of Old Masters and a patron of contemporary artists, including John Opie and the landscape artist John Sell Cotman.[4] Smith's home at 6 Park Street, Westminster, housed an extraordinary collection of paintings, many of which had come onto the market following the French Revolutionary wars. His most famous painting, Rembrandt's *The Mill*, was bought in 1793, together with other Dutch and Flemish paintings by Frans van Mieris, Rembrandt, Rubens and Van Dyck from the Duc d'Orleans' collection. He also owned two landscapes by Claude and several by Nicholas Poussin. He was one of the founders of the British Institution, a gallery in Pall Mall established in 1805 by a committee of subscribers, with a view to encouraging the exhibition and sale of works by contemporary artists. It was also used educationally, which is to say that loan collections of Old Masters were made available for art students to copy. Smith frequently lent the establishment his pictures; for example, when the British Institution put on an exhibition of Dutch and Flemish art in 1815 he loaned *The*

Mill, Aelbert Cuyp's *Horseman and Herdsman with Cattle* and Jacob van Ruisdael's *The Castle of Bentheim*. Through the support of collectors such as William Smith, the Norwich School painters had original Dutch landscapes made available to them for study. William Smith was clearly both a discriminating collector and also deeply committed to the education of artists. Barbara therefore had the great fortune to grow up in a family which was both knowledgable about art and also owned a remarkable collection of original paintings. Unitarians were notable for caring about the education of their daughters, as well as that of their sons, and William Smith employed Francis Nicholson, one of the best water-colour teachers of his day, to give his daughters lessons.

Benjamin Leigh Smith was an unconventional man, even from an unconventional family. His relationship with Barbara's mother, Anne Longden, is shrouded with mystery. At forty he took under his protection a pretty milliner's apprentice of seventeen. She was the daughter of a Norfolk miller, and it appears that his family did not meet her. She died of tuberculosis in 1834 after bearing Benjamin five children.[5] Many Victorian men kept mistresses from a lower class and were fathers to children they did not acknowledge publicly, but this was not the case here. Benjamin Leigh Smith was by all accounts a devoted father, unorthodox in his attempts to give his daughters the same privileges as his sons. When in London, they attended the Westminster Infant School, the first non-charity infant school in England, set up by Benjamin. It was run on Swedenborgian prin-ciples by James Buchanan, formerly a weaver, who had taught at Robert Owen's Lanark school. Although Owen's utopian community was shortlived, some of its ideas were, in effect, transplanted into the minds of the children of the radical middle-class families who attended the Leigh Smith Westminster school. Buchanan educated the children largely by stimulating their imagination with stories from the Bible, tales from the *Arabian Nights* and the teachings of Swedenborg. Barbara wrote that when he visited them at Robertsbridge, Sussex, 'he used to talk much with us in our country walks of the symbolism of nature'.[6] Benjamin, like his father, thought painting was a serious business, and arranged for the children to have lessons from a family friend, William Hunt, Senior.[7] The Leigh Smith children were given endless opportunities for looking, exploring and drawing on family outings. The writer Mary Howitt reported:

> Every year their father takes them out [on] a journey. He has had a large carriage built like an omnibus, in which they and their servants can travel; and in it, with four horses, they make long journeys. This year they were in Ireland, and next year I expect they will go into Italy . . . They take with them books and sketching materials.[8]

Barbara grew up near scenery, both land- and seascape, which many artists had considered beautiful. Near her father's Hastings house, for example, was a scene

which had been painted by numerous artists – Cox, Linnell, Prout and Turner – Hastings Fishmarket. She was extremely unusual, for a woman artist, in having the opportunities to paint a very wide range of topography – the Sussex countryside, the Isle of Wight, Cornwall, Wales, the Lake District, Scotland, Ireland, France, Spain, Germany, America and Africa.

Barbara's friends also tended to be unusual young women, similarly ambitious to make more of their lives than a trivial round of tea parties enlivened with a spot of philanthropy. Bessie Rayner Parkes, great granddaughter of Joseph Priestley, was a lifelong friend. The two young women started to write articles for the *Hastings and St Leonard's News* which gave early indications of their reforming zeal. Barbara's father owned a large estate in Sussex, but Barbara saw it as everyone's right to be able to walk unmolested in the countryside. She urged Bessie:

> Please to write for the H news about the beauty of the green fields and the necessity for people to see and love and study nature for their health of body and mind and of the vile wickedness and baseness and selfishness of men who shut up footpaths, which are the only right which millions hold in their native land. Write write a stirring poem, a battle cry against the oppression of the selfish Squires.[9]

Barbara studied Emerson's work, and no doubt applauded his notion that:

> The charming landscape which I saw this morning is undubitably made up of some twenty or thirty farms. Miller owns this field, Locke that, and Manning the woodland beyond. But none of them owns the landscape. There is a property in the horizon which no man has but he whose eye can integrate all the parts, that is, the poet.[10]

Barbara read eclectically, but many of the books in her library (and the particular pages noted) reveal a musing consideration of the appropriate relationship of humankind with Nature, one that might result in restorative harmony. Predictably, she read the great poets of English Romanticism. The political radicalism of Blake, the young Wordsworth and Shelley attracted her, but also, I think, their insistent privileging of the poetic subjectivity – the visionary eye (I) which could remake the world – was significant to her. In July 1849 Barbara sent Bessie a fiction called 'A Parable. Filia', which construed emblematically the relationship between (female) artist, nature and culture. The narrative relates the story of a rich and privileged young girl who received an invitation to visit a friend in a wild part of Scotland. The condition of the visit was that Filia should leave all her books and sketchbooks and music behind in London for the month of the visit. After the first few days Filia suffered from such devastating boredom that she longed to get back to London. Barbara then goes on to represent Filia experiencing something akin to Emerson's construct of the epiphanic moment (to work through the natural fact to the spiritual truth which lies under it):

she saw that every tree had its leaves written over with beautiful hymns and poems, and every flower had a song written on its open petals, and every stone was engraved with tales of wonder. On the mountain cliffs were written histories of deepest wisdom, and on the sand under her feet were traced tales of the old world – Filia saw all this and stood still in wonder – here were more volumes than all the libraries contained which she had ever seen. She tried to read these poems and these histories. The hymns and songs she could easily read, they were in her own language, but alas there were very few of the histories of which she could read anything. Then she saw the depth and wonder of nature, and felt her own ignorance and wished for books that she might learn the languages of Nature. 'Now that you understand Nature and Life to be *the books* and all others but aids to them you are worthy to be trusted with Men's works' said the friend; and Filia had her books and her drawing and her music, and she went back to the city with new bloom on her cheeks, and a bright lustre in her eyes.[11]

This fable bears witness to Barbara's close reading of William Wollaston's *The Religion of Nature Delineated* (1738) which argued that the seeds or principles of knowledge are given us by nature but not knowledge itself.[12] More importantly, it seems to me that it lays claim to the *same* ideal of selfhood, one which pre-supposed the individual's right to develop a vision, that the male Romantics claimed for themselves.[13] In his epic poem *The Prelude* (1805), for example, Wordsworth represents his own development from an original symbiosis with maternal Nature, through intellectual self-consciousness and finally to harmony between nature and culture achieved by his own Imagination. Wordsworth effectively produces a self as Romantic hero in the figure of Mother Nature's favourite son. As 'Filia' means daughter, Barbara seems to be experimenting with the notion of a similarly privileged Romantic heroine, a model fully explored by the women writers Barbara most admired, George Sand and Charlotte Brontë.[14]

The Romantic quest for the particular vision had arisen from the post-Kantian elevation of individual subjectivity above 'objective' (scientific) accounts of the meaning of nature, in which the sublime indicated an inability to represent the infinite. Although the sublime could be sensuously rendered by representations of the wilder aspects of nature – mountains, waterfalls, storms and vastness of dimension, Romantic art finally is 'concerned with representing that which is *per se* unrepresentable'.[15] Figures in Romantic landscapes are typically tiny in the face of the vastness of nature. The paintings are often suffused with a sense of longing for wholeness and harmony between humankind and nature. It is not so much what the pictures are 'about' but rather, as Hugh Honour wrote, a question of feeling.

The constant sense of Barbara's social/political and aesthetic concerns being intertwined is confirmed by the study of her sketchbooks, which

simultaneously served as diary and commonplace book. In her 1850 notebook, for example, she drew a sketch of Wordsworth's grave.[16] Inside the front and back covers of the notebook she has inscribed two cantos from Shelley's *Queen Mab*, a philosophical poem written in 1821, in which Mab is the personification of the spirit of nature:

> The Man
> Of virtuous soul commands not, nor obeys,
> Power, like a desolating pestilence,
> Pollutes whate'er it touches, and obedience,
> Bane of all genius, virtue, freedom, truth,
> Makes slaves of men, and, of the human frame,
> A mechanised automaton.
>
> Man is of soul and body, formed for deeds
> Of high resolve, on fancy's boldest wing
> To soar unwearied, fearlessly to turn
> The keenest pangs to peacefulness, and taste
> The joys which mingled sense and spirit yield.[17]

Barbara's love of this last stanza seems to be a clue to the Anna Mary Howitt portrait of Barbara as Boadicea, the warrior queen 'formed for deeds of high resolve'.

Barbara studied the techniques of the English landscape masters – David Cox, Derwent, Girtin, Prout and Turner. Her sensuous enjoyment of colour is evident, from the very earliest of her sketchbooks. Various teachers and artistic advisors tried to help her to discipline her draftsmanship. On one occasion she locked up her 'dear colour box' for six months in order to improve her drawing, and it was a torture to her, like Eve locked out of Paradise.[18] Although she occasionally worked in oils, watercolour was her favourite medium and this choice was in itself indicative of her Romantic aesthetic. The Romantic elevation of the human imagination freed the artist from the restrictions of the senses; watercolour, previously considered inferior to oils, was now recognised as the more subtle medium. Its translucent qualities meant that it could transcend the limitations of the opacity of objects in nature so that the vision of the painter could be as untrammelled as that of the poet [26]. Barbara, like the masters she had studied, liked to capture the 'clouds and chasing shadows' of a particular moment, but perhaps more significantly she liked to represent the mood of a landscape, or, arguably, her own mood.[19] Her best paintings were, like herself, 'remarkable for [their] spirit and freedom'.[20]

It is not clear whether Barbara studied aesthetics in the formal sense of having studied Kant or Burke. However, her friendship with George Eliot, who admired Lessing's enormously influential enquiry into the underlying aesthetic

principles of painting and literature, *Laokoön, oder Uber die Grenzen der Malerei und Poesie* (1766), makes it likely that she was familiar with this work. Lessing had challenged Horace's dictum *ut pictura poesis* on the grounds that the sister-arts of painting and poetry had different functions. Instead, Lessing emphasised that the artist must exploit the potentialities of his chosen medium to the full, whilst simultaneously respecting its limitations ('*grenzen*' means 'limits'). The function of poetry, Lessing argued, is to represent processes, because its medium is sounds articulated through time. A painting, on the other hand, handles forms and colours in space and should therefore depict a visual field in an instant of time.[21] It seems likely, for instance, that it is with reference to Lessing's ideas that Barbara described her vibrant response to Velazquez' paintings in Madrid as 'the greatest intellectual pleasure of my life', but went on to condemn the philistines who 'like a touching story told badly by painting better than the inside of a dead ox painted miraculously by Rembrandt or an onion and a herring by Chardin'.[22]

By the time Barbara was serving her apprenticeship as a painter, the 'Romantic landscape' was a clearly defined category. The topographical work of the eighteenth century – accurate representation of subjects of scientific and historical interest – had ranked low in the hierarchy of genres. But the necessity of working from nature, the almost accidental discovery of the luminous subtlety of watercolour had conjoined with Romantic elevation of the imagination to invest landscape painting with new significance. Barbara's acceptance of Romantic ideology is indicated by her impatience with what she saw as the old

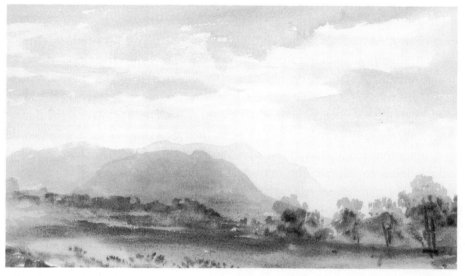

26] Barbara Leigh Smith Bodichon, watercolour sketch from the 1846–51 sketchbook, 22 × 13 cm

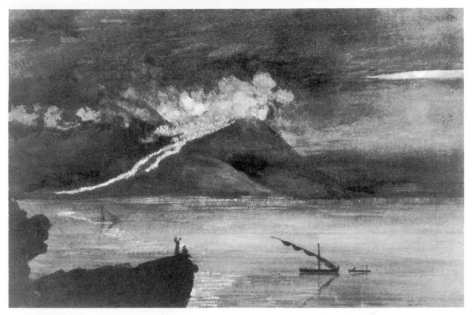

27] Barbara Leigh Smith Bodichon, *Eruption of Vesuvius from Naples*, May 1855, watercolour and bodycolour, 30 × 20 cm

fogeyism of contemporary Italian painting. After a visit to artists' studios in Rome in 1854 she commented with regard to large formal descriptions of historical or religious scenes: 'Oh! the waste of time in studios here! I wish I could turn all the artists out into the country. I am quite disgusted, and feel that for an artist Rome is a very dangerous place. They nearly all get into the old tracks instead of trying new ones!'[23] More to her taste was to paint Vesuvius after an eruption:

> It is really a grand and awful sight to see it even as I have seen it, from the shores of the bay, looking across the water to the dark mountain at night, and watching its crown of fiery vapour, and the long lines of the rivers of lava running down its sides . . . To think there is a hole right down into the red-hot centre of the earth, to the very place where the devil is! That is strange! Strange, very strange, it is to find hot water and hot steam and hot air everywhere about here. One feels terribly close to hell[24] [27]

The vastness, the strangeness, the darkness contrasted with intensely bright colours, the steam-blurred outlines all make this a striking example of the sublime. The intensity of her vision, probably fed by her reading of Milton's *Paradise Lost* is striking. It is essentially this imaginative response, a way of feeling, that makes a work of art 'Romantic'.[25]

Barbara followed contemporary French painters – Corot, Daubigny and the Barbizon school (a group of Romantic painters named after a small village into

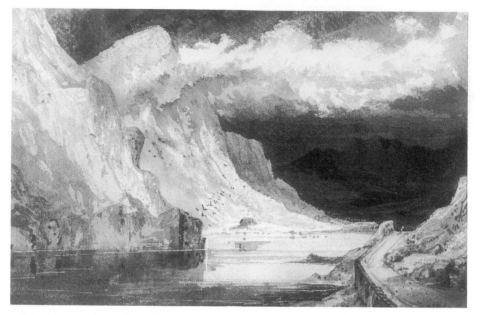

28] Barbara Leigh Smith Bodichon, *Trieste-Vienna Road*, 1850, sepia wash with white highlights, 26 × 17 cm

which they settled on the outskirts of Fontainebleau) – in their commitment to working out of doors.[26] She was known to work outdoors for as long as twelve hours at a stretch, returning to her studio(s) to work up some of the sketches to finished products. Bessie Rayner Parkes depicted Barbara as:

> Perched on a crazy paling,
> Deep in a hawthorn hedge,
> On briny air inhaling
> Which whirls by ocean edge:-
> Wherever Nature calls
> Will this brave artist speed.[27]

Dante Gabriel Rossetti described Barbara to his sister Christina as thinking 'nothing of climbing up a mountain in breeches, or wading through a stream in none, in the sacred name of pigment'.[28] The tone of Rossetti's comment suggests that he viewed her unproblematically as a fellow-artist, and I think this is worth considering. Benjamin Leigh Smith, as we have seen, treated his daughters the same as his sons. At twenty-one Barbara received an annual allowance of £300; after his death in 1860 she had £1,000 a year. (It is tricky to translate financial values from one period to another, but as a rough estimate, multiply by thirty for late twentieth-century values.) She had the freedom to decide who she was, to invent a self; and, as it turned out, she had no children. Meena Alexander has argued that the

Romantic ideal of selfhood and its visionary freedom was not easy to come by . . . The Romantic self presupposed a self-consciousness that had the leisure and space to enshrine itself at the heart of things. Brought up with a very different sense of the self, with constant reminders of how their lives were meshed in with other lives in bonds of care and concern, women could not easily aspire to this ideal.[29]

While this may often have been true, Barbara, by a particular conjunction of familial circumstances was unusually unfettered. Her Unitarian background had taught her to consider wealth as carrying with it social responsibilities, but this was one imposed equally on men and women. She used her money to fund many projects and to help many individuals, but she did not view a female self as a handicap. She was, proudly, a female artist.

Like many young men, but unusually for a middle-class woman of her time, she travelled very widely, often with another woman for a companion. In 1850, Barbara and Bessie, aged twenty-three and twenty-one respectively, went on an unchaperoned trip through Belgium, Germany, Austria and Switzerland [28]. From her earliest travels she was keenly aware of the political, as well as the natural landscape. She wrote to her Aunt Julia from Austria:

> I did not know before how intense, how completely a part of my soul were all my feelings about freedom and justice in politics and government. I did not think, when I was so glad to go into Austria, how the sight of people ruled by the sword in place of law, would stir up my heart, and make me feel as miserable as those who live under it.[30]

During this trip Barbara and Bessie visited artist friends Anna Mary Howitt and Jane Benham who were working in Wilhelm von Kaulbach's studio in Munich.[31] They enjoyed the experience of living almost as freely as young male students, and there, as recorded in Howitt's *An Art Student in Munich* (1853) 'Justina' (Barbara) laid her plans for an art sisterhood which was to include both painters and writers, and also someone able to sew efficiently enough to keep their stockings from falling to pieces.[32] Back in London they set up the Portfolio Club at the Leigh Smith house at 5 Blandford Square, at which members agreed on a particular theme and then produced sketches and poetry on that theme. The women of the club wore 'rational' or 'reformed' dress, following an experiment of Barbara's when she 'drew a diagram of the Venus de Milo's bust measurements and compared them all too favourably with those of pigeon-chested Victorian young ladies who deformed by tight-lacing and weighed down by the under-rigging of the crinoline, had sacrificed both health and natural grace to the fetish of the eighteen-inch waist'.[33] Their clothes signalled that they wished their work to be taken seriously and that they were not amateurish drawing-room scribblers or daubers.

In 1853 Barbara used some of her money to have a cottage built in the style

of the old Sussex houses; it was called 'Scalands Gate' and was built at Robertsbridge, on her father's estate. As with her taste in clothing she decorated it in a spare, uncluttered style, very different from claustrophobically overstuffed Victorian houses. She told her Aunt Julia, 'I am afraid of having a well appointed house. I believe I could not work if I had and I want my money for other things.'[34] Barbara used Scalands as a base for her own painting expeditions and lent it to many other writers and painters. Many of the Pre-Raphaelite Brotherhood – Holman Hunt, Edward Burne-Jones, and the Rossettis – stayed there. She thought Dante Gabriel Rossetti the 'most poetic' of the young men and she tried to help Lizzie Siddal regain her health by arranging seaside holidays for her.[35] Perhaps Barbara's concern for Lizzie Siddal was in part prompted by echoes of her own mother's experience. Anne Longden had also become involved with a man of a different class and had not been accepted by his family; she too had suffered from tuberculosis. As Barbara's mother was a milliner, who would have needed skills of hand and eye, it is tempting to think that Barbara's artistic skills may be a maternal inheritance, not simply a matter of cultural encouragement on the paternal side.

Throughout her life Barbara exhibited steadily, all in all about 250 paintings over the next thirty years. As she wrote to her friend George Eliot: 'I glory in the £10, £15, £10, £5, £15 which come in'.[36] She always insisted that 'what every woman, no less than every man, should have to depend upon, is an ability after some fashion or other, to turn labour into money . . . If she belong to the richer classes she *may* have to exercise it; but every one ought to possess it; if to the poorer, she assuredly *will*'.[37] This idea, of course, ran entirely contrary to Victorian ideology of the 'angel in the house', and the notion that if a woman worked she lost that peculiar position which the word 'lady' conventionally designated. It can be no coincidence that several women writers around the mid-century represented heroines who achieved independence as professional painters; however, there was always an 'excuse' of having a dependent to support. For example, Anne Brontë's novel *The Tenant of Wildfell Hall* (1848) and Dinah Maria Craik's novel, *Olive*, (1850) fit this mould. However, whereas both the Brontë and the Craik novels represent their heroines giving up their careers willingly once marriage to a good man ensues, it is to be noted that there is a quite different outcome in Anna Mary Howitt's serialised story 'The Sisters in Art'. In this narrative the 'beloved sisters in friendship and art' found a Woman's College of Art, and although the narrative ends with the women becoming engaged to marry, the fiancés support the women's careers and are not represented as interfering with the life-style of the 'sisters'. Also one of the sisters has a yearly annuity which allows her to secure a cottage where they could all go to 'renew . . . deep sympathy with nature in the moorland and by the sea'.[38] This

serial was both a fictional casting of the Munich group, with its access to Barbara's country cottage, and also an instructive fable concerning the need for women to get access both to training and to sites for exhibitions.

Barbara, as we might expect, was thoroughly involved in feminist pressure for such things. She was one of the founder members of the Society of Female Artists (1857), the purpose of which was to help women artists get their work exhibited. The *Englishwoman's Journal* of May 1858 in its article on the SFA stressed the possibilities of 'art as an effective vehicle for female autonomy'.[39] The Royal Academy excluded women from its membership throughout the century and from its schools until 1860. The winning of entry to the RA schools was a feminist coup with all the hallmarks of a campaign waged by women with previous political experience. Firstly, in 1859 thirty-nine women artists, including Barbara, petitioned the RA for access to the schools,[40] only to be rejected on the ground that the presence of women students would require the setting up of separate life classes. Secondly, Laura Herford, who had been a fellow student of Barbara's at Bedford College, was accepted by accident to the Royal Academy schools when she disguised her gender by marking her painting 'L. Herford'. The chagrin women artists suffered from their exclusion from the prestigious Academy is expressed in a letter from Anna Mary Howitt to Barbara. After attending a public lecture at the RA she wrote: 'it seemed after all the Royal Academy were greater and more to be desired than the Academy of Nature'. This is surely a reference to Barbara's parable 'Filia', although, of course Barbara had argued for nature *and* culture.[41]

It may well be that the move to found the SFA in 1857 was in part encouraged by the phenomenal acclaim for the work of the French woman painter Rosa Bonheur (1822–99). The art dealer Gambart exhibited her work in London in 1856 and 1857.[42] George Eliot wrote of Bonheur: 'What power! That is the way women should assert their rights', which implied that she too, saw that, for every woman who asserted her right to be an artist, a struggle to assert an autonomous identity had taken place.[43] Bonheur's female Romanticism was evident in her 1849 picture, *Ploughing in the Nivernais*, based on a description from George Sand's 1846 novel *La Mare au Diable*. It represented patient horses working in the fields, dominated and controlled by male figures, a trope which implied a 'sub-text' of the parallel system of the control of *women* by men. It may well be that Gambart's highly successful marketing of Bonheur's work in England in the mid-century helped to encourage interest in women painters' work generally. Certainly he twice offered Barbara solo exhibitions.

At the beginning of 1856 Barbara had written to George Eliot from a painting expedition with Anna Mary Howitt on the Isle of Wight: 'I must go to some wilder country to paint – because I believe I shall paint well.'[44] In autumn of

that same year Barbara made her first visit to Algiers, a visit which was to prove momentous, not only because she met and subsequently married Eugène Bodichon, but because she discovered a landscape which fired her artistic imagination:

> I have seen Swiss mountains and Lombard plains, Scotch lochs and Welsh mountains, but never anything so unearthly, so delicate, so aerial, as the long stretches of blue mountains and shining sea; the dark cypresses, relieved against a background of a thousand dainty tints, and the massive white Moorish houses gleaming out from the grey mysterious green of olive trees.[45]

It seems that Barbara had been destined to have a love affair not merely *in* Algeria, but *with* Algeria; *Tales of the Arabian Nights*, as recounted to her by her first teacher, Buchanan, had a deep-rooted hold on her imaginative processes. Nevertheless the beauty of the place presented its own problems. She wrote to Bessie:

> the foreground of wild olives, ruins of mills, old moorish mosques and houses with their constant companions the tall cypress trees make pictures – this is which strikes one – here are all the subjects ready combined – here are the ideals real which painters have been trying to paint since landscape art began. It is curious to see nothing but pictures – and that was my first feeling here. This place seemed to me the heaven of landscape painters but I did not like it – having a dislike of seeing nature like pictures. Now I begin to see the particular poetry of the place which is beyond any pictures ever painted of course and now begins my real enjoyment . . . An artist who went to the Atlas range to paint said the country was so beautiful that if he had stayed 2 months more he should have gone mad.[46]

There is a wonderful note of alarm at being faced with a landscape where nature ordered the pictures herself, leaving nothing for the synthesising eye of the Romantic artist to do.

Following her marriage to Dr Bodichon in 1857, Barbara spent her winters in Algeria, and her summers in England working for the various women's causes she was involved with. In Eugène Bodichon, Barbara seems to have found a partner whose disinterested efforts on behalf of social and political campaigns were a match for hers. He came from an aristocratic family in Nantes but, as a medical student in Paris in the 1830s had become friends with Ledru-Rollin, Louis Blanc and other democrats. On the completion of his medical studies he sold the patrimonial estate and settled in the French colony of Algiers. As the corresponding member of the Chamber of Deputies for Algeria from 1848, he was instrumental in bringing about the abolition of slavery in the colony. After their marriage the Bodichons bought 'a large, straggling, Moorish-looking house at that time standing alone on [the] heights [called Mustapha Superière], and commanding a splendid view of Algiers bay and Atlas Range'.[47] He clearly

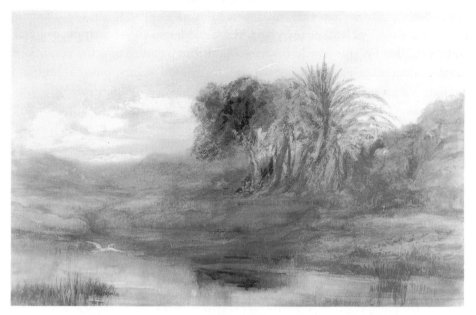

29] Barbara Leigh Smith Bodichon, *Solitude*, undated, but after 1857, watercolour, 48 × 30 cm

respected his wife as a working painter, building her a studio while she was away in England. They were both interested in ecology (a social aspect of the landscape); they worked together at a scheme for planting eucalyptus to rid the colony of malaria. It seems to have been a successful marriage of equals, at least until Barbara suffered a stroke in 1878 which left her partially paralysed and restricted her travels. The one sadness in the marriage was the lack of children. Still hopeful, she wrote to her sister at thirty-seven: 'Did you hear of the storks building on my studio top in Algiers? I hope it is a good omen'.[48] Her picture entitled 'Solitude', with its blue tones and one lonely wheeling stork surely represents that particular unrepresentable – the depth of her disappointment [**29**].

At the beginning of their marriage the Bodichons spent seven months in America. They travelled through most of the slave states and Barbara sent articles back to the *Englishwoman's Journal* expressing her horror at the slave trade in the south. She was also struck by the way the Mississippi landscape seemed to mirror the moral landscape:

> Here, in this swampy, slimy Louisiana, there is ugly dreariness, ugly wildness, ugly quaintness, and the country often struck me as absolutely ugly, and with its alligators basking in the rivers, as almost revolting, somewhat as if it were a country in a geological period not prepared for man's appearance. We were in New Orleans in 1858, and the state of society was not more pleasant to contemplate than the natural scenery; the moral atmosphere was as offensive as the swamp miasma.[49]

One of her pictures from this trip appeared as an engraving in *The Illustrated Evening News* on 23 October 1858 [30]. Mrs Gaskell had either seen the original, or one similar, for she vividly described both the painting and the conditions of its production as 'in a gorge full of rich rank tropical vegetation – her husband keeping watch over her with loaded pistols because of the alligators infesting the stream'.[50] As usual, Barbara was taking her work seriously, and it is charming to have the figure of Dr Bodichon, dressed in the Arab burnous he loved to wear, in the picture.

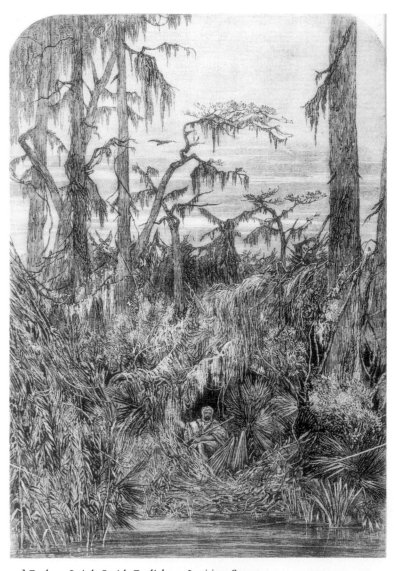

30] Barbara Leigh Smith Bodichon, *Louisiana Swamp*

All contemporary accounts remark on Barbara's energy, her ability to keep up the spirits of those who were flagging with her generosity and care. She took her career seriously, yet did not want it to excuse her from commitment to social causes. In a tired moment she wrote to her friend, the poet William Allingham:

> I love my art more than ever – in fact more in proportion to other loves than ever for I confess the enthusiasm with which I used to leave my easel and go teach at the school or help Bessie in her affairs is wearing off, and if it were not that at thirty-five one has acquired habits which happily cannot be broken I should not go on as I do; I could not *begin* as I used ten years ago at any of these dusty dirty attempts to help one's fellow creatures.[51]

This letter usefully speaks of both 'art' and 'habits' of social activism. Barbara had made notes in one of her sketchbooks on William Godwin's *Political Justice*, in which he gave an account of how men come to act disinterestedly out of habit.[52] Godwin (as Barbara noted) had used the term 'disinterested' because he was drawing on Lord Shaftesbury's argument that a human being could be defined as acting disinterestedly when, instead of being motivated by self-regard, he acted for 'the good and interest of his species and community'.[53] Shaftesbury regarded this ethical disinterest as similar to the aesthetic disinterest, where a human being can contemplate the beauty of nature without wishing to possess it or master it. The Romantic poets, especially Wordsworth, derived their social and aesthetic analysis from Shaftesbury. Similarly, in Barbara's life, the pursuit of her art was not in conflict with her desire to serve the community but both represented twin aspects of Romantic disinterestedness.

Notes

1 Ellen Clayton, *English Female Artists*, 2 vols. (London, Tinsley Brothers, 1876), vol. ii, p. 176.

2 Hester Burton, *Barbara Bodichon* (London, John Murray, 1949) writes of her as 'a creature of two quite separate personalities' (p. 29). S. R. Herstein's *A Mid-Victorian Feminist: Barbara Leigh Smith Bodichon* (New Haven and London, Yale University Press, 1985) ignores her career as an artist completely. Jacqui Matthews' essay, 'Barbara Bodichon: integrity in diversity' in Dale Spender (ed.), *Feminist Theorists* (London, The Women's Press, 1983), is far more sensitive in this respect, although she does not seek to theorise the connections.

3 Hugh Honour, *Romanticism* (Harmondsworth, Penguin, 1991), p. 14.

4 John Opie (1761–1807) was a painter of portraits and genre scenes. Opie painted a portrait of William Smith and also one of two of his children (one believed to be Barbara's father, Benjamin). This was exhibited at the Royal Academy in 1796. See John Jope Rogers, *Opie and His Works* (London, 1878). John Sell Cotman (1782–1842) was the most original of the Norwich School watercolourists. His early landscapes painted in broad washes with a minimum number of colours may well have influenced Barbara's work. See Andrew W. Moore, *The Norwich School of Artists* (Norwich, Norfolk Museums Service, 1985).

5 Family papers suggest that William Smith had intended arranging a marriage between Benjamin and Mary Shore. She had to marry a younger Smith son, Samuel. As Mary (Mai) Shore was the sister of William Nightingale (father of Florence), Benjamin's common-law

marriage to Anne may have been experienced as an insult and account for the fact that the senior Nightingales never recognised the Leigh Smith children; William Smith Papers, Cambridge University Library.

6 Copy of letter from Barbara to Florence (Nightingale) in William Smith Papers, Cambridge University Library. Emmanuel Swedenborg (1688–1772) was a Swedish scientist, philosopher and theologian. His 'doctrine of correspondences' implied that every substance and form had its spiritual and moral meaning. This visionary aspect underpinned the poetry of another Swedenborgian, William Blake. See, for example, 'Auguries of Innocence':

To see a World in a Grain of Sand
And Heaven in a Wild Flower,
Hold Infinity in the palm of your hand
And Eternity in an hour

Blake, *Complete Writings*, ed. Geoffrey Keynes (London, Oxford, New York Oxford University Press, 1972) p. 431.

7 Clayton, *English Female Artists*, vol. ii, p. 171.

8 Mary Howitt, in a letter to her sister, 1845; quoted by Burton *Barbara Bodichon* p. 4.

9 Parkes Papers, BRP V 167 Girton College, Cambridge. Bessie Rayner Parkes (1829–1925) came from a similar Unitarian family with parliamentary connections to that of Barbara. Bessie was a poet and co-editor with Matilda Hays of *The English Woman's Journal*, which was largely funded by Barbara. See Jane Rendall's essay, 'Friendship and Politics: Barbara Leigh Smith Bodichon (1827–91) and Bessie Rayner Parkes (1829–1925), in Susan Mendus and Jane Rendall (eds.), *Sexuality and Subordination* (London and New York, Routledge, 1989).

10 Ralph Waldo Emerson, *Nature as Natural History and as Human History* (Boston, Beacon Press, [1836] 1989), p. 11. John Barrell's book *The Dark Side of the Landscape: the rural poor in English painting 1730–1840* (Cambridge, Cambridge University Press, 1987) argues that landscape painting disguises the fact that the vision the leisured classes enjoy is built on the unremitting work of the labouring class; 'if those men once stopped working, the vision would fade' (p. 132).

11 Parkes Papers, Girton College, Cambridge. After the holiday in Scotland when this was written, Barbara returned to London that year to study drawing with Professor Francis Carey at Bedford College. The college was founded by Elizabeth Jesser Reid, a Unitarian friend of Barbara's aunt, Julia Smith. It was at that time one of the few places in England where women could receive first-class instruction in drawing.

12 William Wollaston, *The Religion of Nature Delineated* (London, J. & P. Knapton, 1759) p. 95. Pages are marked in both Benjamin's and Barbara's handwriting.

13 A maternal Nature was represented by Wordsworth in 'Lines composed a few miles above Tintern Abbey' (1798) as:

The anchor of my purest thoughts, the nurse,
The guide, the guardian of my heart, and soul
Of all my moral being

In two recent books – Meena Alexander, *Women in Romanticism* (Basingstoke, Macmillan, 1989) and Anne K. Mellor, *Romanticism and Gender* (London and New York, Routledge, 1993) – it is argued that what is usually called Romanticism is actually *male* Romanticism and that women's differing sense of self makes the assumption of the role of Romantic visionary especially difficult for women.

14 The woman who became her lifelong friend, Marian Evans (who wrote as George Eliot), took over as her favourite author. My Ph.D. thesis 'Barbara Leigh Smith Bodichon and George Eliot: an examination of their work and friendship' (Anglia Polytechnic University in collaboration with the University of Essex, 1992) argued that the basis of the two

women's friendship was the sense of being sister artists with a largely shared theory of (female) Romanticism.

15 Andrew Bowie, *Aesthetics and Subjectivity: from Kant to Nietzsche* (Manchester, Manchester University Press, 1990), p. 43.

16 Lakes Sketchbook privately owned but on loan to Wordsworth Museum, Dove Cottage, Grasmere, Cumbria.

17 *Queen Mab* canto III, lines 175–9 and canto IV, lines 153–8

18 Letter to Bessie Rayner Parkes, Parkes Papers, BRP V/165, Girton College, Cambridge.

19 *Letters to William Allingham*, ed. by H. Allingham and E. Baumer (London, Williams, Longmans, Green & Co., 1911), p. 86.

20 *Illustrated London News*, 16 July 1864.

21 David E. Wellbery, *Lessing's Laocoön: Semiotics and Aesthetics in the Age of Reason* (Cambridge, Cambridge University Press, 1984) p. 135.

22 Unpublished letter written to George Eliot as Barbara travelled through Spain (?) Nov. – 16 Dec. 1866 (MS Vault Microfilms 604, The Beinecke Rare Book and Manuscript Library, Yale University Library). An edited and abbreviated version appeared as 'An Easy Railway Journey in Spain' in *Temple Bar*, 25 (Jan. 1869).

23 Burton, *Barbara Bodichon*, p. 75.

24 *Ibid.*, p. 78.

25 Barbara approved of Feuerbach's dictum that 'feeling is alone real knowledge . . . Thou must feel what a thing is; otherwise thou wilt never learn to know it'. She had George Eliot's translation in her library. *Essence of Christianity*, trans. Marian Evans (New York, Harper & Row, 1957) p. 228.

26 Bessie Parkes wrote in Nov. 1864, that 'Mrs Bodichon is working in a Parisian studio, Corot's; he being an artist on whose instruction she had greatly set her mind; and, though he had never had but three pupils in his life, he has taken her'. *Letters to William Allingham*, p. 82.

27 Bessie Parkes, *Poems* (London, John Chapman, 1855), p. 33.

28 Burton, *Barbara Bodichon*, p. 43.

29 Meena Alexander, *Women in Romanticism*, p. 5.

30 Burton, *Barbara Bodichon*, p. 33.

31 Wilhelm von Kaulbach (1805–74) specialised in a rather bombastic brand of history painting. His illustrations of Goethe's works were much more attractive and clearly influenced Anna Mary Howitt. For her exhibition debut in 1854 at the National Institution (the erstwhile Free Exhibition) she entered 'Margaret returning from the Fountain' an illustration from *Faust*.

32 Anna Mary Howitt (1824–84), female Pre-Raphaelite painter, was the daughter of the writers William and Mary Howitt. See Jan Marsh and Pamela Gerrish Nunn, *Women Artists and the Pre-Raphaelite Movement* (London, Virago, 1989) for a detailed account of the women painters' relationship with the PRB.

33 Burton, *Barbara Bodichon*, p. 39.

34 Barbara to Julia Smith, 1859, vol. 8, Autograph Collection (Fawcett Library, London). Later she invited Girton students for holidays there and, towards the end of her life, used it for a nightschool for working people.

35 Letter from Barbara to Bessie: 'Private now my dear, I have got a strong interest in a young girl, formerly model to Millais and Dante Rossetti, now Rossetti's love and pupil, she is a genius and will (if she lives) be a great artist,' BRP V/172, Parkes Papers (Girton College, Cambridge).

36 Letter from Barbara to Marian Evans, 14 Jan. 1856 (Beinecke Library, Yale).

37 'Women and Work' first appeared as an article in the *Waverley Journal* on 7 Feb. 1857. It was republished as a pamphlet (London, Bosworth and Harrison, 1859). The quote is from this latter version, pp. 11–12.

38 'Sisters in Art', *The Illustrated Exhibitor and Magazine of Art* (July 1852).

39 Barbara and Bessie founded the *English Woman's Journal* in 1858. Its offices in Langham Place became a centre for an employment bureau, a printing press, a law copying office, a reading room. See Jane Rendall, '"A Moral Engine"? Feminism, Liberalism and the *English Woman's Journal*', in Jane Rendall (ed.), *Equal or Different: Women's Politics 1800–1914* (Oxford, Blackwell, 1987).

40 Barbara's first political campaign in 1854 was to petition Parliament to amend the Married Women's Property Bill so that married women could have the same rights under law as single women.

41 Anna Mary Howitt to Barbara Bodichon, transcribed in Barbara Stephen's notebook; William Smith Papers, Cambridge University Library. My guess is that it was written in 1849, after 'Filia'. Barbara Stephen is a granddaughter of Samuel Smith and Mary Shore. She wrote *Emily Davies and Girton College* (London, Constable, 1927). Her transcriptions are sometimes the only evidence of letters now lost.

42 See Jeremy Maas, *Gambart: Prince of the Victorian Art World* (London, Barrie & Jenkins, 1975). D. G. Rossetti, rather rudely, called him 'Gamble-Art', implying that he was more a speculative businessman than an art-lover, but at least he promoted contemporary paintings and stimulated a market for them.

43 George Eliot to Sara Hennell, 19 Aug. 1857; *The George Eliot Letters*, ed. Gordon Haight, 9 vols. (New Haven, Yale University Press, 1954–78) vol. ii, p. 377.

44 Barbara to George Eliot, 14 Jan. 1856 (Beinecke Library, Yale).

45 Burton, *Barbara Bodichon*, p. 83.

46 BRP V/176 (Girton College, Cambridge).

47 Matilda Betham-Edwards, *Reminiscences* (London, George Redway, 1898) p. 277.

48 Burton, *Barbara Bodichon*, p. 138.

49 'A Dull Life', *Macmillan's Magazine*, 74 (May 1867) 47.

50 *The Letters of Mrs Gaskell*, ed. J. A. V. Chapple and A. Pollard (Manchester, Manchester University Press, 1966) pp. 606–7.

51 *Letters to William Allingham*, p. 79. The Portman Hall School (1854–64) was Barbara's version of the Westminster Infant School, a coeducational, non-denominational school. Barbara, Bessie, Elizabeth Whitehead and Octavia Hill taught in it. It was largely funded by Barbara's money.

52 BLSB notebook in private collection.

53 Jerome Stolnitz, 'On the Origins of Aesthetic Disinterestedness', *Journal of Aesthetic and Art Criticism*, 20 (1960–62) 132.

9

Art education for women in the 1860s: a decade of debate

Sara M. Dodd

THE 1860s provide as fruitful a case study for art education as for education in general in terms of opportunities for women. For example, debates about women's work, status (amateur versus professional), class (suitable training for middle-class artists and working-class or artisan designers), the place of work training in an industrial context and the doctrine of separate spheres versus equality are all familiar issues in the 'woman question' and essential to any discussion of art education in the 1860s.

Whereas in the area of general education for women it was a decade of debate and struggle, with positive action coming slightly later, in art education there were great strides forward throughout the 1860s. In terms of chronology, a positive move had been made with the establishment of the Society of Female Artists (SFA) in 1857 and the decade began with pleas for the continuation of the recently established Female School of Art (FSA). It seemed an inauspicious start to the 1860s when the government withdrew funds from the FSA in 1859, but by the end of the period, in 1869, the FSA was not merely surviving but flourishing, with a former pupil exhibiting at the SFA.[1] Sarah Macgregor had won a Queen's Gold Medal for applied design and Miss A. A. Manley had just been admitted as a pupil to the Royal Academy.[2]

By 1869 the verdict of a critic in a contemporary journal was that 'female artists cannot justly be ignored,'[3] and this was in no small measure due to their improved training. At South Kensington School of Art, a year later, Kate Greenaway received a silver medal and Julia Pocock was awarded the Queen's Gold Medal and five pounds for the best modelled hand from nature.[4] (No less a personage than the Queen herself had by this time taken a hand in the survival

of the school). All these triumphs were to a large extent due to improvements in training, methods and opportunities for female artists, the results of which were modifying contemporary attitudes. One example of a change in status can be seen in the critical reception of the work of Barbara Leigh Smith Bodichon. Throughout most of the decade, she was castigated for being 'too ambitious' in her landscape conceptions in the *Art Journal*, for example (though there is rather patronising congratulation for her 'strength of vision'). By 1869 the verdict was 'masterly' with 'several effective sketches'.[5] Though by no means suggesting that she really was a 'master', there was a subtle change in tone. Critical attitudes were beginning by the end of the decade to admit into their canon of womanly virtues in art qualities like strength, vision or imagination – though this was perhaps as much due to the impact that individuals such as Barbara Leigh Smith Bodichon herself were making on the art scene as to art education.[6]

The traditional obstacles for women art students were being broached, if not entirely overcome, at this time, in both opportunities to train and methods of training. One of the main objections of many art critics when reviewing women artists in the 1860s was their lack of anatomical knowledge which precluded even an attempt at figure drawing. It was frequently pointed out that the subject matter of women artists was severely limited because of the barriers imposed by their lack of opportunity to study from life (either from draped or undraped models). Flowers, fruit and still life[7] were seen as too inhibiting and repetitive by some critics. A reviewer of the ninth exhibition of the SFA, which took place on 28 January 1865, while congratulating the Society on the gradual increase in 'the real value of its productions', was obliged to comment that 'Lady artists are not sufficiently ambitious of excelling in figure composition. Flowers and "still life" form a proportion, too marked, of this collection. One of the evils for which our Schools of Design have to answer,' he suggests. The reviewer continues, 'What we have already said, and what we now repeat in one word is that there is a noble field open for landscape art of high character to those Englishwomen who may not choose to meet the difficulties of study from the life.'[8] This may well have been the verdict of the editor, Samuel Carter Hall, and difficulties in studying from the life there were, as he would have known from his friendship with the artist Henrietta Ward among others. Life classes from the 'costumed model' were at least introduced by the SFA in 1863[9] and adopted as standard practice later by the FSA. The school for the study of the draped figure 'has been well attended' by March 1864.[10]

By March 1866, there was an evening class for the study of the 'draped Living Figure' being advertised at the FSA, and an account of the talk given by Mr E. T. Parris to invited guests on how he would conduct the class (no doubt to reassure anxious mammas) appeared in the *Art Journal*.

He produced a variety of sketches, prints, &c., from Rafaelle and others, with several of his own sketches and studies from the life, and a few highly finished drawings, showing every mode of study by the specimens placed before his audience. His method of instruction is rather different from that usually pursued in this country. Having 'placed' the living model, before the students commence work he marks out all the principal features of the subject, describes the bones and muscles of the hands, arms, throat, &c., drawing attention to the variety of form which the muscles assume in different actions, appealing to the surrounding casts from the antique and the skeleton; and having noted the many beauties of light and shade and colour, and so far instructed his pupils by such demonstrations, he sets them to work – watches their progress, and corrects their faults, referring constantly to those particulars of the model to which he had previously directed their attention. We earnestly recommend these classes to artists and teachers, and also to those ladies who have gone through the preliminary practice previously acquired in this and other schools of Art[11]

The description is worth quoting in detail because it encompasses various points of interest; for example, the delicate use of a certain amount of anatomical study (classes in anatomy were to be advertised for lady students in 1868 in the same journal) and the cross-reference to anatomical casts, in the traditional manner. Nude study was a very different matter, of course. It was inaccessible to women, apart from the occasional rebel like Frances Strong (later Pattison, later Lady Dilke) who, we are told, insisted on being given the opportunity in her last year at South Kensington, and was even congratulated on her drawing by her teacher, William Mulready.[12] Mulready, along with Thomas Woolner and Richard Westmacott, at the Royal Academy, and Richard Redgrave and Henry Cole at the South Kensington Schools, were amongst those interviewed in 1864 by the Select Committee on Art Education who insisted that study from the life was essential for their male students; there were only age limitations as far as the study of the nude was concerned.[13]

It has to be said that there was nervousness about allowing male students to study the nude body as well as about the embargo on female exposure to nakedness. There was a somewhat hysterical outburst by Lord Haddo in Parliament in 1859 about 'painful and scandalous' exhibitions at government schools of art[14] and massive correspondence in the pages of *The Times* and the *Art Journal* on subjects such as 'The Nude in Art Studies' thereafter, with the Right Honourable C. B. Adderley MP, one of the members of the Select Committee on Education and Fine Arts of later years mentioned above, accusing young male students at the Royal Hibernian Academy of 'prurient curiosity' and 'immoral irregularities' (though he denied this later).[15] All this correspondence was taking place in the year that 'a lady desirous of becoming a pupil [at the Royal Academy, which forbade women entry] sent in, as is

customary, a drawing for approval, and the Council, ignorant that it was the work of a female hand, admitted it,' as the *Art Journal* reported the famous incident when Laura Herford gained entry by signing her work with her initial, thus fooling the Council.[16] No wonder honourable parliamentarians and Royal Academicians alike were uneasy about subjecting young ladies to the same moral dangers as young gentlemen, particularly if there was a suspicion that young male students could not cope with the excitement. For women there had to be constant guarantees of 'good and safe instruction' under respected and respectable teachers, even when drawing from the draped model,[17] but at least it was normal practice by the end of the decade. This was an important example of the barriers and prejudices with which potential women artists had to contend in the 1860s and it demonstrates the way in which art education can be taken as a microcosm of the 'woman question' and the 'separate spheres' debates of the time. One link can be made with Barbara Leigh Smith Bodichon's plea for equality of educational opportunities in endowed schools for girls in 1860.[18] As for women, the link is evident, for instance in Harriet Martineau's article in the *Cornhill Magazine* of 1864 which declared that 'Training schools are an urgent want of the time and of the country' and called for a 'substantial and liberal training of the mind'.[19]

There were those who preferred the idea of 'separateness' in order to encourage young women and free them both from the bonds of male competition and from the constraints of chaperonage in male company. Others were afraid that classes held in mixed company might lead to 'levity and indiscretion', which one observer feared would be the result of women being admitted to the Sheffield People's College (one of the first colleges to admit women to drawing classes). In fact, looking back in 1859, he was forced to admit that 'an increased decorum and self-respect' was exhibited by both sexes, despite their proximity.[20]

The feeling that women should be educated separately in order to fulfil different roles in life, whether through the inferiority of their cranial structure or the necessities of their social and familial duties, was prevalent in the 1860s. The most notorious example of this attitude is, perhaps, to be found in the words of John Ruskin in his lecture, 'Of Queens' Gardens', later published in *Sesame and Lilies* (1865). For example,

> We cannot consider how education may fit them [women] for any widely extending duty, until we are agreed what is their true constant duty. And there never was a time when wilder words were spoken, or more vain imagination permitted, respecting this question . . . The man's power is active, progressive, defensive. He is eminently the doer, the creator, the discoverer. His intellect is for speculation and invention; his energy for adventure, for war, and for conquest, wherever war is just,

wherever conquest is necessary. But the woman's power is for rule, not for battle, – and her intellect is not for invention or creation, but for sweet ordering, arrangement, and decision.[21]

Therefore, Ruskin concludes, women must be educated differently. His attitude has been identified, contextualised and deconstructed in various ways in recent years; for example, in Kate Millett's well-known attack in the late 1960s (where she contrasts his restrictive ideas with those of John Stuart Mill on the subjection of women)[22] and David Sonstroem's rather unconvincing defence of Ruskin's meaning in 1977.[23]

At the time that Ruskin was writing, the outrage expressed in various articles and books at any thought of equality of education or professional training on a par with men can best be exemplified by purportedly medical articles in *The Lancet* on the unsuitability of women's physiology for such tasks,[24] or by 'improving' volumes for women such as the last in Sarah Stickney Ellis's famous series on woman's role, *The Education of the Heart: Woman's Best Work*, which came out in 1869. The controversy revolved around the issue of women's work, of course, a vexed question at the time and one which again seems encapsulated in the debates on what was known as 'Art Employment for Women'. This raises the case of class and status again, the professional versus the amateur artist.

Throughout the 1860s, there is evidence of earnest discussion on the suitability of art training, for men as well as for women, in relation to their future employment, whether middle- or working-class. For example, in the year that Jessie Boucherett founded the Society for the Promotion of Employment for Women there was an article in the *Art Journal* on 'Art Employment for Females',[25] more discussion in 1860 and thereafter the issue was taken up repeatedly in the journal until three articles in 1872 ended the period in question. In the *Art Journal* of February 1860,[26] the editor introduced two letters on the subject of the Female School of Art, with the hope that 'the difficulty may be met by the co-operation of all those who desire to promote Art, and especially of those who advocate every means of procuring employment for educated women.' The letters came from Louisa Gann, superintendent of the FSA, and from 'R. H.'. Louisa Gann wrote, 'should the Gower Street School be closed, one of the most useful institutions for the professional education of women would be lost to the public', while the letter from 'R. H.' began 'Sir, – Your long and liberal advocacy of the principle of improving the social condition of the women of England, by means of Art-education in combination with manufacture, leads me to hope that you will find room for the insertion of the enclosed', and pointed out that the teachers at Gower Street, female teachers at South Kensington and at many other schools were educated at the Female School of Art, 'without reference to the number engaged in private schools and Art-manufactories'. There

were many subsequent references to art education and its relevance to employ-
ment for women in the *Art Journal* of 1860; for example, Louisa Gann again (p.
111), and a letter from 'Fair Play' (p. 214), who refers to the efforts of Emily
Faithfull and Bessie Parkes to 'prove how valuable the hitherto neglected female
intellectual labour is'. Eventually, the issues of professional training versus what
was seen as amateur dabbling polarised the school's supporters.[27] Thomas
Purnell, writing in 1861, stressed in particular the vocational aspect of the
school's training: 'it is in this case, less the advancement of Art – though we
would advocate it also on specific grounds, – than the useful and honourable
employment of those who are unhappily compelled to labour in order that they
may live.' He specified the class of women to whom the training would be most
useful: 'the intermediate classes – those who are known as the "respectable"
classes' who have fallen on hard times'.[28]

Parliamentary Select Committees, examining work opportunities for men
and women at this time, were particularly concerned that funds should be made
available to help the artisan class to train as designers at South Kensington and
at the provincial art schools which were springing up during the 1860s. Funds
were being restructured in 1864, and the bias was towards encouraging art
schools to be self-supporting, with an emphasis on vocational training geared
towards local industries. Thus, for example, Lambeth School of Art, which had
thirty female students in 1864, is reported to have favoured the copying of
engines or ironwork rather than the silk or lace designs done at the Female
School of Art – or even fresh designs, according to its superintendent – simply
because it was close to Messrs. Easton and other engineering firms in Lambeth
who fell within its catchment area for students and provided job opportunities.[29]
The need for thorough vocational training was perceived by many as essential
for women.[30]

The training could be used in various ways, not just with a view to employ-
ment in the manufacturing industries but also with a view to a career as an art
teacher or governess, as has been suggested by the views quoted above. The
career of governess tended to be reserved in general for middle-class women,
but it is noteworthy that Richard Redgrave in his evidence to the Select
Committee of 1864 classed governesses with artisans (particularly significant in
the light of the career of his sister and his series of paintings on the subject of
the governess). In the year of these parliamentary investigations and of
Redgrave's and others' suggestion for improvements in finance for art training
(the Four Minutes), there were four governesses studying at South Kensington,
one schoolmistress and six female pupil-teachers;[31] there were 1,513 governesses
training at art schools nationwide recorded in the statistics for the previous year,
1863.[32] So questions of the appropriateness of art training, whether it was to be

in design or simply in drawing, were to become increasingly apparent in the debate over women's work.

Though the emphasis was on vocational training, the teaching of design was not seen as incompatible with instruction in fine art by people like Louisa Gann, the 'indefatigable' (as she was dubbed in the art press) superintendent of the Female School of Art in the 1860s. As the *Art Journal* of 1867 put it, 'Miss Gann had set herself the task of breaking down that barrier, and she was engaged in fighting the battle not only for the present time, but for future generations.'[33] She was congratulated by the Honourable Beresford Hope MP for grappling with 'that pedantic rule that would "dub" him or her an artist who would paint some picturesque old gate, or ruin, or landscape, but would refuse the name to one who produced with great care or elaboration a design for a screen or a grille to be reproduced afterwards in metal'.[34] Other MPs, such as Edmund Potter (inquisitor and witness at Select Committees), were very much against what they saw as incompatible types of training: 'I do not think High Art and technical teaching can flourish together', he told a Select Committee on 28 April 1864.[35] For Louisa Gann the variety of education she could provide at the FSA had been a vital factor in her tireless efforts to ensure its survival in the 1860s, despite the withdrawal of government funding through what was seen as its lack of direct vocational training.

During the lengthy and meticulous parliamentary investigations of art training in the 1860s, it was the school at South Kensington that emerged as the cornerstone of art and design instruction for the whole country. Committees elicited solid promises during their interviews that the collections and resources of the school would be made more widely available to provincial schools. The school was seen as having an important role to play in general art training, in training 'adults of both sexes' to become teachers, and in encouraging a knowledge of 'elementary drawing among the humbler classes, the mechanical classes'.[36] Provision was made on 17 March 1863 for special funding 'in respect of students who are artisans, or who are engaged in some industrial occupation, or are preparing to be so, or who are teachers or governesses, or are preparing to become so'.[37] This may explain a certain antagonism, if not rivalry, between the female section at South Kensington and the FSA – possibly blown up by the art press.

Right at the beginning of the decade, when there were eloquent pleas from all sides for the support of the FSA, then threatened with closure, one anonymous letter writer took a sour view of South Kensington's apparent complicity in the matter of self-funding for schools of art: 'The fiat having gone forth from South Kensington that all schools of art should be self-supporting, it is only just that this most successful school should be also self-supporting.' The tone

becomes more explicitly ironic, even bitter, as the letter progresses: 'the Department of Art [South Kensington], piously respecting public money, sacrifices Gower Street School [the FSA] to an ideal, impractical theory, that schools of art should be self-supporting.'[38] The writer goes on to defend the FSA's reputation in the area of lace designing as one example of 'undisputed pre-eminence' in several branches of design, and concludes that 'to withdraw the Gower Street grant, on the transparently false principle of self-support, is an insult to the common sense of England.' The appeal, mentioned above, to 'those philanthropic individuals who supported Miss Emily Faithfull at her printing office, in Great Coram Street; or who listened with interest to Miss Bessie Parkes at the Social Science Congress in Bradford' shows that this was someone who was automatically making the link between women's art and women's issues in general.

Another letter of the same year makes the point that the FSA had not only been instructing pupils 'to a degree of excellence that would enable them to design,' but aimed 'to teach those who wished to learn the elements of Art, to sufficiently appreciate the combination of true Art with manufacture.'[39] The point is made that one pupil had been given the commission of designing the bridal dress of the Princess Royal in competition with South Kensington school. The emphasis of such letters in defence of the FSA is clearly on the vocational aspect of its training and the success of its students in the world of commerce and manufacture. In the same issue is Louisa Gann's spirited and sensible defence of her school's professionalism, where she writes of its accessibility to 'as large a number as possible'. She, too, addresses the issues of education and employment so vital to contemporary debates on female emancipation:

> Of its importance as a means of providing honourable and remunerative employment for educated women, too much can scarcely be said, especially at the present time, when one hears the question asked on all sides, 'What can educated women do?' Few, indeed, are the means by which they can earn a livelihood, and, I believe I am fully justified in stating that should the Gower Street School be closed, one of the most useful institutions for the professional education of women would be lost to the public.[40]

The following year Thomas Purnell was to echo this eloquent defence of Gann's with his more lengthy explanation of the difficulties that the 'respectable classes' had in finding suitable employment for their daughters when all else had failed – women owing 'allegiance to the hearth' primarily, of course! He cited the various institutions already established in London, such as the women's printing house, the women's law-stationer's office and various art schools that women could enter to procure respectable employment thereafter, and ended with a paean of praise to the FSA, which had been founded 'partly to enable young

women of the middle classes to obtain honourable and profitable employment, and partly to improve ornamental design in manufactures, by cultivating the taste of the designer'.[41] It seemed as if the defence rested on the fact that not only could the FSA produce well-trained artisans as required by parliamentary committees, but it was also able to provide a means of livelihood for women of a higher class who found themselves in distressed circumstances.

To return to parliamentary reports, where official policies on art training are being laboriously worked out and meticulously documented, a letter from John Charles Robinson is produced as evidence in 1863, and the writer is clearly on the side of those arguing for the admission of females to Royal Academy training and professional qualifications. He cites Angelica Kauffman, as do so many of the witnesses called before committees on this issue, and he argues, 'surely we have lady artists now who are at least her equals. In a social point of view it seems to me most desirable to hold out every encouragement for the adoption of art as a profession for females.'[42] Significantly, the whole issue of women RAs and RA students is ignored in the summing up of the report on the RA by its president, Charles Eastlake. Pamela Gerrish Nunn and others have discussed in detail the struggle to enter the portals of the RA.[43] Laura Herford's success in gaining entry caused a flurry of discussion at the time and later, both in the art press and on Select Committees. Take, for example, Edwin Landseer's account three years after the incident.[44] He was asked how many females were training at the RA at that time and the response was a surprising 'Ten' (1863). Thereafter the doors of the RA opened and closed almost at random during the 1860s, the usual excuse for non-admission of females being lack of space.

Without equality of educational facilities, art employment for women would be, as in so many other professions, severely restricted. Thus the battle for equality of opportunity to train, as well as within training, was a hard-fought one in the 1860s. One of the main battlegrounds in employment terms was drawn up around the demarcation limits imposed by male workers. An article of the 1860s on 'Art Decoration, a Suitable Employment for Women', by J. Stewart, mentions the selfishness of the male porcelain painters of Worcester, for example. They refused to work with women, who were seen as a threat to their livelihoods. This was certainly seen as 'selfishness' by the writer of the article, but he goes on, 'these men were only following their instinct of self-preservation.' The essential message of the article seems to be that work for women 'should not interfere with the present employment of men'.[45]

This incident has implications concerning wider feminist issues, of course, and it was, in fact, cited by Josephine Butler in her article on 'The Education and Employment of Women' of 1868 as a scandalous episode that should have excited 'more general indignation' at the time (an account had appeared in the

Edinburgh Review of 1859, and the question was still being discussed at a Social Science meeting at Leeds in 1872, according to the writer of the *Art Journal* articles cited above; see n. 45). According to Butler, the women had provoked jealousy at their 'skilful execution' which meant that they earned better wages than the men. The men then 'forcibly deprived them of their maulsticks on which it is necessary to rest the wrist while painting. Thus the women are at once rendered incapable of any fine work, and can only be employed in the coarser kinds of painting.'[46] Butler's description is quoted in detail in order to make clear her attitude to what she obviously saw as a typical example of what women had to put up with in the 1860s when they tried to enter male preserves of employment. In the same essay, Butler listed three main obstacles in the way of 'the enlargement of women's opportunities' for employment.

(1) Prejudice of employers and of the public.
(2) Combinations among workmen to exclude women from their trades.
(3) Defective education and training of the women themselves.[47]

These problems would have been very familiar to women trying to obtain employment in art, from the prejudices of the Royal Academy against professional membership or even training for women to the unfair exclusion of women from porcelain painting at Worcester. (The problems were gone over in detail in articles in the 1872 edition of the *Art Journal*). Butler does conclude on a note of hope at the 'earnest spirit in which some of the best and most thoughtful men are beginning to consider these matters'.[48] She cites people like F. D. Maurice in matters of education, and this spirit can be seen in some of the Royal Academicians interviewed by Select Committees during the 1860s and in writers of impassioned articles in the art press, particularly those writing in the *Art Journal* (as has been seen).

Purely practical disadvantages for women wanting to attend art schools could involve not only the strict rules about chaperonage, but the dangers of walking anywhere unaccompanied, especially on dark evenings. The young Francis Strong's mother was extremely nervous about her going to school in London, and 'precautions had to be taken so that she should not walk home unaccompanied.'[49] That had been at the end of the previous decade, but in 1864 similar fears were in evidence. To take but two examples from outside London, it was noted that girls were withdrawn from Cork School of Art in winter, so that female numbers fell from 70 or 80 to 23;[50] at another art school the accommodation was in such a 'low' part of the town that, a Select Committee was told, 'ladies of that city will not go down and get instruction there.'[51]

On the plus side, it was considered by one writer that ladies at the FSA in London actually received superior instruction to the students, male or female,

in other art schools where there was a constant change of teachers. This was another vexed question of the time: Mulready and Landseer were quizzed about the advantages of a single teacher over several teachers at the Royal Academy schools by Parliamentary Committees in 1863, for example.[52] A letter from 'An Old Student' to the *Art Journal* in 1860 makes her position on this issue clear: 'One half of the instruction received in drawing is rendered comparatively valueless (at most schools) by having several teachers when only one is required, and nothing is more disheartening to a student, after toiling for days, to have a second teacher come, whose system is in opposition to the first.' She adds that 'the same system is not unknown at the school of the Royal Academy. This evil has hitherto been most carefully avoided by the present and previous ladies superintendent [at the FSA].'[53]

Methods in general tended to follow those prescribed by the Committee of Council on Education, with drawing from the flat, then from the round, geometrical projections, free-hand drawing, drawing from casts in outline, then with shading (avoiding the 'dangers of laborious copying').[54] These method would prove particularly useful to those female students who went on to become teachers or governesses. In 1861, the British and Foreign Schools Society provided advice and regulations on the teaching of drawing in schools, where the art training received by young women would be translated into the teaching of basic drawing to children. It was felt that the acquisition of drawing skills was an essential part of a child's learning process, and that all teachers should be given some training in drawing and design. 'Children are able to convey their ideas much sooner in [drawing] than in [writing],' suggested the Drawing Master of the Normal College in a paper read to the May meeting of the British Teachers' Association.[55] Similar sentiments were expressed in the evidence given to a Select Committee a few years later by the director of the Lambeth School, an art school which, it will be remembered, had particular vocational concerns: 'Learning to draw helps children in the National School learn to write,' he asserted, speaking of the mutual support and co-operation between the two institutions.[56]

Thus the link between the professional training of artists, designers and general teachers can be seen in the attitudes of these two men whose professional life brought them into contact with opportunities for women in the workplace. In the Drawing Master's address to the British teachers he recommended Dyce's *Outlines of Ornament* as a guide, and the various stages, from geometrical drawing to freehand, outlining to shading (using stippling, hatching, stripping in short lines), are carefully explained in his talk. It is clear, therefore, that there was a link between the basic design taught at art schools and the drawing taught to ordinary teachers. This, indeed, was one of the conclusions of the lengthy

articles on 'Art-Work for Women' published in the *Art Journal* of 1872.[57] It was symptomatic of the 1870s for concern to shift to the practicalities of women's work as artists: a decade of debate had given way to a decade of more direct action.

Notes

1 Julia Pocock. See *Art Journal* (Mar. 1869), 82.
2 *Ibid.*
3 *Art Journal* (Jun. 1869), 184, article on Rebecca Solomon.
4 *Art Journal* (Mar. 1870), 92.
5 See, for example, *Art Journal* (Sep. 1859), 291; (May 1861), 159; (Mar. 1867), 88; (Mar. 1869), 82.
6 cf. Sheila R. Herstein: *A Mid-Victorian Feminist: Barbara Leigh Smith Bodichon* (New Haven and London, Yale University Press, 1985); Pam Hirsch, 'Barbara Leigh Smith Bodichon and George Eliot – An Examination of Their Work and Friendship', Ph.D. thesis, Anglia Polytechnic University (1992); Candida Ann Lacey (ed.), *Barbara Leigh Smith Bodichon and the Langham Place Group* (1987); and Jaquie Matthews, 'Barbara Bodichon: Integrity in Diversity', in Dale Spender (ed.), *Feminist Theories* (1983).
7 *Art Journal* (May 1863), 95.
8 *Art Journal* (May 1865), 68.
9 *Art Journal* (May 1863), 95.
10 *Art Journal* (May 1864), 91.
11 *Art Journal* (May 1866), 94.
12 Betty Askwith, *Lady Dilke: A Biography* (London, 1969), p. 8.
13 *Parliamentary Papers*, vol. vi (1864), 'Education and the Fine Arts', p. 85; vol. v (1863) 'The Royal Academy', pp. 206, 212. All citations of parliamentary papers refer to page numbers in the collection *British Parliamentary Papers* (Shannon, Irish University Press, 1969).
14 *Art Journal* (Sep. 1859), 277.
15 *Art Journal* (Aug. 1860), 245.
16 *Art Journal* (Sep. 1860), 286.
17 *Art Journal* (Apr. 1868), 78.
18 'Middle class Schools for Girls' in *Transactions of the Social Science Association* (1860), 432–8
19 Harriet Martineau, 'Middle-class Education in England: Girls', *Cornhill Magazine*, 10 (1864), 560.
20 T. Rowbotham, 'An Account of the Origin and Progress of the People's College at Sheffield', in *The Working Men's College Magazine*, 1 (1859), quoted in J. Purvis, 'Working-class Women and Adult Education in Britain', in *History of Education*, 9 (1980), 193–212.
21 John Ruskin, *Sesame and Lilies*, Lecture 2 'Of Queens' Gardens', two lectures delivered in Manchester in 1864 and published in 1865 (republished Dent, 1907), pp. 49, 59.
22 Kate Millett, 'The Debate over Women, Ruskin versus Mill', *Victorian Studies*, 14:1 (Sep. 1970), 63–82; reprinted in Martha Vicinus (ed.), *Suffer and Be Still: Women in the Victorian Age* (London, Methuen, 1972), p. 121; see also Kate Millett, *Sexual Politics* (London, Rupert Hart Davis, 1968).
23 David Sonstroem, 'Millett versus Ruskin: A Defence of Ruskin's "Of Queens' Gardens"', *Victorian Studies*, 20:3 (Spring 1977), 283–97.
24 See the scathing account of Miss Becker's paper, 'On Some Supposed Differences in the Minds of Men and Women with Regard to Educational Necessities' (delivered to the British Association at Norwich), in *The Lancet*, 2 (5 Sep. 1868), 320–1. For example, 'we think that

men possess bigger and stronger heads for the same reason that they have stronger limbs –
viz., that Nature has fitted them to do stronger work . . . no physiologist can doubt, we
think, that there is a corresponding relation between the delicacy of the organisation and
character of woman's structures and that of her duties in life' (p. 320). See also the editor-
ial in *The Lancet*, 2 (9 Oct. 1869), 510–12, attacking John Stuart Mill's *Subjection of Women*:
'Of course there are some women whose physical and intellectual powers are alike great;
but these form the exception, and they are generally as remarkable for the masculine qual-
ities of their bodies as for those of their minds' (p. 511).

25 *Art Journal* (Dec. 1859), 378.

26 *Art Journal* (Feb. 1860), 61.

27 *Parliamentary Papers*, 5th Report of the Council of the School of Design, 1845–46, p. 11ff.

28 'Women and Art', *Art Journal* (Apr. 1861), 107.

29 Evidence of Rev. Gregory, Superintendent of the Lambeth School of Art, 18 Apr. 1864,
minutes 736–44, *Parliamentary Papers*, vol. vi, p. 103.

30 Pamela Gerrish Nunn cites the views of Caroline Dall, for example, writing in 1859
and quoted in the *Atheneum* in 1960, on the amateurishness of women's attempts to labour
and the need for rigorous training. Pamela Gerrish Nunn: *Victorian Women Artists* (1987), p.
43.

31 14 Apr. 1864, *Parliamentary Papers*, vol. vi, pp. 91, 373.

32 14 Apr. 1864, *Parliamentary Papers*, vol. vi, p. 308.

33 *Art Journal* (Apr. 1867), 111.

34 *Ibid.*

35 Minutes of Evidence Taken Before the Select Committee on Schools of Art, 28 Apr. 1864,
minute 2312, *Parliamentary Papers*, vol. vi, p. 182.

36 14 Apr. 1864, minute 456, *Parliamentary Papers*, vol. vi, p. 84.

37 Appendix to Report from the Select Committee on Schools of Art: Payments on Results of
Instruction in Schools of Art, 17 Mar 1863, minute 4, *Parliamentary Papers*, vol. vi, p. 319.

38 *Art Journal* (Jul. 1860), 214–15, letter from 'Fair Play'.

39 'R. H. ' in *Art Journal* (Feb. 1860) cited above.

40 *Art Journal* (Feb. 1860), 61.

41 *Art Journal* (Apr. 1861), 106–7. See also, F. D. Maurice on 'The Female School of Art; Mrs
Jameson' in *Macmillan's Magazine*, 2:9 (Jul. 1860), quoting a paper issued by the School's
Committee of Management.

42 Royal Academy Commission: Minutes of Evidence, 14 May 1863, *Parliamentary Papers*, vol.
v, p. 529, quoting letter of 9 Apr.

43 For example, Gerrish Nunn, *Victorian Women Artists*, and Charlotte Yeldham, *Women Artists
in Nineteenth-century England and France* (London, Garland, 1984).

44 Royal Academy Commission: Minutes of Evidence, 28 Feb. 1863, minute 1006, *Parliamentary
Papers*, vol. v, p. 148.

45 *Art Journal* (Mar. 1860), p. 70; cf. also three articles on 'Art-Work for Women' in the spring
editions of 1872.

46 Quoted in Dale Spender (ed.), *The Education Papers: Women's Quest for Equality in Britain
1850–1912* (London, Routledge, 1987), p. 77.

47 *Ibid.*, p. 75.

48 *Ibid.*, p. 87.

49 Askwith, *Lady Dilke*, p. 5.

50 Minutes of Evidence Taken Before the Select Committee on Schools of Art, 5 May 1864,
minute 3118, *Parliamentary Papers*, vol. vi, p. 217.

51 14 Apr. 1864, minute 523, *Parliamentary Papers*, vol. vi, p. 89.

52 See Royal Academy Commission: Minutes of Evidence, 27 Feb. 1863, minute 959,
Parliamentary Papers, vol. 5, p. 144, where Landseer states, 'I am of the opinion that the change

of teachers is advantageous both in the painting school and in the life school'; Mulready makes the same point, 9 Mar. 1863, minute 1496, *ibid.*, p. 203.

53 *Art Journal* (Oct. 1860), 317.

54 See the debate outlined in Minutes of Evidence Taken Before the Select Committee on Schools of Art, 11 Apr. 1864, *Parliamentary Papers* vol. vi, p. 74 and description of methods by Cole and Redgrave, ibid., p. 107, p. 117, etc.

55 *The Educational Record*, 5 (1860–3), 91.

56 Rev. Gregory in 18 Apr. 1864, minute 768, *Parliamentary Papers*, vol. vi, p. 104.

57 See 'Art-Work for Women III', *Art Journal* (May 1872), 130.

INDEX